Twenty years ago, while skiing in Sun Valley, Idaho, I was on a chairlift with a fellow skier. As we rose up above the valley, we talked about what we did for a living. I explained to her that I made microchips and I tried to describe what they were and what they did. But the more I said, the more puzzled she became. Finally, I pointed to my digital watch, a newfangled gadget at the time, and I explained that inside was a chip—a sliver of silicon—keeping the time and changing the digits. She still looked confused, so I politely changed the subject.

Recently I thought about how much the world has changed since that chairlift conversation, and I found myself looking for a tangible way to demonstrate the remarkable and often invisible ways in which microchips—microprocessors, microcontrollers and memory chips—are now woven into the fabric of life in many corners of the world.

To mark the occasion of Intel's thirtieth anniversary and to capture the incredible impact microprocessors have had on everyday life, Intel decided to sponsor the book you are holding in your hands. Last July, on an ordinary day, 100 of the world's leading photojournalists were sent to every corner of the globe to capture the human face of the computer revolution during a single 24-hour period. This book is the result: an extraordinary visual time capsule.

As you turn these pages, you'll see a world being reshaped by technology in ways previously unthinkable. For one thing, the photographs show the effect of the millions of personal computers now in use. Increasingly, these computers are connected in networks, which are in turn linked to form what is rapidly becoming a global nervous system. World news, personal correspondence, educational pursuits, music, art and business now flow seamlessly through this network, merging Detroit, Dakar and Delhi into one place.

But microprocessors are also penetrating and improving existing products of every conceivable kind. Today's cars, for example, have numerous microprocessors tucked away inside of them to control brakes, lock doors and to remind you to fasten your seat belt. Microprocessors are in toys and thermostats; in cellular phones and automatic teller machines. They change how existing products function and allow the creation of new ones. In the aggregate, they change how we live, how we work, how we entertain ourselves and how we are able to imagine—and thus create—the world our children will inherit.

We've come a long way from the time when a digital watch was the best example I had to explain the microchip. Intel's sixty-thousand plus employees are proud of the pivotal roles we have played in the history of the computer revolution. We hope you will enjoy this photographic record of an ordinary day in the life of the microprocessor.

Andy Grove
Chairman and CEO of Intel Corporation

Children at New York City's Sony IMAX theater wear headsets that transform the images on the movie screen into a three-dimensional wonderland. Microprocessors are used to coordinate the entire theater experience, controlling the lights, sound, operation of the projectors and the infrared signals that communicate with the headsets. *Photo by Theo Westenberger*

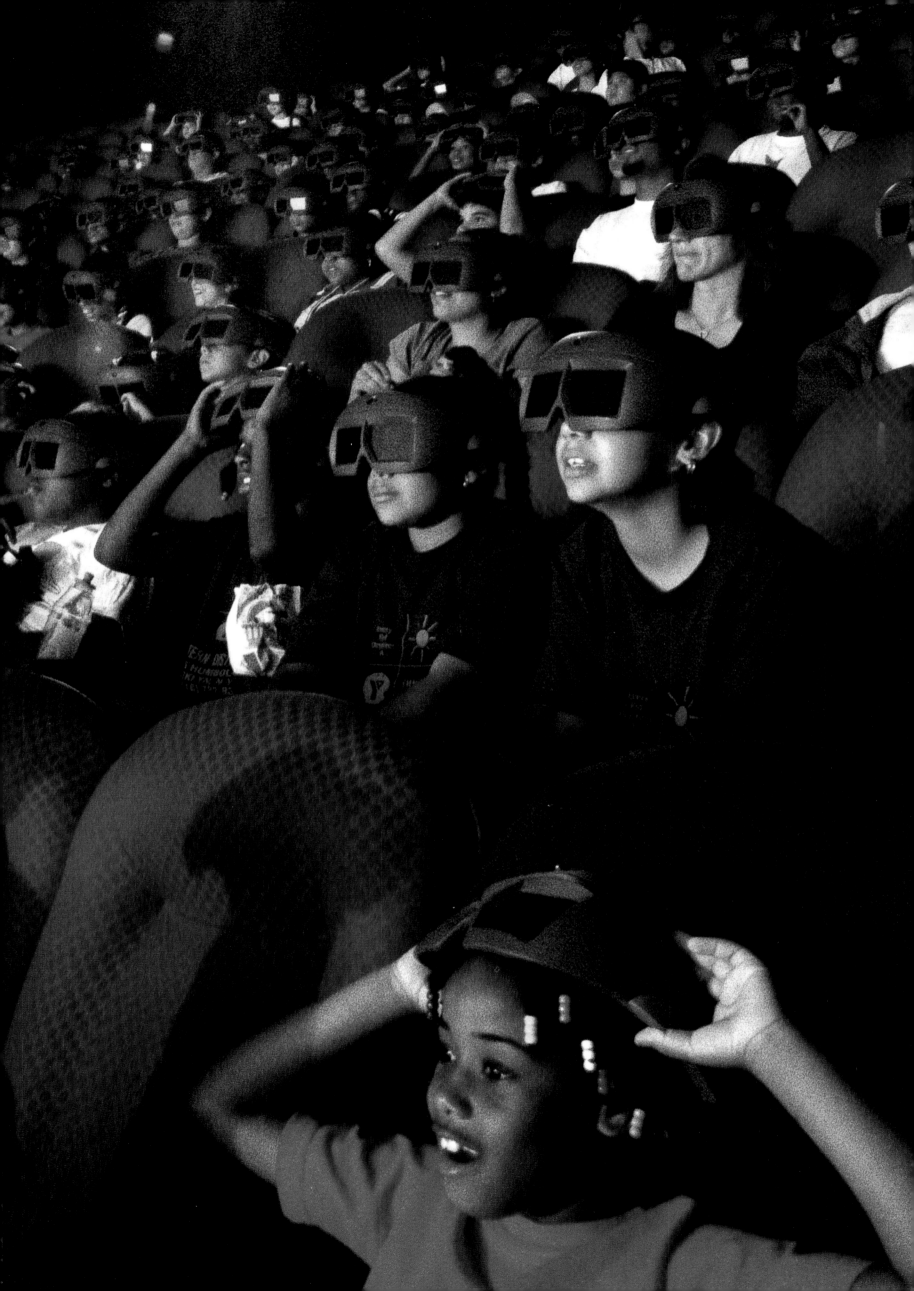

Thai Buddhist monks peer into the future at Panthip Plaza, a Bangkok mall specializing in computer products. In addition to traditional methods, the monks, from the Maha Phrutharam Temple, use computers to learn about Buddha and his teachings. *Photo by Dilip Mehta*

Keiko, the "killer whale" known to moviegoers as the star of *Free Willy*, wears a monitor that records his heart and respiration rate. Information is stored on a computer chip and later downloaded by researchers at the Oregon Coast Aquarium, aiding in their study of orca physiology. *Photo by Gary Braasch*

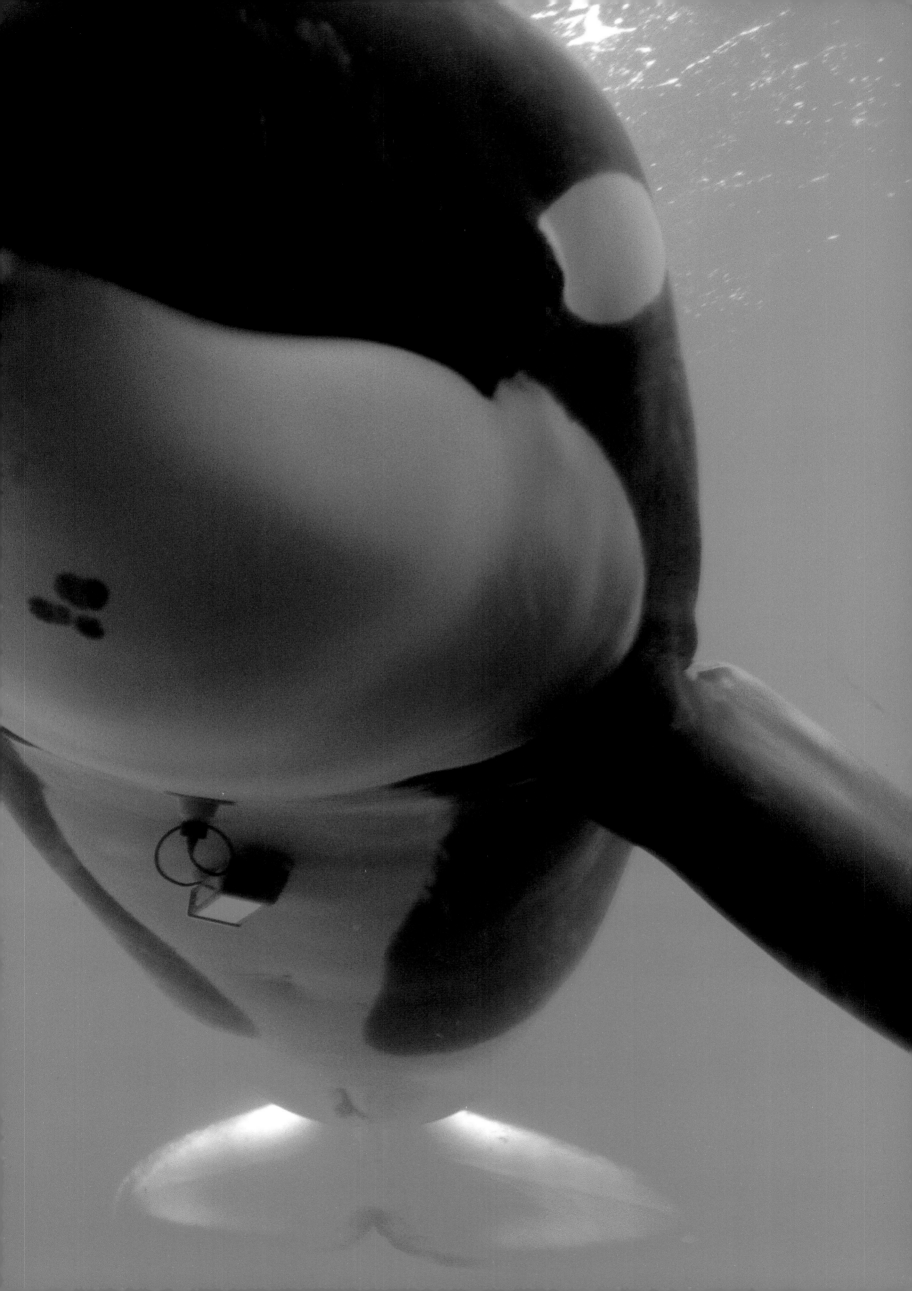

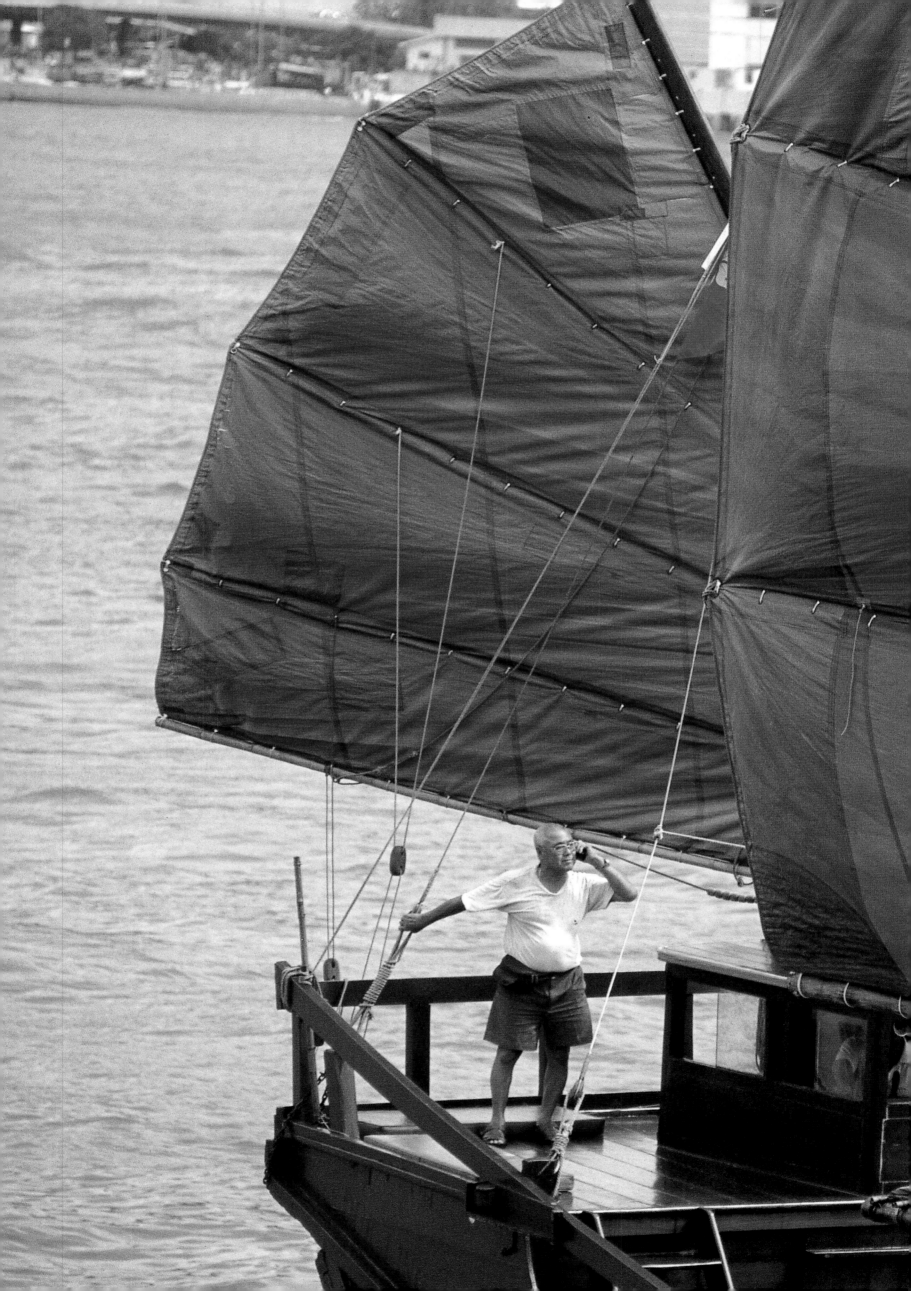

Hong Kong skipper Cheung Shing's great-grandfather would have used signal flags to communicate with the Mainland, but today, wireless networks are connecting families and co-workers all over the world in ways our ancestors could never have imagined. *Photo by Jeffrey Aaronson*

This project was made possible through
the generous assistance of Intel Corporation.

One Digital Day

How the Microchip
is Changing Our World

Created by Rick Smolan and Jennifer Erwitt
Designed by Tom Walker

TIMES BOOKS/RANDOM HOUSE
in association with
Against All Odds Productions

Previous pages: Early morning on the farm, outside Urbana, Illinois. Photo by Joel Sartore

Library of Congress Cataloging-in-Publication Data

One digital day : how the microchip is changing our world / created by
 Rick Smolan and Jennifer Erwitt : designed by Tom Walker. -- 1st ed.
 p. cm.

 1. Microprocessors--Social aspects--Pictorial works. 2. Digital
control systems--Social aspects--Pictorial works. 3. Manners and
customs--Pictorial works. 4. Documentary photography. I. Smolan,
Rick. II. Erwitt, Jennifer.
TK7819.053 1998
303.48' 34--dc21 97-48434
 CIP

Random House website address: www.randomhouse.com
Against All Odds Productions, Inc. website address: www.AgainstAllOdds.com

Printed in Japan

10 9 8 7 6 5 4 3 2 1

First Edition

Introduction

by Michael S. Malone

The microprocessor is one of the greatest accomplishments of the twentieth century. Those are bold words, and a quarter of a century ago such a claim would have seemed absurd. But each year, the microprocessor moves closer to the center of our lives, staking out its place in the heart of one machine after another. Its presence has begun to change the way we perceive the world and even ourselves. It is becoming more and more difficult to dismiss the microprocessor as just another product in a long line of technology innovations.

No invention in history has so quickly spread throughout the world or so deeply touched so many aspects of human existence. Today there are nearly 15 billion microchips of some kind in use—the equivalent of two powerful computers for every man, woman and child on the planet. In the face of that fact, who can doubt that the microprocessor is not only changing the products we use, but also the way we live, and, ultimately, the way we perceive reality?

Yet even as we acknowledge the pervasiveness of the microprocessor in our lives, we are already growing indifferent to the presence of those thousands of tiny machines we unknowingly encounter every day. So, before it becomes too invisibly embedded into our daily existence, it is time to celebrate the microprocessor and the revolution it created, to appreciate what a miracle each one of those tiny silicon chips

Tomorrow's scientists track the wind's speed, direction and temperature on a hillside in Wales. Their findings are then e-mailed to school kids in other parts of Wales. Photo by Jeffrey Morgan

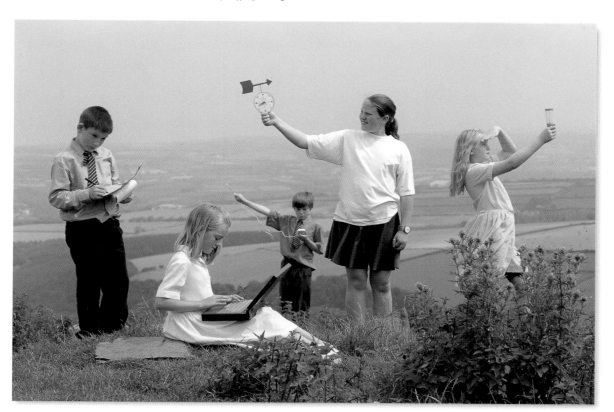

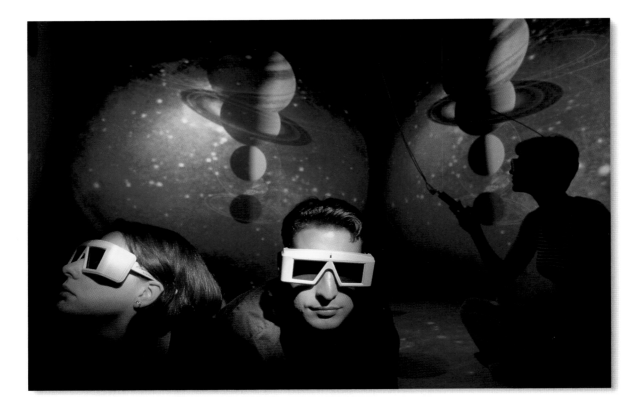

Thrill-seekers visit the future of entertainment at the CAVE, part of a virtual reality center in Linz, Austria. Computer generated 3-D graphics are projected onto the walls and floor of the small room. Photo by Lois Lammerhuber

really is and to meditate on what it means to our lives and to those of our descendants.

First, the revolution. Were we to strip away the microchip from every application in which it now finds a home, we would be both stunned and frightened by the loss. The modern kitchen would be rendered nearly useless since the microwave, the dishwasher and most other appliances would become unworkable. The television and VCR would fade to black, the stereo would grow mute and most of the clocks would stop. The car wouldn't start. Airplanes would be unable to leave the ground. The phone system would go dead, as would most streetlights, thermostats, and, of course, a half-billion computers. And these are only the most obvious applications. Every factory in the industrial world would also shut down, as would the electrical grid, stock exchanges and the global banking system. But let's go deeper: pacemakers would stop too, as would surgical equipment and fetal monitoring systems in obstetrics wards.

All because of the loss of a tiny square of silicon the size of a fingernail, weighing less than a postage stamp, and constructed of just crystal, fire, water and metal.

This, of course, is the miracle. Tens of thousands of microprocessors are built every day in the most sophisticated manufacturing plants ever known, where a single speck of dust can mean disaster, where processes occur in environments cleaner than any other place on earth. Even the water used to rinse the surfaces of the finished chips is purer than that used in open-heart surgery.

The modern microprocessor contains as many as 20 million transistors, and each finished chip is the product of processes more complicated than those used by the Manhattan Project in building the atomic bomb. Yet despite an extraordinarily sophisticated manufacturing process, microchips are produced en masse at the rate of more than a billion each year. To put this complexity in perspective, imagine that within each tiny

microprocessor there exists a structure as complex as a mid-sized city, including all its power lines, phone lines, sewer lines, buildings, streets and homes. Now imagine that throughout that same city, millions of people are racing around at light speed and with perfect timing in an intricately choreographed dance.

And that is just one chip. Of all the stunning statistics used to describe the world of the microprocessor, none is more extraordinary than this: the total number of transistors packed onto all the microchips produced in the world this year is equivalent to the number of raindrops that fell in California during that same period.

Faced with such stupefying numbers, it becomes even more difficult, and more vital, to ask what it all means for us and for the generations to come.

Historical precedent is a good place to start. The Industrial Revolution, which irrevocably changed the world, was brought on by a 50-times improvement in productivity—a leap so prodigious that it turned society upside down. It changed the nature of work and play; it transformed commerce, education, medicine, government and religion. It led to new forms of art, literature and political theory. More important, it changed forever the way we look at ourselves and our families, and at time and the universe.

But the microprocessor has already eclipsed that revolution. Evolving faster than any invention in history, the microprocessor's capability has grown ten thousand-fold over the past 25 years.

The result is not merely a world turned upside down, but one tumbling over and over down the path of history. What is remarkable, and maybe a little frightening, is that by all indications, we are only halfway through the story of the microprocessor. It is not far-fetched to suggest that it will take another century for humankind to realize all of

Pulling on standard facility work suits over their traditional garb, Malay, Chinese and Indian women work side-by-side, making the Penang, Malaysia facility one of Intel's most diverse. Photo by Munshi Ahmed

the implications of this revolution. Thus, all the miracles we see around us today resulting from the microprocessor may be but a tiny fraction of all the wonders that we will derive from this device well into the new millennium.

The microprocessor is helping inventors propel humanity into an era of change the likes of which we have never known. It is not merely an invention, but a meta-invention which enables us to create yet other inventions. Thousands of new devices and products have been made possible by the existence of the microprocessor and by the embedded intelligence it offers despite infinitesimal demands for space or power. Millions more microprocessor-enabled inventions await their inventors.

That's only part of the story, because the microprocessor also revitalizes products and services that already exist. Look no further than your smart refrigerator or the dashboard of your car. The greatest attribute of the microprocessor is that it can embed intelligence into almost anything. It can be trained to adapt to its environment, respond to changing conditions and become more efficient and responsive to the unique needs of its users.

Thus, the microprocessor's greatest role may be to help us design our own lives—and in doing so, to enhance that most precious of human traits, our individuality. The microprocessor is not only giving us power over our own lives, it's also the greatest instrument for achieving freedom ever invented. It's allowing us to reach out from our desks, to grasp and share knowledge that was beyond the reach of the wealthiest man in the world just a century ago. It's tearing down the walls of the world's tyrannies. It's freeing us to work at home, wherever we choose our home to be.

In 1986, after receiving a diagnosis of Lou Gehrig's disease—a condition that gradually destroys the nerve cells controlling body movement—Intel physicist and engineer Mike Ward, based in Portland, Oregon, immediately began drawing blueprints for a computer system that would allow him to continue working as the disease progressed. "Typing" an e-mail message using eye-gaze technology, Ward says, "I cannot move or speak, but I can still be productive." Photo by J. Kyle Keener

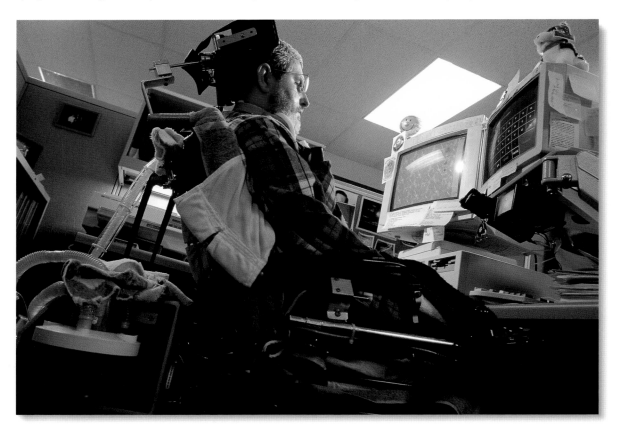

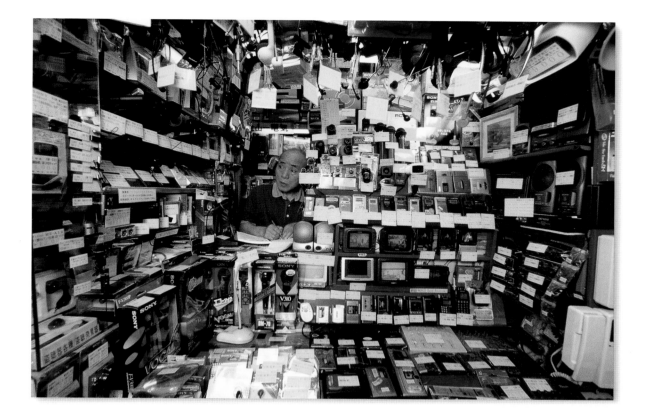

While most of the world associates microprocessors with desktop computers, the majority, in fact, are embedded into common, everyday electronic devices like the hundreds displayed in Bunzo Miyazawa's cluttered electronics stall in Akihabara, the Tokyo neighborhood where thousands of vendors offer the latest in entertainment and business equipment. Photo by Kaku Kurita

By the middle of the next century, the typical microprocessor may have more computing power than today's fastest supercomputers. It will talk, and more important, it will listen. The relationship we have with it will change in almost unimaginable ways. Yesterday, the microprocessor was a tool. Today, it is a partner. And who knows what vital role it will play in our lives in the years to come?

For hundreds of years, humankind has searched for the philosophers' stone, the magical object that turns ordinary metal into gold. Who would have thought it would turn out to be a little sliver of crystal with etching on its surface? As the following pages so vividly show, the microprocessor, in the span of a single generation, has evolved from a clever technical novelty to a tireless, almost invisible partner to humanity. Today, there is no place on, above or below the earth that it has not reached.

▶ SAN ANSELMO, CALIFORNIA

Finding the microchips in our lives can be like a game of *Where's Waldo?* They wake us up, heat our food, change our channels, keep us healthy and prevent our cars from skidding. Microchips are present in almost every aspect of our lives.

Over the last 25 years, these tiny, solid-state devices have quietly crept into our lives in ways that few of us are aware. Sure, we all know that microprocessors make our computers run, but did you know that the average American touches 70 microprocessors before lunch?

This northern California family turned their home inside out at dawn to illustrate how all-pervasive this technology is in our daily lives. Items include:

- Volvo
- Global Positioning System
- Compact disc player with remote
- Portable compact disc player
- Digital controller
- Digital console
- Digital cyclometer
- Personal computer
- Washer & Dryer
- Digital thermometer
- Video editing controller/titler
- Dishwasher
- Microwave oven
- Calculator
- Camcorder
- Color video printer
- 54" Television
- Digital satellite system with remote
- VCR with remote
- Game console/ controller
- Voice-activated toy
- Stove
- Mixer
- Laptop computer
- Refrigerator/freezer
- Telephone/fax

- DVD player
- Digital signal transfer system with remote
- Stereo receiver/tuner with remote
- Mercedes
- Toaster
- Juicer
- Breadmaker
- Blender
- Pager
- Coffee maker
- Telephone/answering device
- WebTV® with remote
- WebTV® keyboard
- Robot toy
- Digital watch
- Digital bathroom scale
- Portable radio/tape player
- Digital dog-silencing collar
- Clock radio
- Personal stereo CD component system
- Digital camera
- Hand-held television
- Cordless telephone
- Portable mini-disc recorder

Photo by Peter J. Menzel

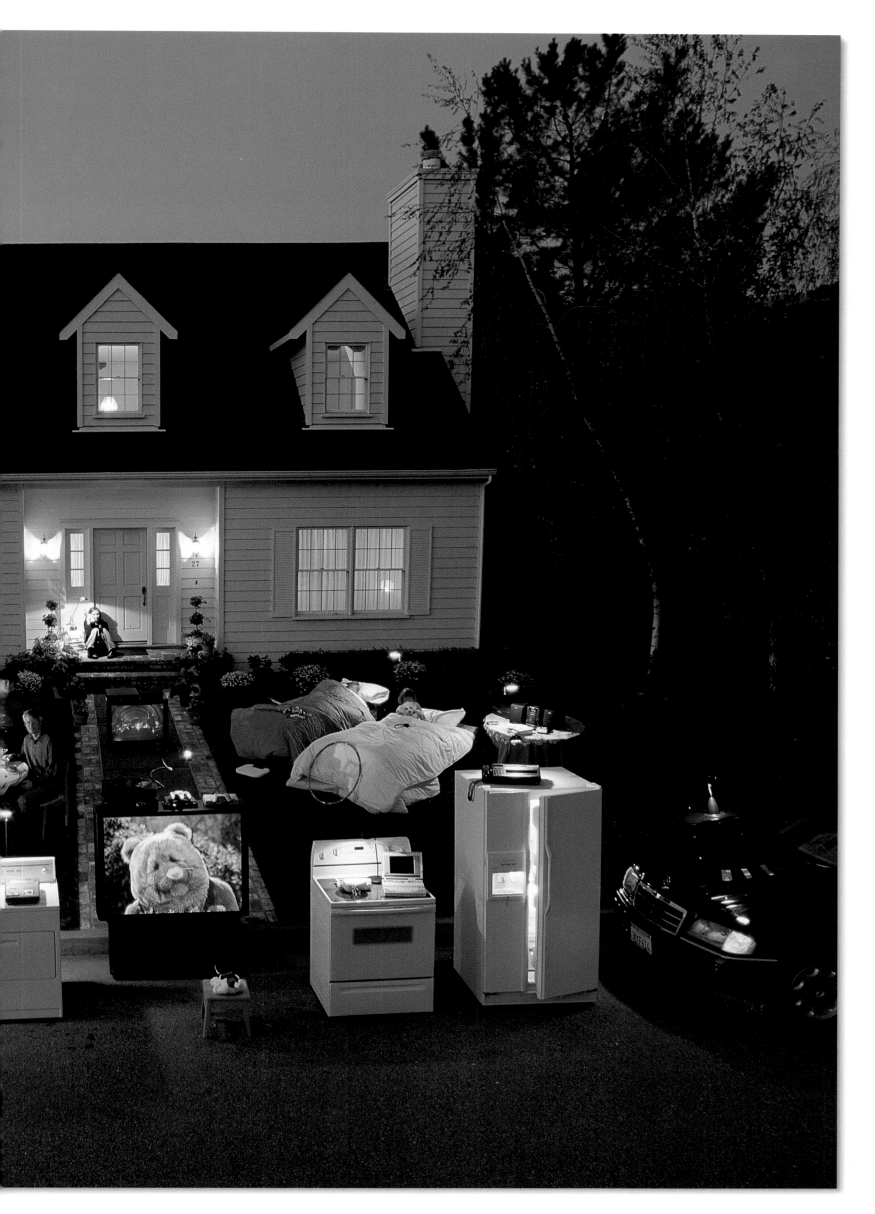

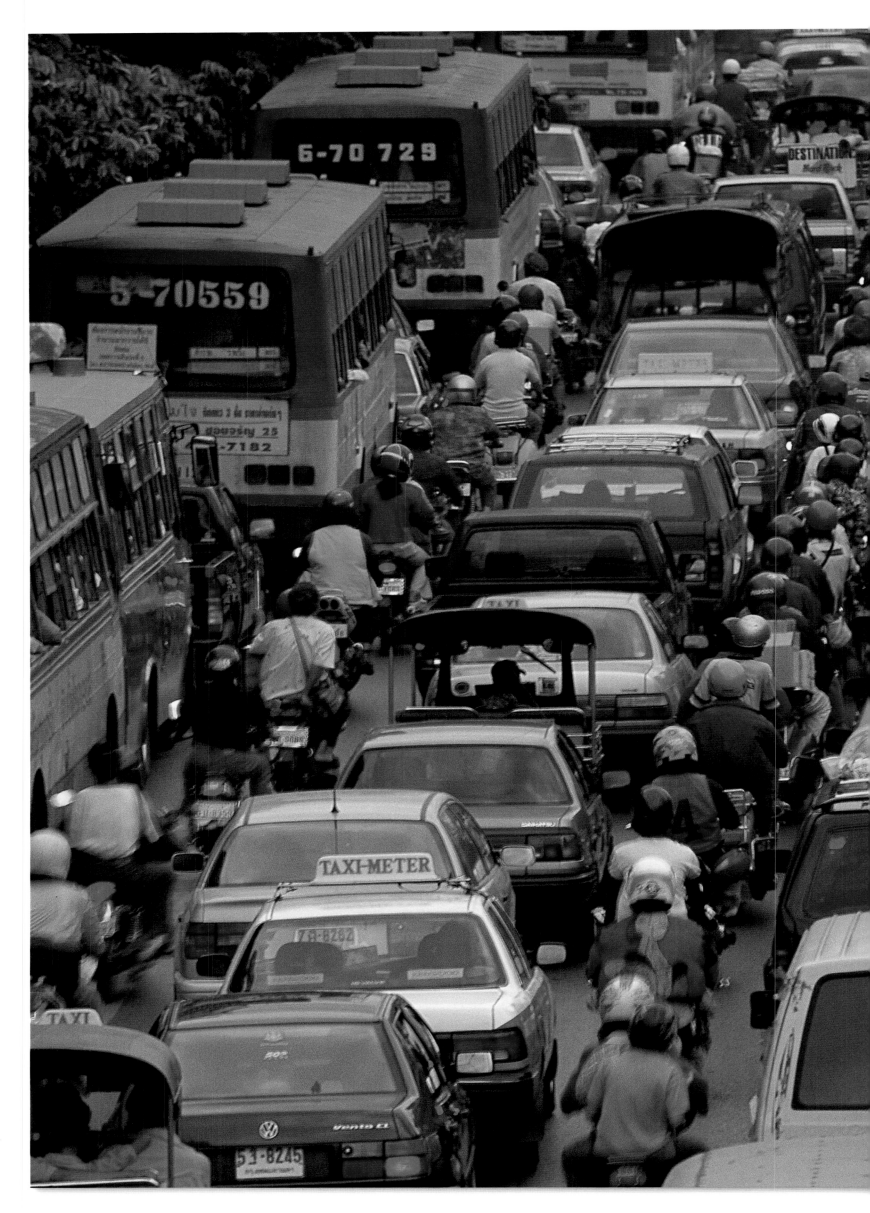

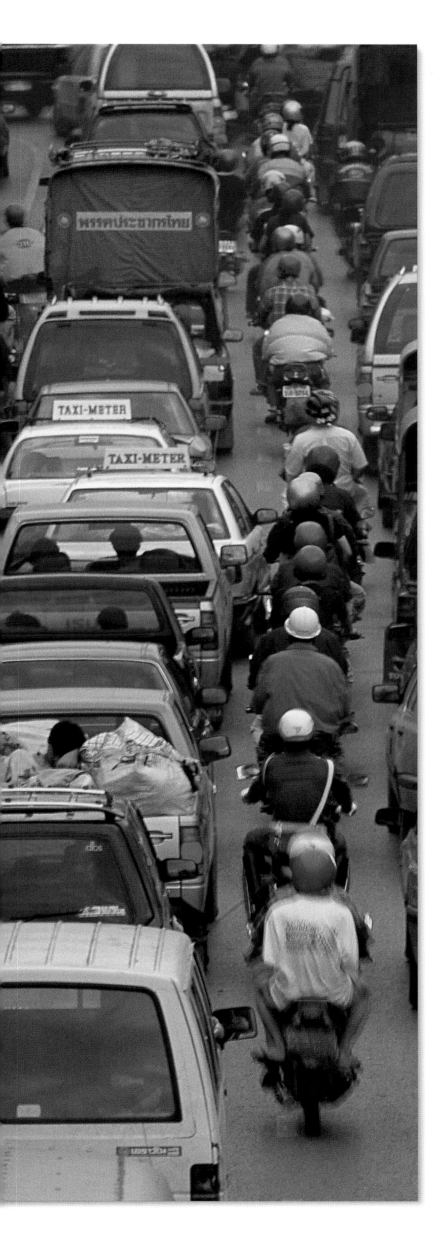

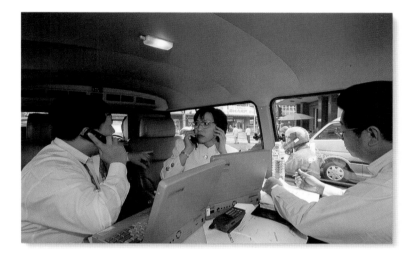

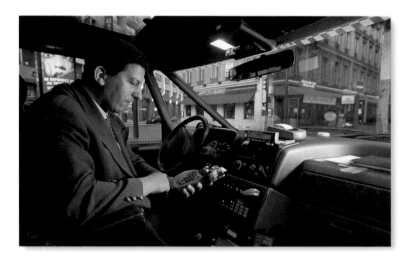

◀ ▲ ▲ ▲ **BANGKOK, THAILAND**

Business moves even when traffic doesn't in gridlocked Bangkok, where cars creep a mile or two in a typical hour. Savvy commuters work as they wait (*top*), riding in an office-on-wheels—specially equipped rental vans with laptops, fax machines, cell phones and modems. The most creative solution to a city stuck in a permanent traffic jam? Giving the van's exact location to motorcycle messengers, who weave through the Thai capital's strangled streets to deliver and pick up important packages to and from stranded passengers.
Photo by Dilip Mehta

▲ **PARIS, FRANCE**

It's like having a chauffeur. Cabbie Salah Bjaoni routinely picks up passengers less than five minutes after they call, thanks to a $200 Global Positioning System (GPS) transmitter installed under the hood of his Mercedes. His dispatcher back at Taxi Bleu headquarters uses the GPS and custom-mapping software to pinpoint the exact location of each of the company's 2,000 cabs and alerts only the cab closest to the pick-up spot. Here Bjaoni charges a customer's credit card using a wireless verification terminal. That's something he's done more of in recent months. Business is up 20 percent since Taxi Bleu started matching passengers and drivers by computer.
Photo by Arnaud de Wildenberg

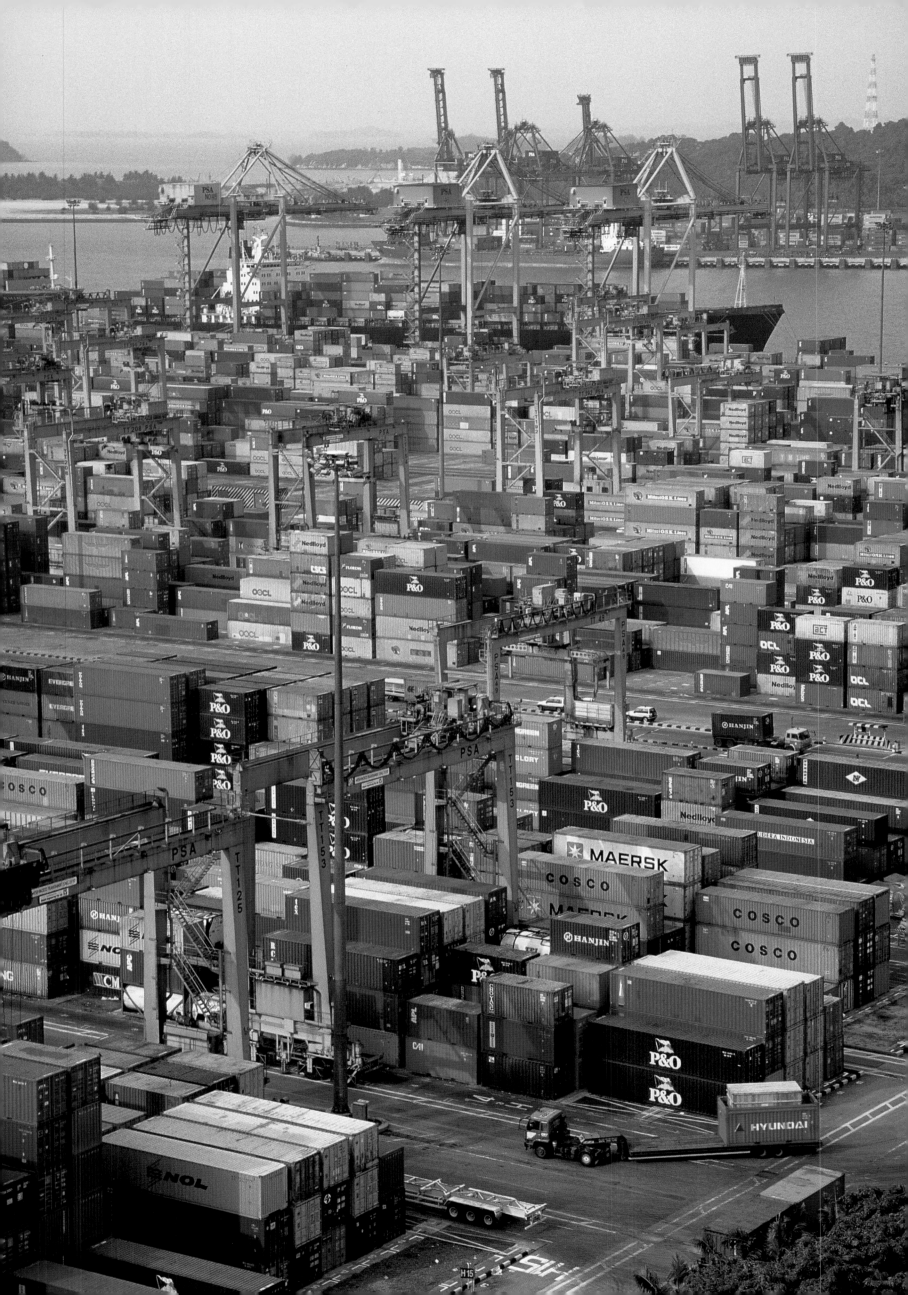

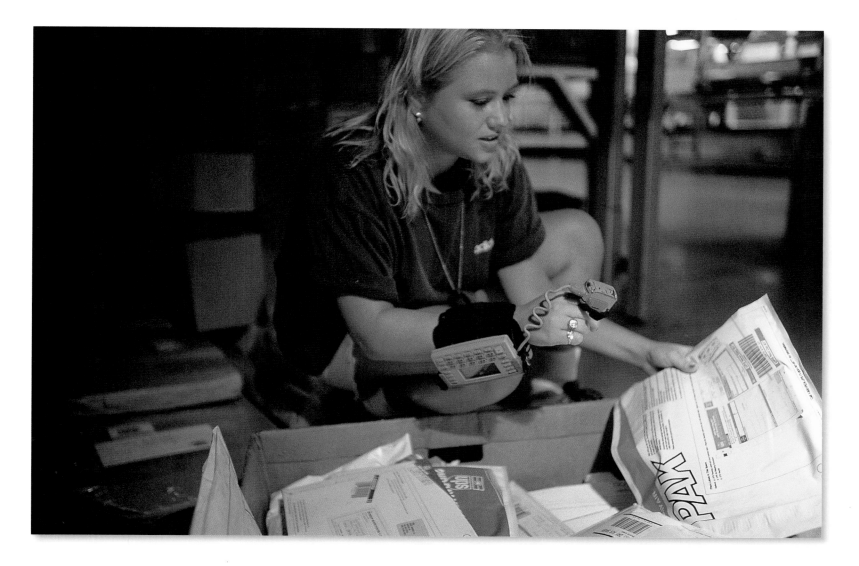

On a typical day, more than 30,000 containers will move through the Port of Singapore—one of the busiest and most modern ports in the world. Over 350 technology applications are used to track each container as it moves through this automated system.

In order to save time and money, shipping companies now submit declarations and stowage instructions electronically. Trucks hauling containers can drive through the gate without stopping, since their container numbers and characteristics are visually read by a computer. This system then sends a message via pager to the hauler directing the shipment to the correct yard location. Like a relay race, this series of systems tracks the location of every container in real time. With this technology in place, most ships move in and out of Singapore in 10 hours, less than half the time it takes at other ports.

Photo by R. Ian Lloyd

▲ LOUISVILLE, KENTUCKY

UPS is teaching its packages to talk. Scanning a package into the UPS tracking system, Melissa Bently logs a shipment via a laser scanner on her index finger and the computer strapped to her wrist. On the way to its final destination—passing barcode scanners on each of the company's containers, trailers and docks—the package constantly announces its whereabouts to the UPS computers. Only when a package reaches its final destination, and the recipient enters a digital signature on a driver's hand-held computer, does it end its electronic journey. With its $35 million tracking system in place, UPS can now locate and redirect any of its 12 million daily packages at a moment's notice.

Photo by Melissa Farlow

▶ ALSMEER, NETHERLANDS

Dutch flowers will melt hearts around the world by evening, thanks to an early-morning electronic auction in this small town. Buyers bid electronically for the flowers, following the prices on the circular displays dominating the hall. The computerized auction begins at 6:30 A.M. Within three hours, buyers will have snapped up 17 million flowers— freshly cut from greenhouses around the Netherlands, the world's largest flower exporter. By noon, the flowers are on jets, bound for shops around the globe.

Photo by Rudi Meisel

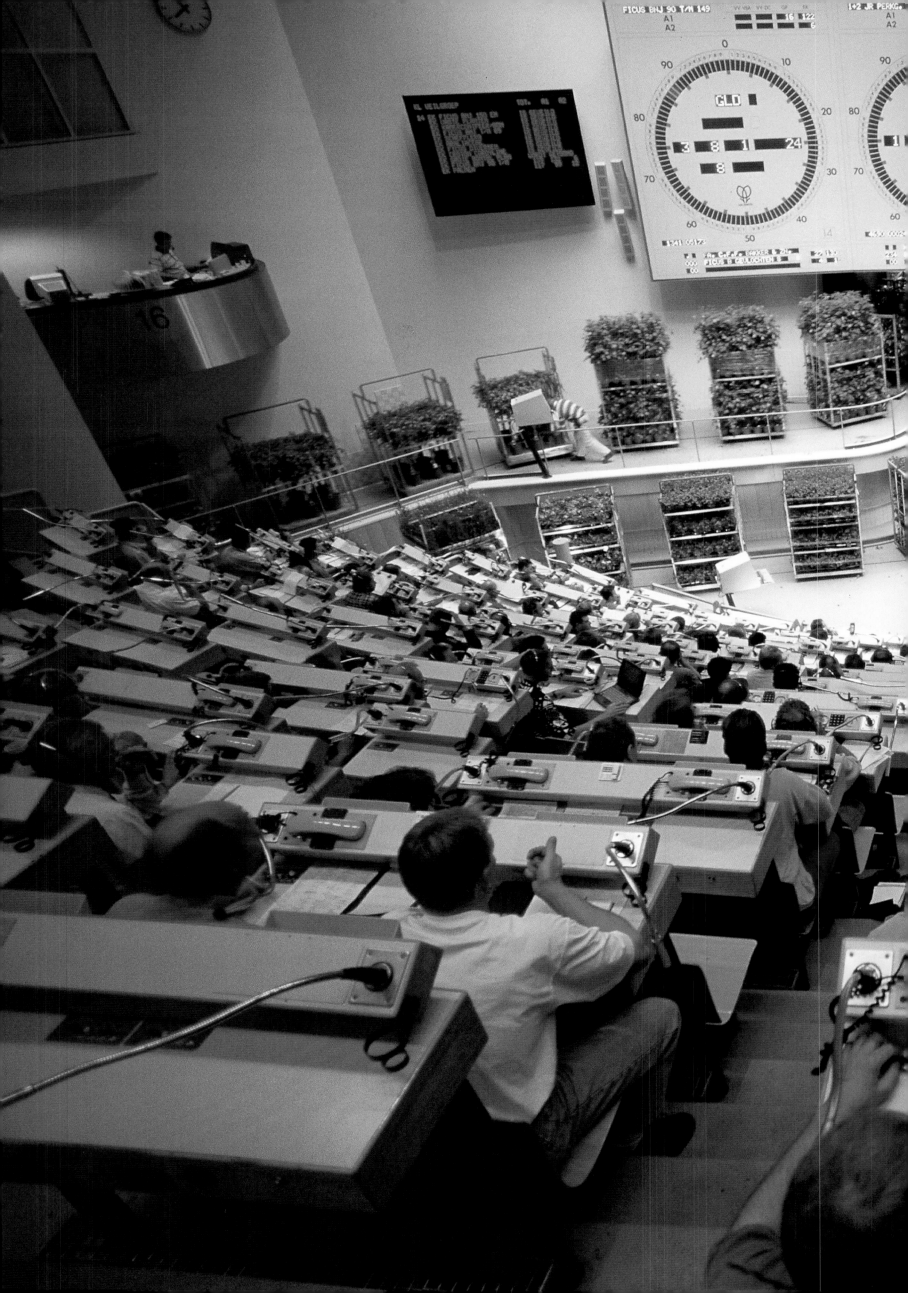

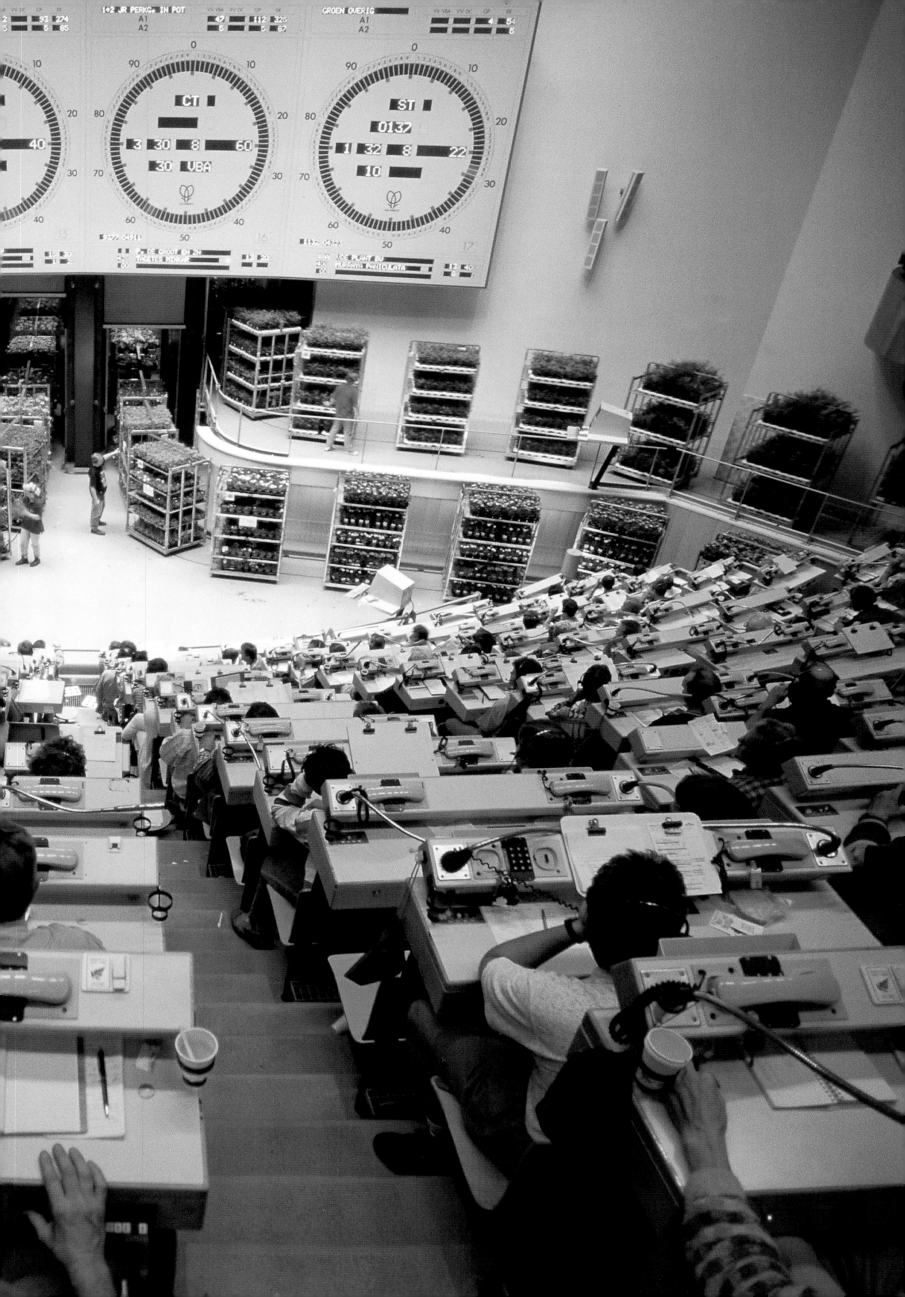

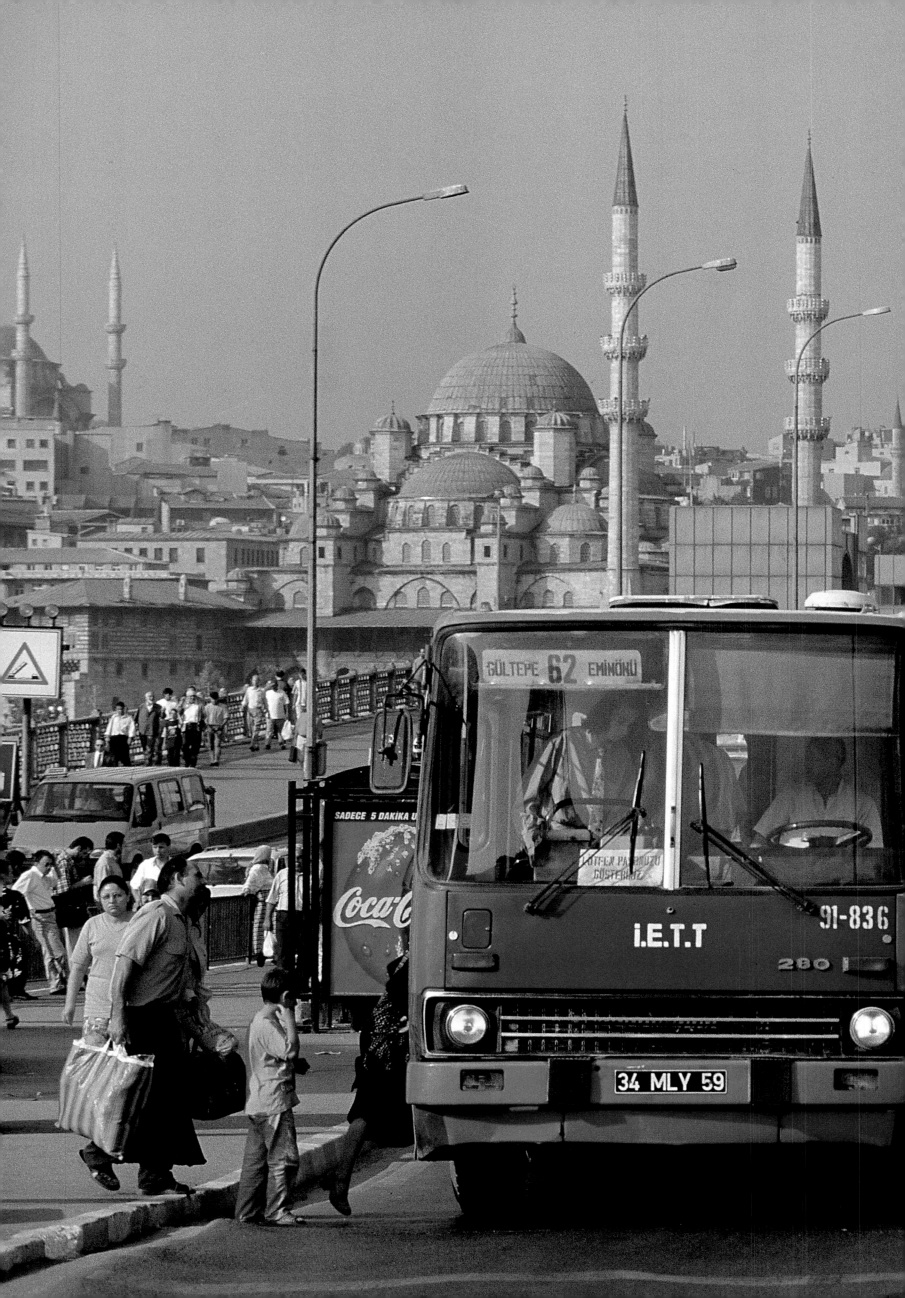

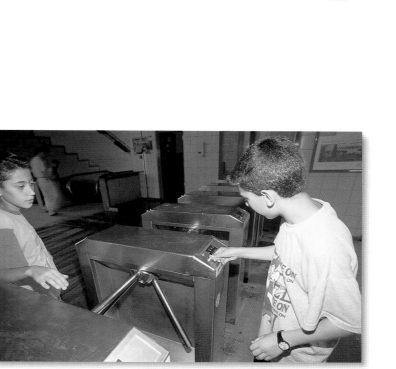

◀▲ ISTANBUL, TURKEY

A Turkish boy (*above*) gains access to the Istanbul subway using a rechargeable computer chip that eliminates the need for cash. Originally developed in the United States, the "I-button" has taken hold in the Turkish capital, where a million people use it daily to pay bus and subway fares, gain access to secure buildings and even buy sodas from vending machines. The button, which can also be worn as a ring, holds 64k of read/write memory—about as much as an average desktop computer could hold 15 years ago. Just as Istanbul itself spans two continents, its transit system today bridges two eras of financial exchange: city buses still accept coins, although boarding with an I-button is considerably quicker. *Photos by Mehmet Gulbiz*

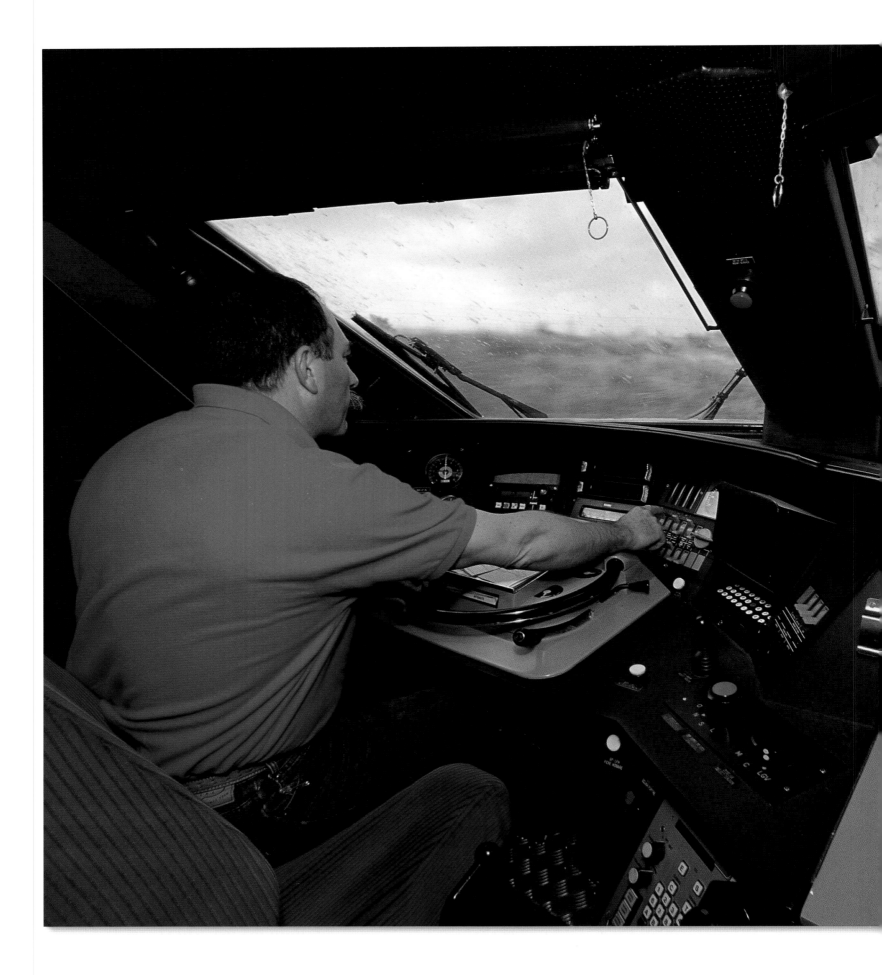

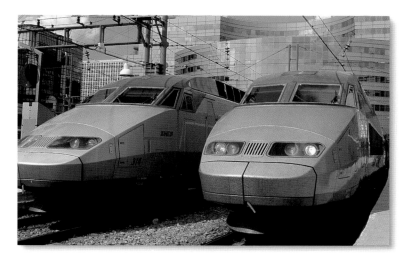

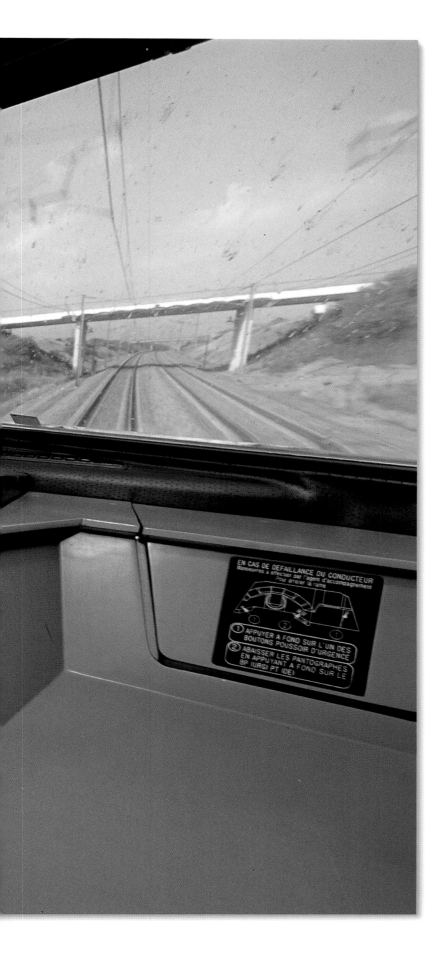

◀ ▲ CENTRAL FRANCE

Hurtling through the countryside at 190 miles per hour makes it virtually impossible for the engineers of France's TGV trains to see and respond quickly to trackside signals. Instead, they rely on electrical signals that are transmitted to their control consoles. On-board computers process the signals, transmitted from trackside boxes and picked up by antennas under the wheels, and display instructions on the engineer's dashboard (*left*). While computers drive a growing number of rail systems worldwide, especially subway trains, humans still control the sleek and shark-nosed TGVs (*above*). But the customer using a touch screen (*top*) at the computerized ticket booth at La Gare Montparnasse in Paris needn't worry about driver error. An automated system kicks in if the engineer exceeds safe speeds, and TGV officials say the system is so well-designed it should only experience a "dangerous failure" once every million years.
Photo by Raphaël Gaillarde

These are the Good Old Days

by Michael S. Malone

f human beings are a reflection of the tools we create, then we are truly the "people of the processor." Disassemble any corner of modern life, pull back the outer layer of boxes and building materials and flashing lights, and like seeds in a pod, out spill microprocessors by the millions. And in the new world of cyberspace (which is essentially a giant global conversation run by microprocessors), they don't even need a box. On the contrary, embodied as software agents scurrying about the global network fulfilling our desires, they will construct virtual bodies of their own.

It is all very thrilling, and very disorienting. Times of great change inevitably lead to nostalgia for simpler, seemingly better times. During these moments, no time seems more idyllic than that of the American frontier.

Back in the 1890s, in a hillside bank on a tributary of the Cimarron River under a stand of cottonwood trees near Marshall, Oklahoma, there was a dugout cave with a worn wooden door. It was in that crude setting that my grandmother spent her infancy. Her parents had just claimed 40 acres of land in the Oklahoma Land Rush, and they were busy—when they weren't fighting winter cold or summer wildfires, they built a house and worked on getting the first crops in. For nearly 50 years, the house they built had no electricity or indoor plumbing and was heated only by a wood stove.

When I think of my grandmother in that dugout cave, my thoughts are not of the romanticized "good old days" but of a world lacking many of the things we take for granted today. Conjure up that world in your mind and imagine what it was like: No pasteurized milk. No vaccines. No new medicines created by computer models and tested by computer-based

▼ **SHANGHAI, CHINA**

Everything but the kitchen sink. Modern conveniences don't include a bathroom or cooking facilities in this one-room Shanghai apartment. Instead, the Hei family has invested in a PC, cell phone, pager, TV and VCR. The patriarch of this middle-class Chinese family, Xiao Ping, runs his printing business with the cell phone; son Dan studies computer science at the university. The family shares a toilet and kitchen with several others in their high-rise and showers in a public facility across the street.

Photo by Fritz Hoffmann

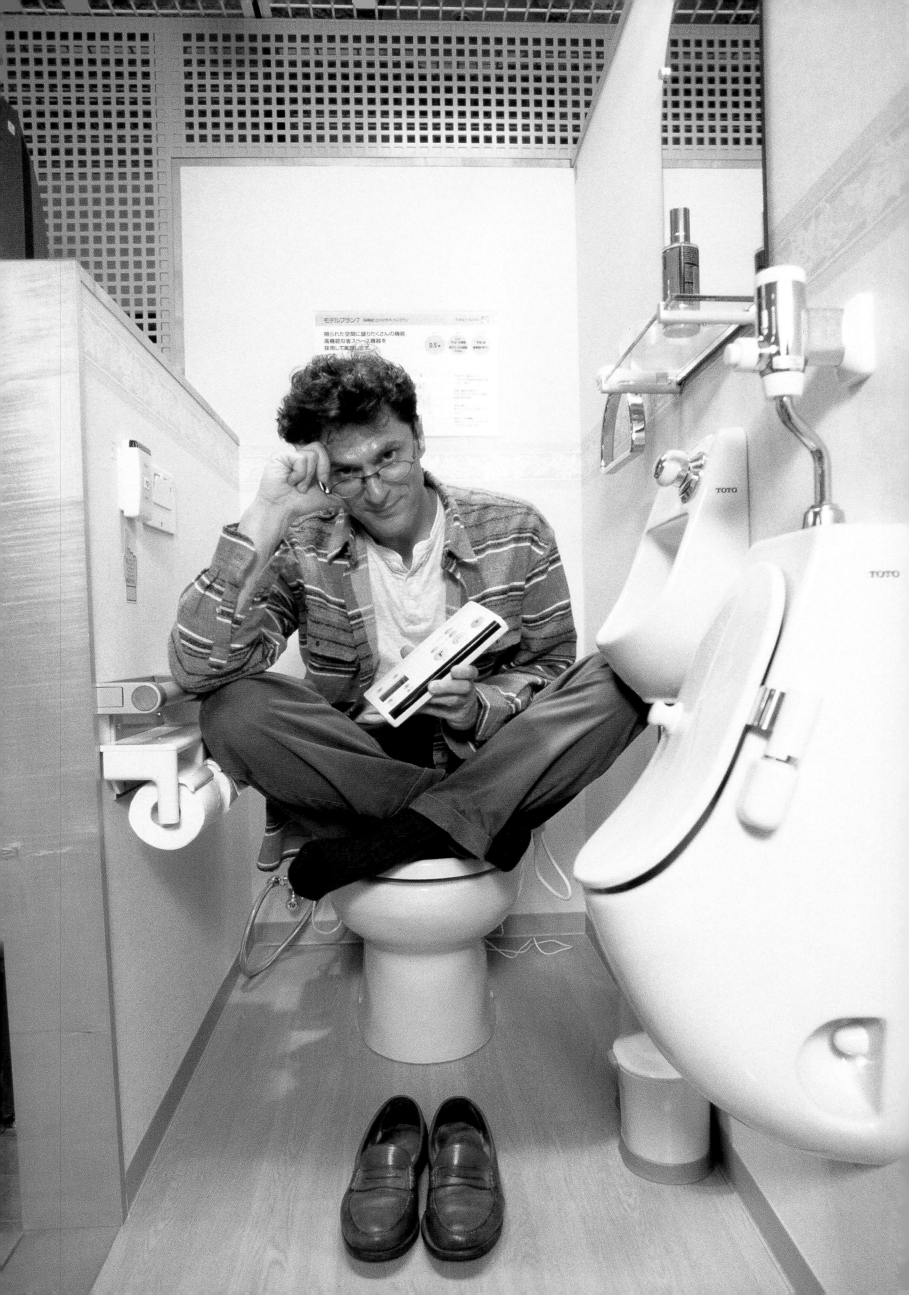

statistical programs. No air conditioning. No laser surgery or microprocessor-ground eyeglass lenses. No airplanes or ambulances. No patient-monitoring systems or cell phones. No MRIs or CAT scans. No regular access to the world beyond the horizon. No mass spectrometers to test the water. No satellites to predict tornadoes.

It was a world in which the idyllic simplicity we often look back on with nostalgia was, more often than not, filled with tiny coffins and quarantine notices on front doors, injuries that too often turned fatal, frequent deaths in childbirth and a life expectancy of less than 60 years. Young men and women became old before their time. A quarter of all babies never reached the age of ten. And a centenarian was a rare and celebrated individual, famous for five hundred miles around.

It was also a world of terrifying isolation. Of servitude to machines that, because they had no built-in intelligence, were often as deadly as they were useful. Of doctors and teachers who, no matter what their gifts, lacked the tools to truly perform their magic. And a world at the mercy of the vagaries of weather, natural disasters and disease.

I think now of my grandmother, who, at the age of seventy-five, sat with my grandfather on the mohair sofa in the living room of their house in Enid, Oklahoma, and watched on television as the first human being set foot on the moon. Before she died, my grandmother—who had arrived in Oklahoma in a horse-drawn wagon—had flown in a jet airplane, made numerous transcontinental telephone calls, owned a color television and dealt with computers on nearly a daily basis. She perfectly exemplified the generation born at the end of the nineteenth century, who saw more change in their lifetimes than any generation before it in human history.

Recently I had a chance to visit her house, which is now owned by another family, one whose children are blissfully unaware of the way life used to be in this same house, this same town. On a worn side street of Enid, the house was indistinguishable from the millions of other houses that line forgotten streets of the industrial world. Had my grandmother been alive today and wandered into this house, she would have felt a bit disoriented, but still at home.

But had she really explored her old home, she would have become more and more astounded at the appliances and

These days, making a phone call requires a touch of lipstick. Ida Schofield, a 69-year-old grandmother, had never touched a computer or thought she had any need for one.

Then in March 1997, Intel UK installed a PC in her house as part of a program designed to observe how technology neophytes would use a state-of-the-art desktop system with ProShare® Technology video conferencing.

Today, Schofield makes good use of this technology by chatting with her son. She also enjoys being a digital pen pal, regularly exchanging e-mails with new friends in Australia, the United States and Europe. "My friends can't understand why I'm using a computer at my age," says Schofield, "but I've met such a lot of different people online."

Other participants in the 18-month program include an unemployed Scottish truck driver hoping to improve his job prospects and a divorced mother who uses ProShare Technology to talk to her kids when they're at their father's house.

Photo by Michael Freeman

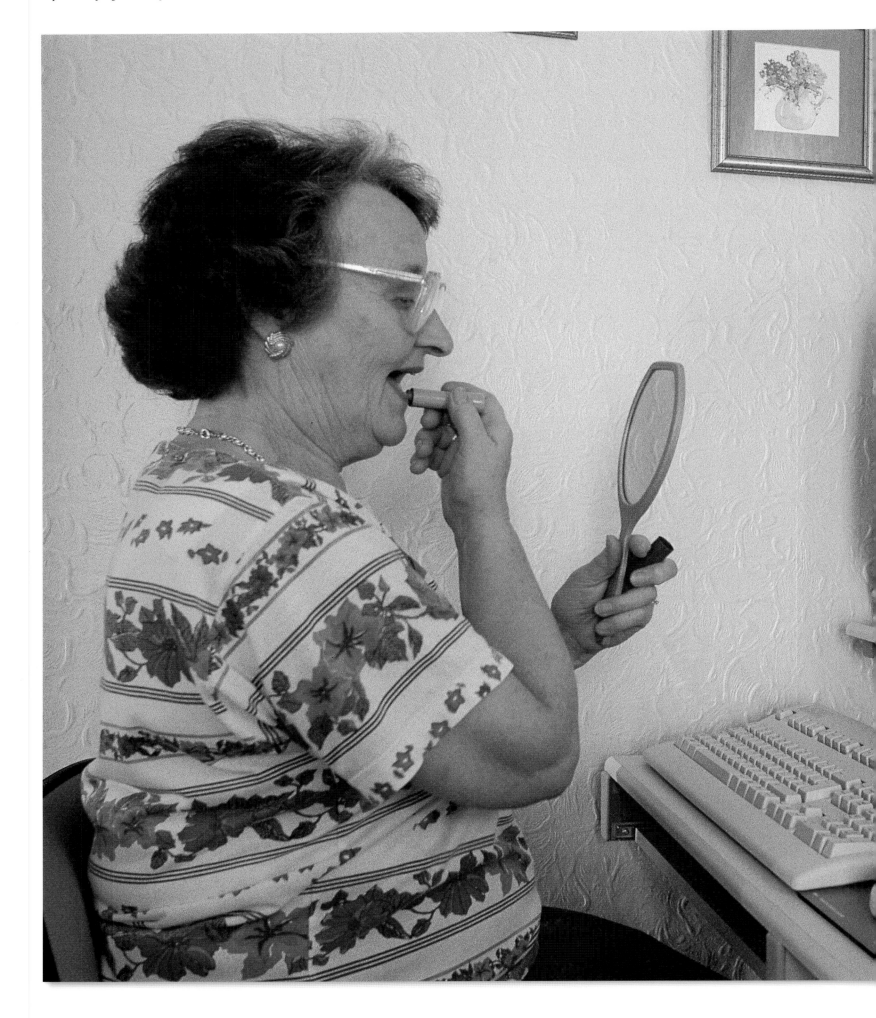

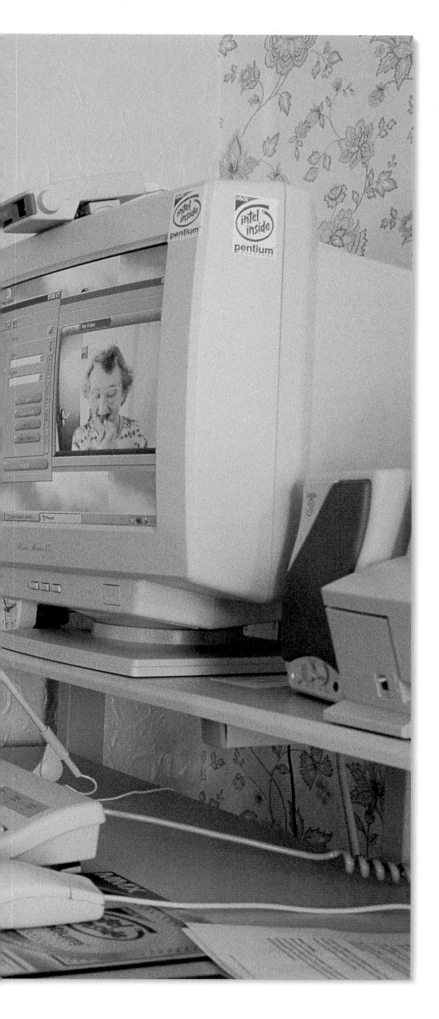

machines empowered by tiny devices installed just under the surface, beneath the superficial trappings of the house she had died in 15 years ago. As I wandered through that house, which held so many of my own memories, I took a quick mental inventory—big-screen TV, stereo, VCR, microwave oven, a new car in the driveway, a video game player in a kid's room—and the thought suddenly struck me: in this prosaic little home there was now more computing power than that employed by all of NASA on the day Neil Armstrong stepped out into the lunar dust.

Looking back now at the transformation of my grandmother's house, I have no doubt that the changes we are experiencing today are as great as those she and her peers witnessed. While her generation is celebrated for the dramatic changes it endured as humankind went—in one generation—from horse-and-buggy to man-on-the-moon, the revolution we are experiencing has been so continuous, so deeply embedded, that we hardly notice it.

Our revolution is different in degree. It is so complete, so all-encompassing, so relentless, that it has utterly changed the way we deal with the world. It has made change so omnipresent that change itself has become the leitmotif of our time. We no longer endure change; we *are* change. And, without question, in the past quarter-century, the primary agent of that perpetual change has been the microprocessor.

In our hearts many of us secretly sense that we are now living in a golden age. Certainly we still face immense problems, yet the crucial difference between modern life and the world of those early homesteaders is that we no longer suffer from the fatalism and resigned acceptance of the status quo. Rather, we are creatures of hope. Hope that not only will all our children reach adulthood, but that they will live longer than we will. Hope that the plagues that have forever swept across the globe will at last be defeated. Hope that our lives will continue to be richer and more enlightened, and ultimately, more complete.

Much of that optimism rests upon a growing belief that technology will enable us to leap the chasms ahead. Technology itself would seem a fragile vessel upon which to place such high hopes, but it has proven sturdy enough so far. My grandmother, who happily made use of every technological innovation that came her way for nearly ninety years, would have approved. Her descendants certainly do.

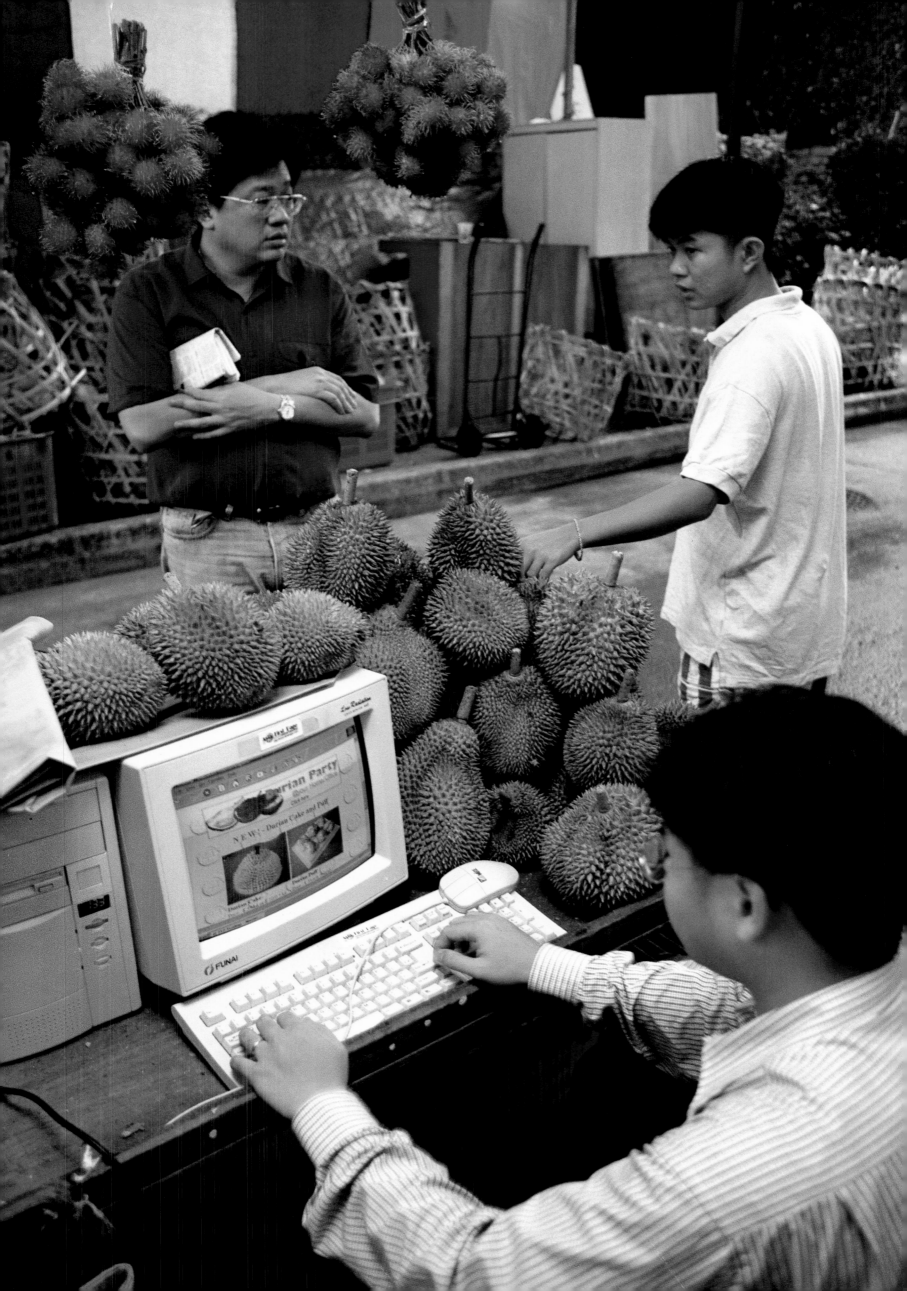

AMSTERDAM, NETHERLANDS
Self-service comes to the super-market, where a Dutch shopper scans her own groceries using a hand-held device that works on any item with a barcode. Checkout clerks simply bag the groceries and read a printout from the scanner to determine the total due. To dissuade shoppers who might be tempted to slip an unscanned item into their baskets, the clerks randomly re-scan entire orders. About two dozen stores in the Albert Heijn chain of super-markets use the system to cut labor costs and to speed customers through checkout lines.

Technology offers U.S. shop-pers an even faster way to buy groceries. In nine metropolitan cities, including Atlanta, Boston and Chicago, consumers can browse through a virtual super-market at www.peapod.com, clicking on what they want to buy. The chosen groceries are hand-selected and delivered to their homes 30 minutes later.
Photo by Rudi Meisel

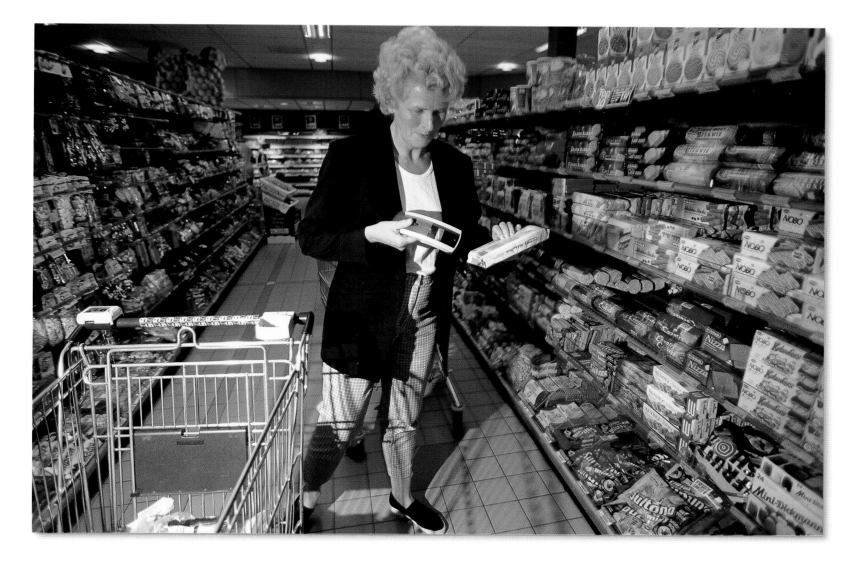

SINGAPORE
Tastes great, smells awful. The stinky tropical fruit known as *durian* is adored throughout Asia, but devotees dread carrying it home in their cars or keeping it around the house. Now connoisseurs of the odoriferous delicacy can order it online from 717 Trading Company and have it delivered just when they're ready to eat it. Since 717 made its debut on the World Wide Web in early 1996, about 20 percent of its sales have come from customers shopping online.
Photo by R. Ian Lloyd

http://www.gs.com.sg/717trading/

Fashion shows go digital at Trussardi's (*below*). Wholesale buyers the world over visit the company's showroom to watch digital videos of the latest line and then to use ModaCad software to alter fabrics and colors on screen before placing an order.
Photo by Guglielmo de' Micheli

No dressing room? No problem. The aptly named New World Department Store saves space by letting shoppers try on clothes right on the sales floor. After their video image is captured on screen, customers can see themselves in any outfit in any color, at the click of a mouse.
Photo by Fritz Hoffmann

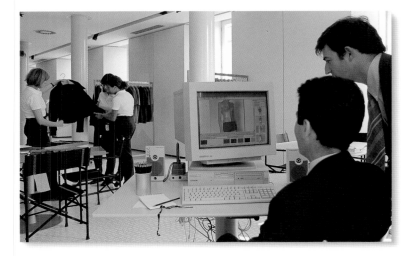

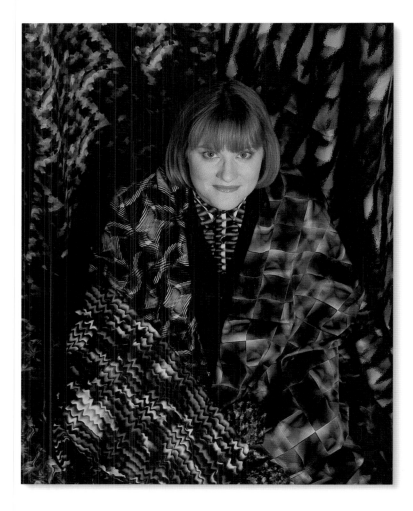

▲ NEW YORK, NEW YORK
Swaddled in the colors and textures that have made her one of the most popular menswear designers in the world, fashion designer Jhane Barnes (*above*) provides further evidence that art created by computer needn't be cold and steely. Barnes uses custom-designed software to create the original patterns for which her clothing is renowned, and then transmits them to computer-operated looms. Wondering if Jhane's creations would suit you? Check out some virtual swatches of her latest patterns—including Infinity, Apparition, Education and Multimedia—at her company's Web site, www.jhanebarnes.com.
Photo by Scott Thode

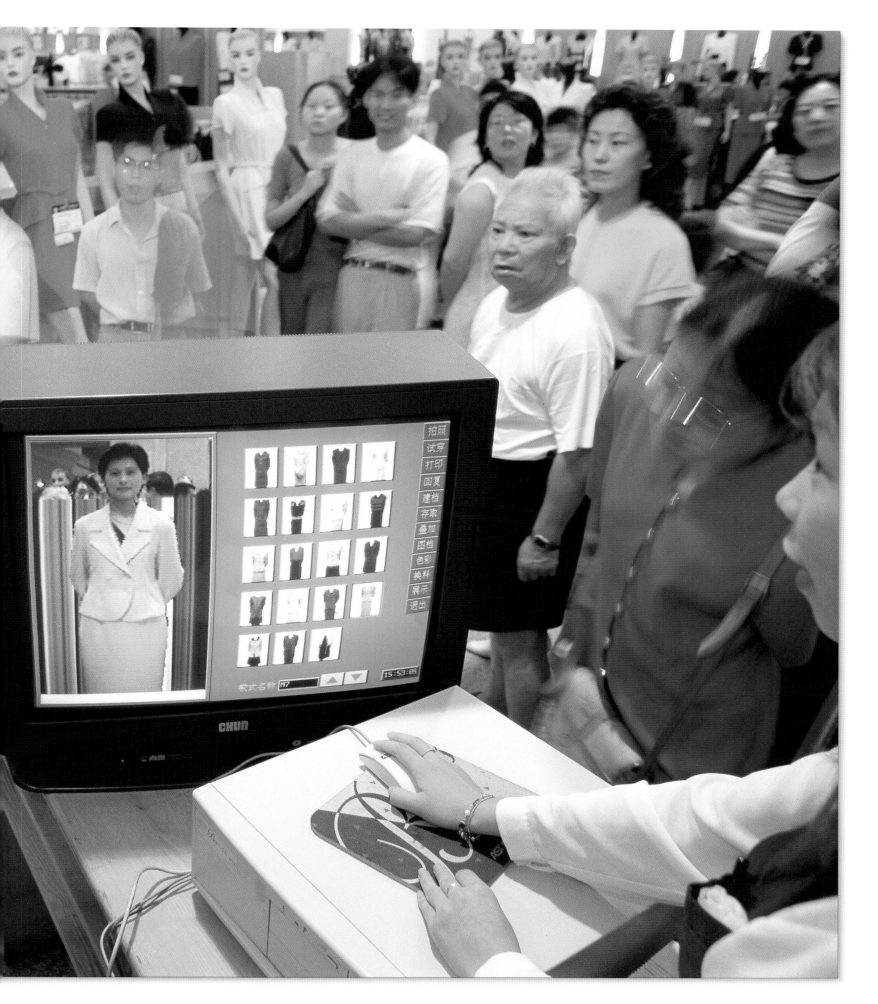

▲ Sun Valley, Idaho

When Intel CEO Andy Grove gathers with fellow industry leaders at investor Herb Allen's annual Sun Valley, Idaho retreat, he drags non-technical CEOs into a hands-on training course and tells them, "Get your hands around it." He and his wife, Eva, together with other Intel trainers, collar dignitaries and their spouses and patiently explain, "This is a mouse, this is a browser."

Grove advises other CEOs that in an age when business competitiveness is inextricably linked to technological savvy, even companies that are not technology companies will live and die by their ability to use technology to compete. He believes that the best way to understand the technology is through direct hands-on experience. Says Grove, "Hey, you've got to do that. We did it for our own board, we did it for our own management."
Photo by Rick Smolan

▶ Barcelona, Spain

I scrolled the news today, oh boy. The newspaper of the future gets a test drive, attracting the stares of the curious. In a world of online information services and 24-hour television news, the traditional morning paper often seems stale. Now, several European companies are testing the concept of an electronic newspaper, to marry the desire for instant news with the need for a familiar morning ritual. If the plan is successful, readers will be able to download the news, presented in a newspaper format with audio and video mixed in, to a thin wireless tablet, "turning" the pages using a touchscreen. It may be a decade before the "NewsPAD" hits the streets with its first "Extra! Extra!" but as developer Tim Caspell of the British firm Acorn Group points out, 10 years is like "the blink of an eye" in the newspaper business.
Photo by Ed Kashi

► DENVER, COLORADO

It used to be a place to read a book, close your eyes, reflect on your family or simply daydream. But today, 15 minutes after the plane reaches cruising speed, the ritual of pulling out, plugging in and powering up begins as today's wired warriors make every waking moment count. Soon working at 30,000 feet will be easier than ever. Boeing's new 777s feature a digital phone service, allowing laptop-toters to send and receive faxes or log onto the Internet. Seat-back power outlets eliminate the need to change batteries after a few hours in the air. *Photo by James Balog*

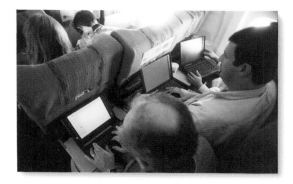

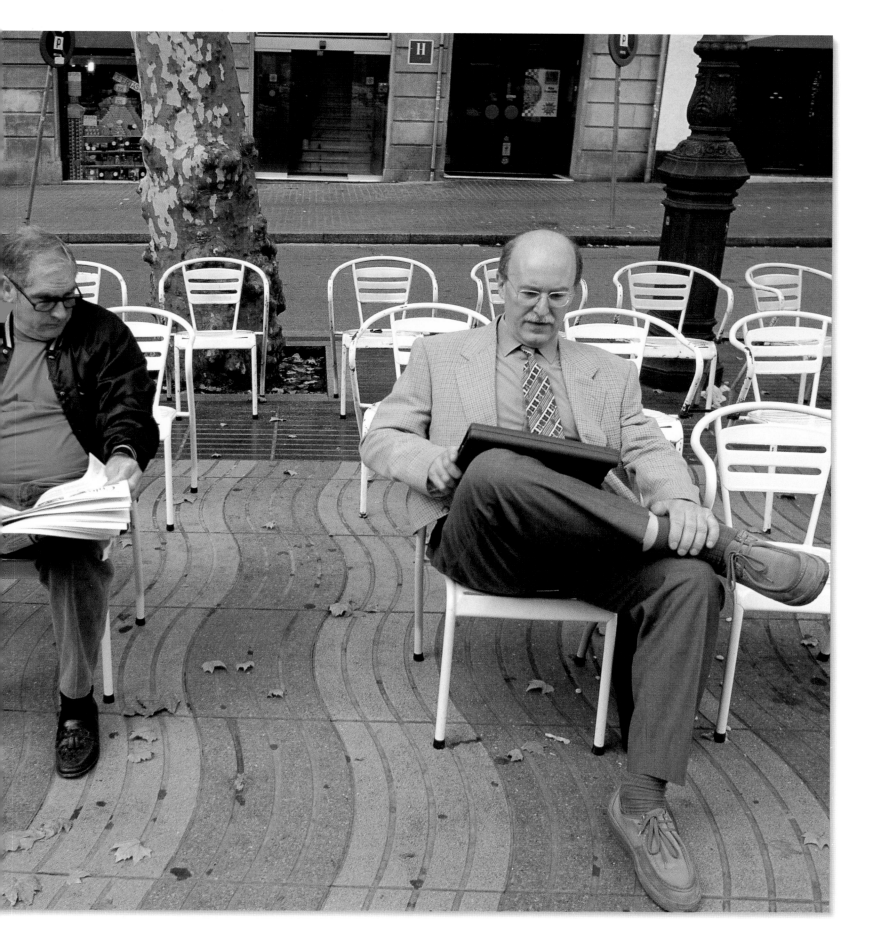

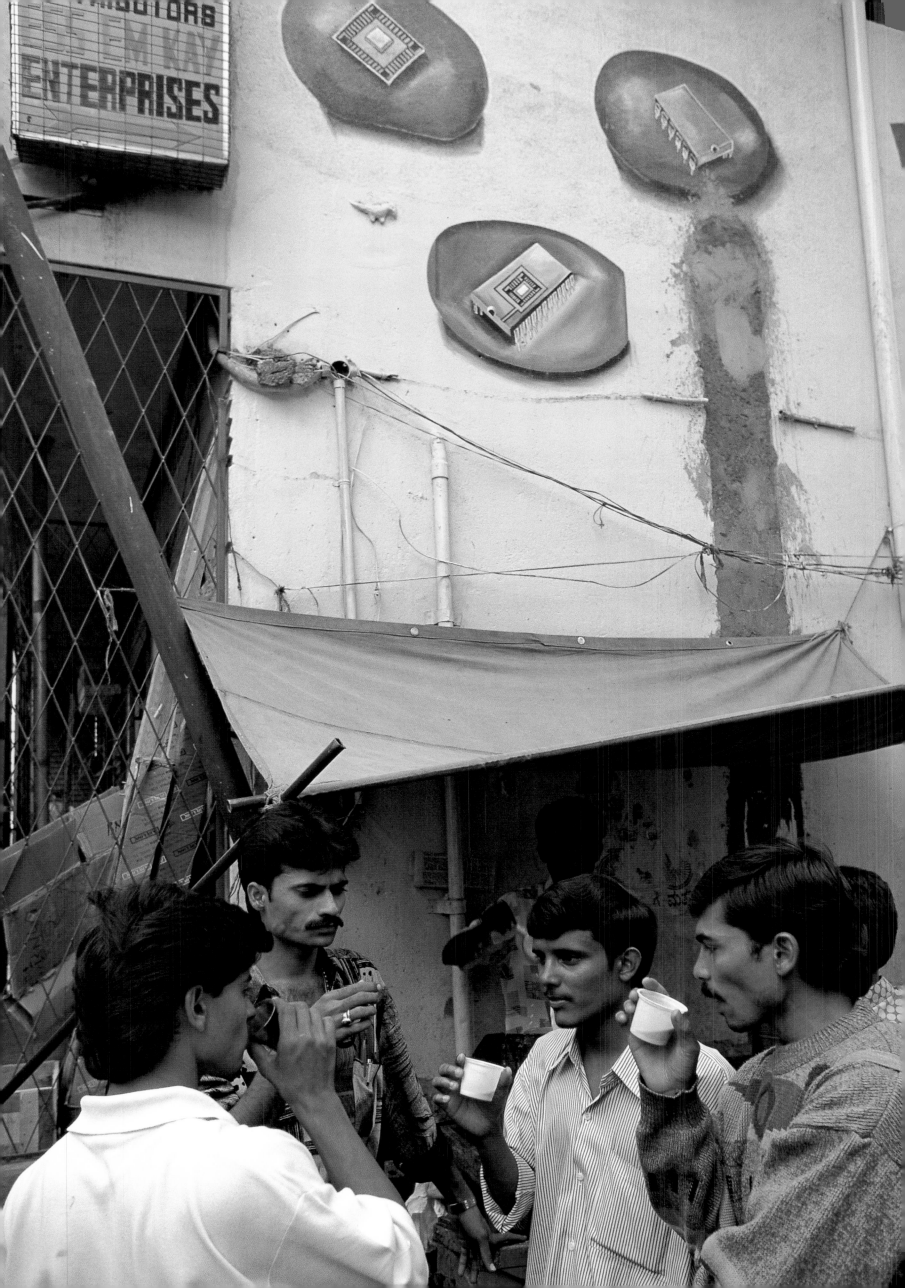

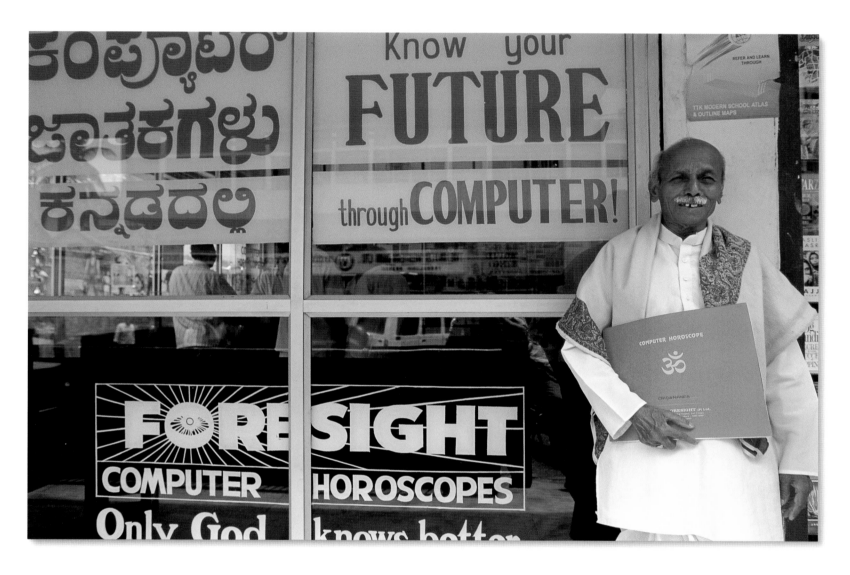

◀ **BANGALORE, INDIA**

Code-writers break for tea in Bangalore, home to the country's burgeoning computer industry. As the city's reputation as a world-class computing center grows, Indian programmers and engineers who left to work abroad are now returning home, to work for both Indian and multinational technology firms with offices in Bangalore. The competitive nature of the software industry has resulted in an environment in which every night teams of programmers send their work to the next team on the other side of the world. This passing of the baton across multiple time zones has created an industry that never sleeps.

Photo by Pablo Bartholomew

▲ **BANGALORE, INDIA**

A true computer guru marries tradition and technology, promising the fastest horoscopes in town. With custom astrology software, the guru takes about five minutes to compile charts that used to take hours—based on the exact position of the stars at the time and place of birth. His time freed up, he focuses on interpreting the charts, which many Indians use to make major life decisions.

Photo by Pablo Bartholomew

▲ LONDON, ENGLAND

Christine Downton donated her brain to science—and lived to tell the tale. To see if the thought process of a human mind could be replicated, the renowned British bond trader spent 18 months laying down 1,500 "rules" that guide her international investment strategy. An artificial intelligence expert at Hughes Labs in California then translated her rules into algorithms and wrote a computer program designed to mimic her thought process. Downton and other traders at Pareto Partners now follow the computer's advice, riding what she says is the wave of the financial future. "The judgment of most traders," she says, "is distorted by emotion. The human mind, after all, can only juggle so many pieces of data at once before being overwhelmed." Since its introduction in 1994, the computer program has generated a return comparable to that of the best human traders.

Photo by David Modell

▷ NEW YORK, NEW YORK

With a hand-held computer in a sea of notepads, Wall Street stockbroker Todd Bertsch makes a deal amid the frantic hand signals, earsplitting shouts and jostle of humanity on the floor of the New York Stock Exchange. Bertsch uses his wireless computer to instantly record and transmit his transactions; traditional brokers rely on "runners," who carry slips of paper with details of a deal across the crowded floor to company trading booths. The palm computer speeds up the recording process, crucial to traders like Bertsch, who close about 20 deals an hour. The device's radio signals are scrambled to thwart electronic eavesdroppers.

Photo by Scott Thode

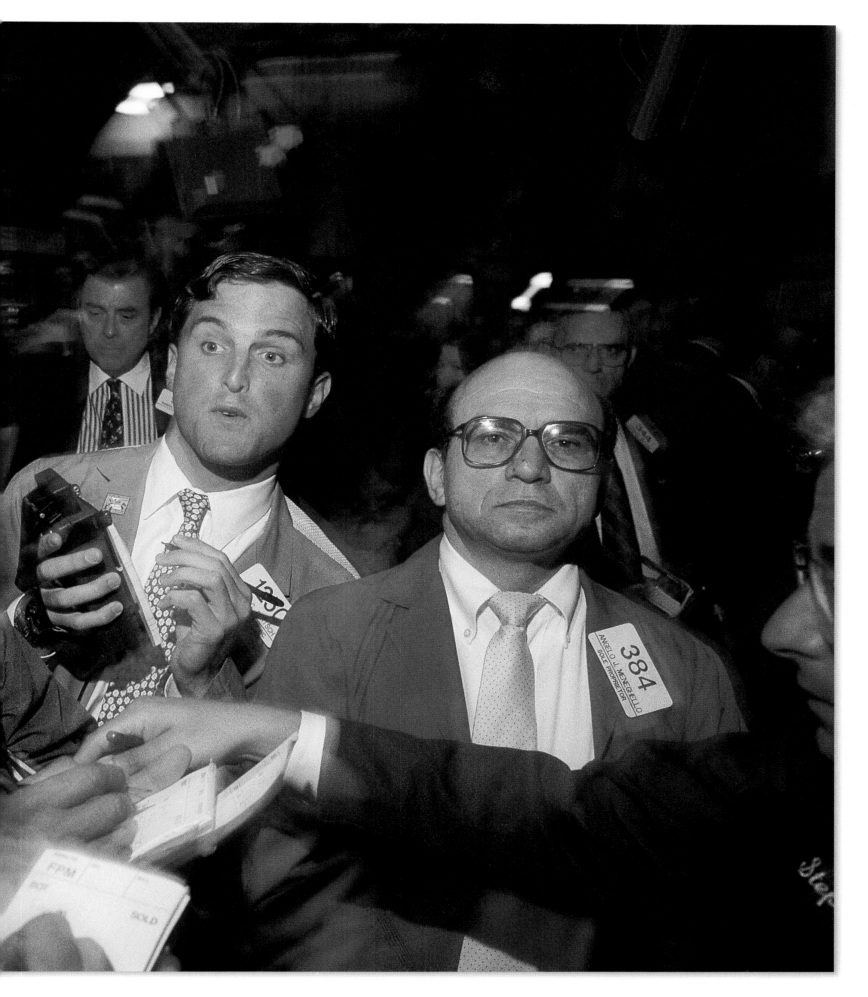

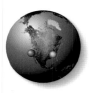

▲ HOLLYWOOD, CALIFORNIA

The glitterati become digerati at the Creative Artists Agency's media lab in Hollywood, where Magic Johnson learns how to make a video phone call from his laptop. Producers, directors, writers and celebrities visit the $10 million lab to test technology's latest bells and whistles; the lab's sponsors, led by Intel, hope they have created an atmosphere in which artists can feel comfortable playing with the future.

Photo by Dana Fineman-Appel

▶ MEMPHIS, TENNESSEE

Love me tender, love me true, I'm on CD-ROM: Elvis is a bigger phenomenon dead than alive, thanks in part to technology he didn't live to see. Each year, three-quarters of a million people visit Graceland, Elvis' house and grave site. Visitors can rent a Walkman that narrates their tour. Those who can't make the pilgrimage can follow along on *Virtual Graceland,* a CD-ROM that walks users through the Memphis mansion. Countless more commune with the King at the official Graceland Web site (www.elvis-presley.com) as well as surf sites maintained by the National Association of Amateur Elvis Impersonators, the 24-Hour Church of Elvis, and the flying Elvi (skydivers who dress like Elvis).

Photo by Shelly Katz

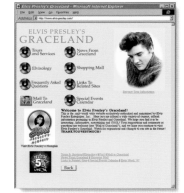

http://www.elvis-presley.com

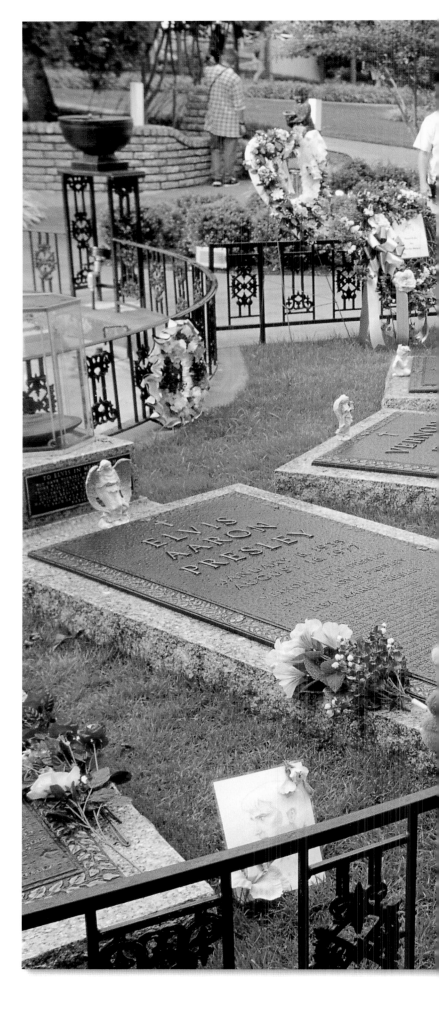

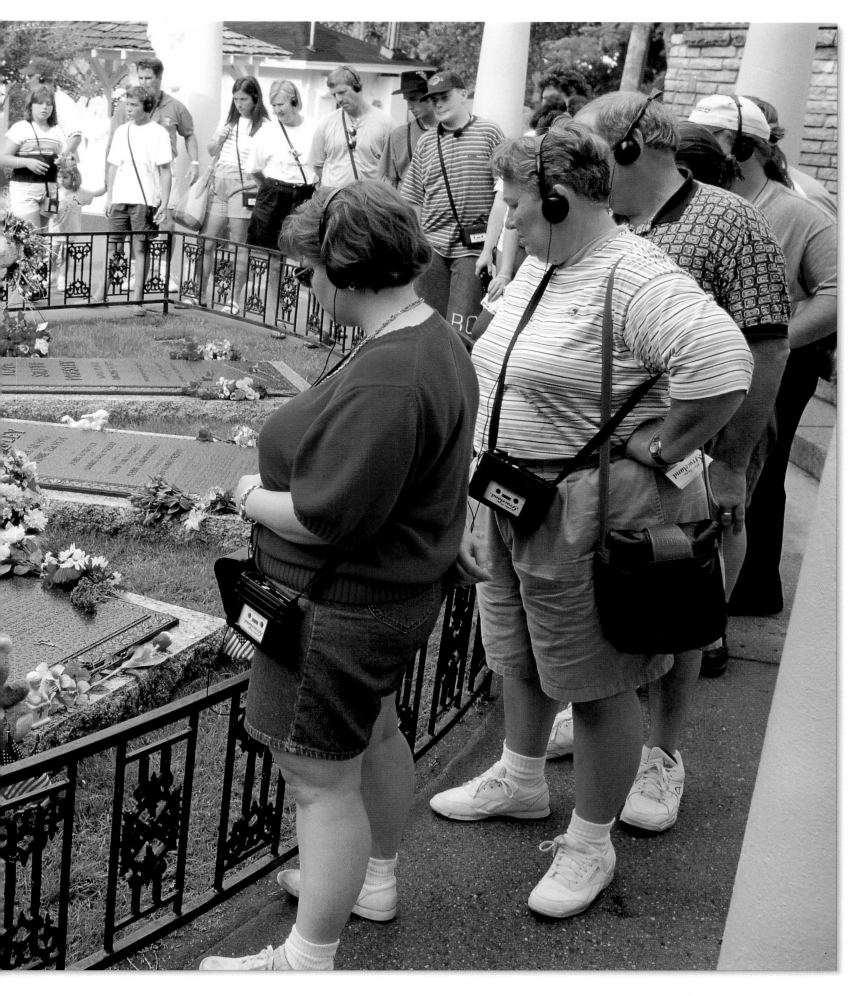

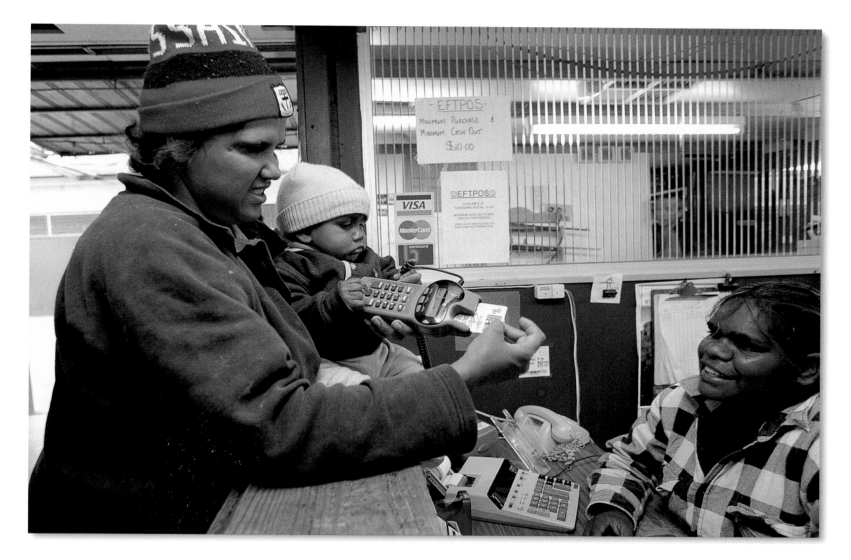

◀ **ISTANBUL, TURKEY**

Since Sputnik I was launched on Oct. 4, 1957, more than 5,000 satellites have followed in its path around the earth. Since 1987, 23 have been launched specifically to provide direct broadcast TV to even the most remote corners of the world. These 6,000-pound satellites are in geosynchronous orbit, meaning that they remain fixed over one specific place on earth. The satellite dishes on this Istanbul street each represent a different dish vendor, vividly demonstrating how competitive the industry has become. Now couch potatoes eagerly plunk down as much as $500—twice the average monthly income—to buy a dish and watch their favorite shows. Particularly popular are European and American programs, including *Larry King Live*. While some worry that this glut of foreign entertainment is destroying local culture, others dismiss such concerns with a shrug. Says a local journalist, "I don't know if most people really watch any one show. People just kind of surf through them all since there are so many shows and it's hard to really choose something to watch. And besides, they are all in foreign languages."

Photo by Mehmet Gulbiz

▲ **YUENDUMU, AUSTRALIA**

In the remote Australian outback, more than 200 miles away from the nearest bank in Alice Springs, eight-month-old Shanley Malbunka helps his mother Celina withdraw money from her bank account. Hand-held ATM machines, installed in January 1997, enable the 1,000 aboriginal residents in the town of Yuendumu to conduct their banking without having to make the arduous two-day trip to the city. Remote banking has also been a boon to the local community's economy. In the past, the town's residents often spent their money in Alice Springs before returning home. Now a swipe of a card allows them to walk down the street for cash or groceries, enabling local stores to stay in business. "Now, 98 percent of the money earned in Yuendumu," says Dave Powers, community store manager, "gets spent in Yuendumu."

Photo by Philip Quirk

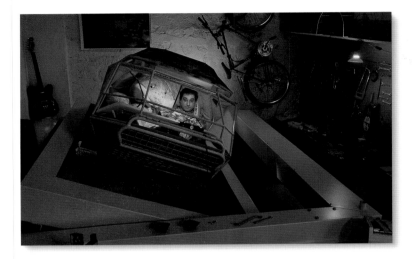

▲ PARIS, FRANCE

Never leave home because of it!
Tired of waiting in line at the local
arcade, Antoine Fautrad built his
very own computer-controlled *sim-
ulateur d'acceleration gravitationnel*
in his garage. The Parisian printer
and his co-pilot (his son's toy
rabbit) strap themselves in and
pretend to be race car drivers or
airplane pilots. Fautrad's device
is a full-fledged simulator, capable
of subjecting drivers to nearly three
times the force of gravity. The
contraption rotates 180 degrees
and turns 45 degrees in each
direction—handy for negotiating
the hairpin turns at Le Mans. And
the master tinkerer isn't done yet:
he's planning to mount three moni-
tors in front of the windshield to
give himself and fellow passengers
a surround-screen effect.
Photo by Arnaud de Wildenberg

▶ TOKYO, JAPAN

The Japanese call them *otaku,*
those computer-crazed youths
whose passion for technology
seems to take over their lives. The
bedroom of 27-year-old
Masakazu Kobayashi, who says
he's living a "cyberlife," is domi-
nated by seven PCs networked
together, six videogame machines
and a variety of peripherals.
When he ventures out of the
house, he travels with a laptop
and a palmtop computer, a cell
phone and a modem. His passions
may seem rather extreme to out-
side observers, but when mea-
sured against Japan's society at
large, Kobayashi's techno-lust
seems more likely a harbinger of
things to come. Japan's obsession
with technology is reflected in the
world's first full-sized video
aquarium, where visitors gaze at
life-sized digital whales, dolphins
and a variety of fish; video games
so popular that young children
routinely dress as their favorite
characters; and the virtual pets,
or *tamagotchi,* that swept through
Japan and the United States in the
summer of 1997.
Photo by Torin Boyd

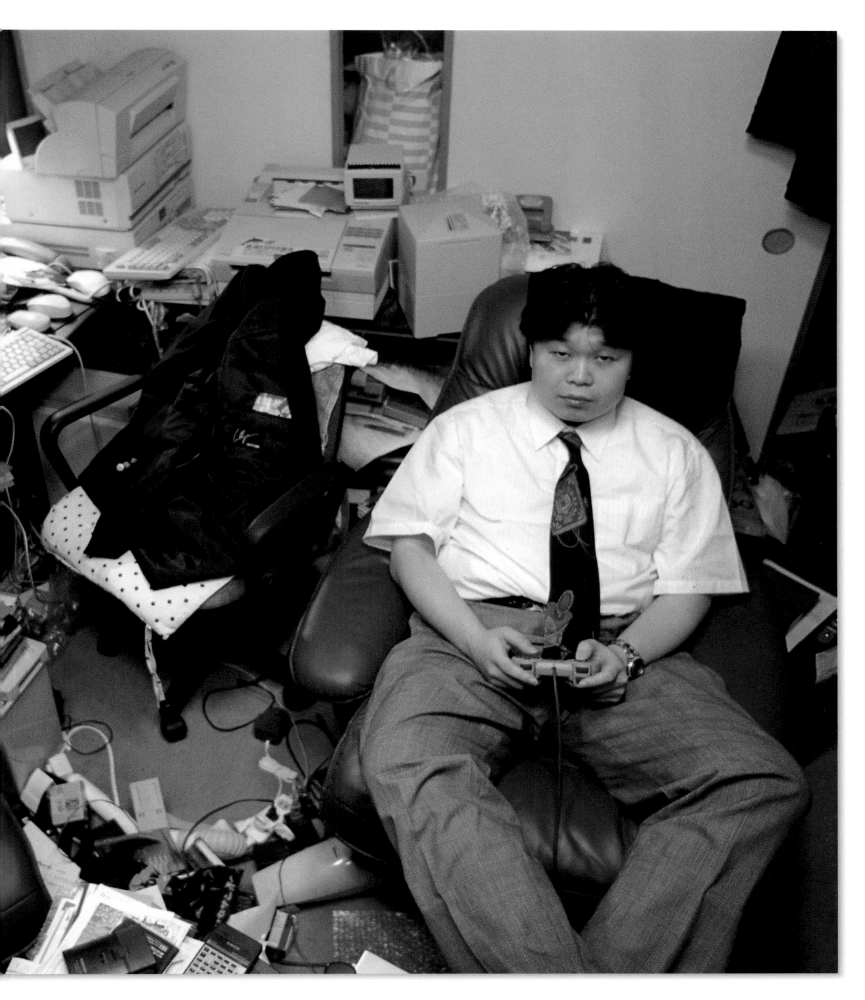

In these days of mass production, it's reassuring to note that many of the technologies and inventions that profoundly change our lives still come from the mind of one individual, one person whose ideas end up rippling around the world. The imaginations of Vint Cerf, Tim Berners-Lee and Gordon Moore have changed daily life for much of the world—Cerf by imagining how remote computers could communicate with one another, Berners-Lee by imagining the World Wide Web, and Moore by imagining how quickly the power of computers could grow. Although they may not be household names, their ideas have led to household products—making them among the most influential dreamers of the late twentieth century.

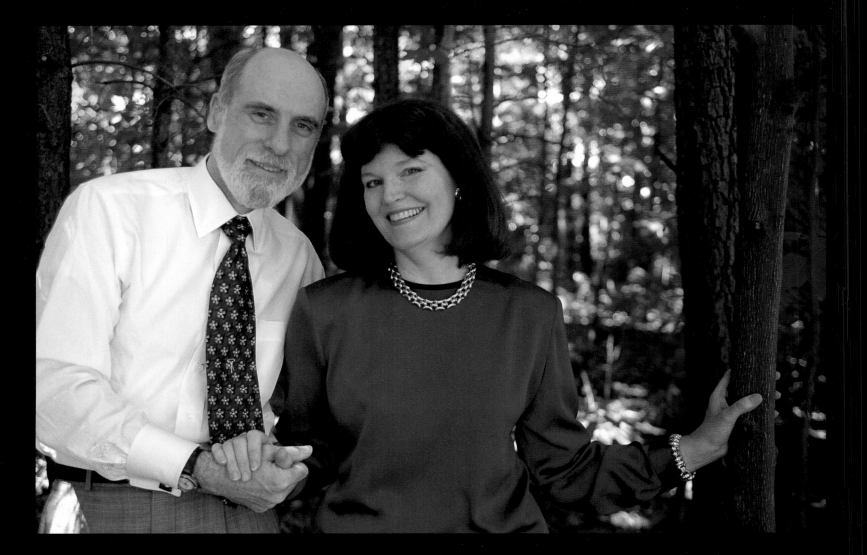

▲ RESTON, VIRGINIA
After 35 years of marriage, Sigrid Cerf finally phoned home. It was the Internet that helped make possible her first-ever telephone conversation with husband Vint—an ironic twist, since the visionary Vint is affectionately known as the "father" of the Internet.

As a young Stanford professor in 1974, Vint co-wrote TCP/IP, the language that allows computers to communicate with one another. In the early 1990s, Sigrid, hearing-impaired since childhood, began using the Internet to research cochlear implants, electronic devices that work with the ear's own physiology to enable hearing. Unlike hearing aids, which amplify all sounds equally, cochlear implants allow users to clearly distinguish voices—even to converse on the phone.

Thanks in part to information she gleaned from a chat room called "Beyond Hearing," Sigrid decided to go ahead with the implants in April of 1996. The moment she came out of the operation, she immediately called home from the doctor's office, a phone conversation that Vint still relates with tears in his eyes.
Photo by Dirck Halstead

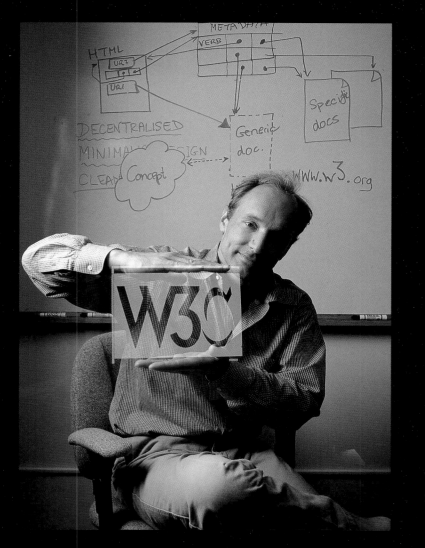

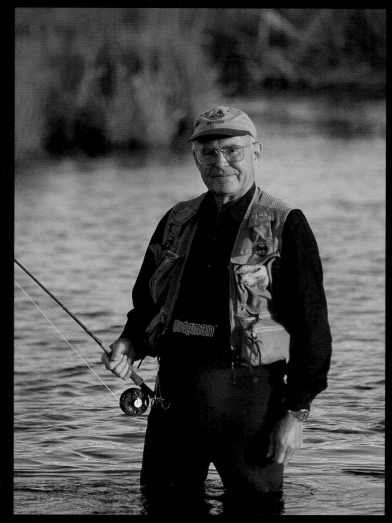

▲ CAMBRIDGE, MASSACHUSETTS
The mind that launched 100 million Web pages belongs to Tim Berners-Lee, the Oxford-trained computer scientist who invented the World Wide Web. While working as a research fellow at the European Particle Physics Laboratory in 1989, he cooked up the idea for a "global hypertext project." The idea sparked little enthusiasm until he produced a prototype in 1990. By the next year the Web began transforming the text-only Internet, and it hasn't stopped since. By the year 2000, it's a good bet that children will ask their parents, in equal parts awe and derision, how they ever survived without it. Now at MIT, Berners-Lee runs the World Wide Web Consortium, which aims to further refine his landmark creation.
Photo by Sam Ogden

▲ HAMILTON, MONTANA
Gordon Moore has earned the right to go fishing. Moore, who co-founded Intel in 1968, predicted with amazing accuracy that the power of microchips would double every 18 months. To put Moore's Law—as his prediction came to be known—in perspective, if the same rules were applied to the automotive industry, today a Rolls Royce could travel 50,000 miles per hour, would cost $14.95 and could be driven for a month on a gallon of gas. What is Intel's Chairman Emeritus' next prediction? "I believe natural speech recognition will make the computer accessible throughout the world," says Moore. "Eventually we'll be able to converse with our computers."
Photo by Kenneth Jarecke

▼ CHANDLER, ARIZONA

The microprocessor industry has not only transformed the way devices work, it has also changed the nature of work itself. The men and women who design, manufacture and market microprocessors (and all of the industries associated with these chips) have created a unique global culture. Redefining the modern workplace, they are altering everything from the clothing worn to work to the way workers relate to one another.

In the chip industry, the emphasis is on the team rather than on the individual. For many workers that team spirit is much more than a nine-to-five job. Volunteer groups like the "lawn chair brigade" at the Intel plant in Chandler, Arizona (*below*), practice after work several times a week for appearances in parades and other community events.

But behind the seemingly casual and unpretentious exterior is a fanatically driven work ethic. Engineers rushing to meet production deadlines often work overtime for weeks at a stretch, leading some companies to set up mobile dentists' offices in parking lots and provide on-site washers and dryers to accommodate their workers.

The industry is also noted for its open offices. At Intel, not even company President Craig Barrett,

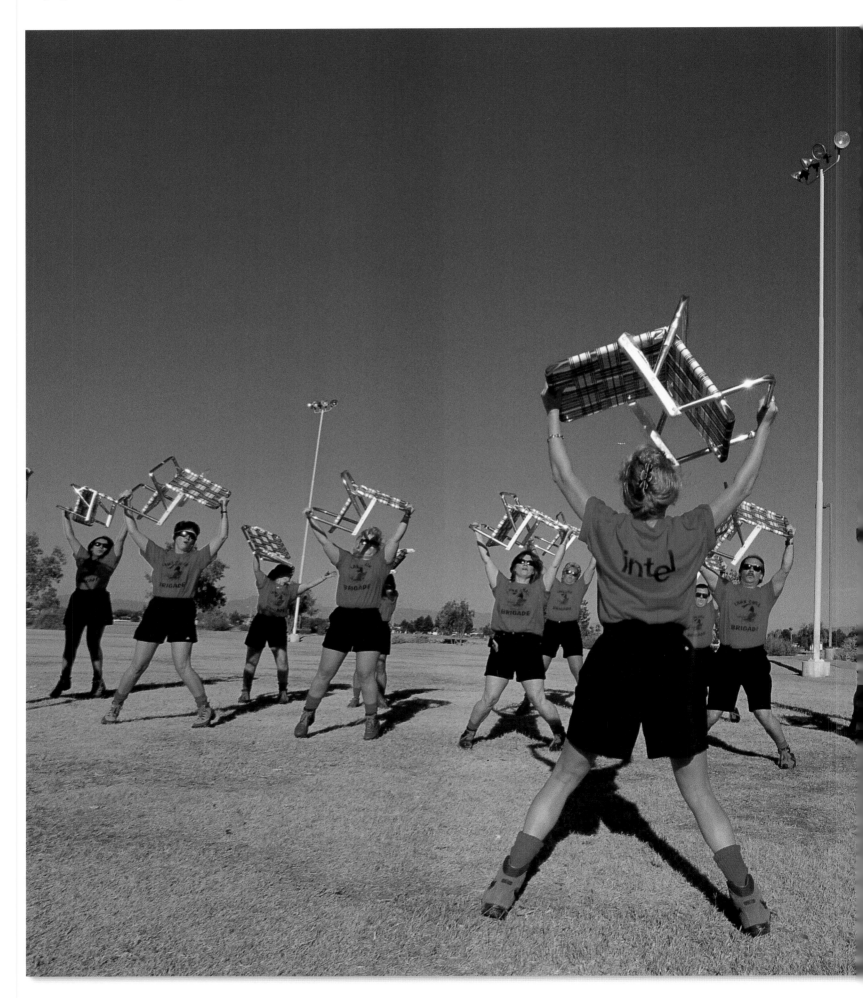

conferring with colleague Dave Small (*top, right*), has a private office—part of a company philosophy, he says, that's designed to promote "an egalitarian atmosphere where knowledge triumphs over position."

As Barrett points out, the computer has created "a peaceful revolution that continues to change the way we work, learn and play."

Photos by Mark S. Wexler (below and top, right) and Doug Menuez (below, right)

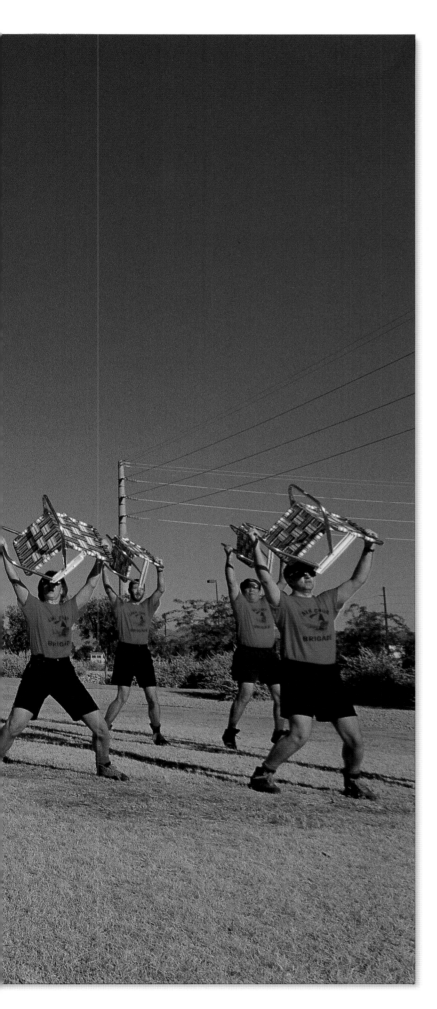

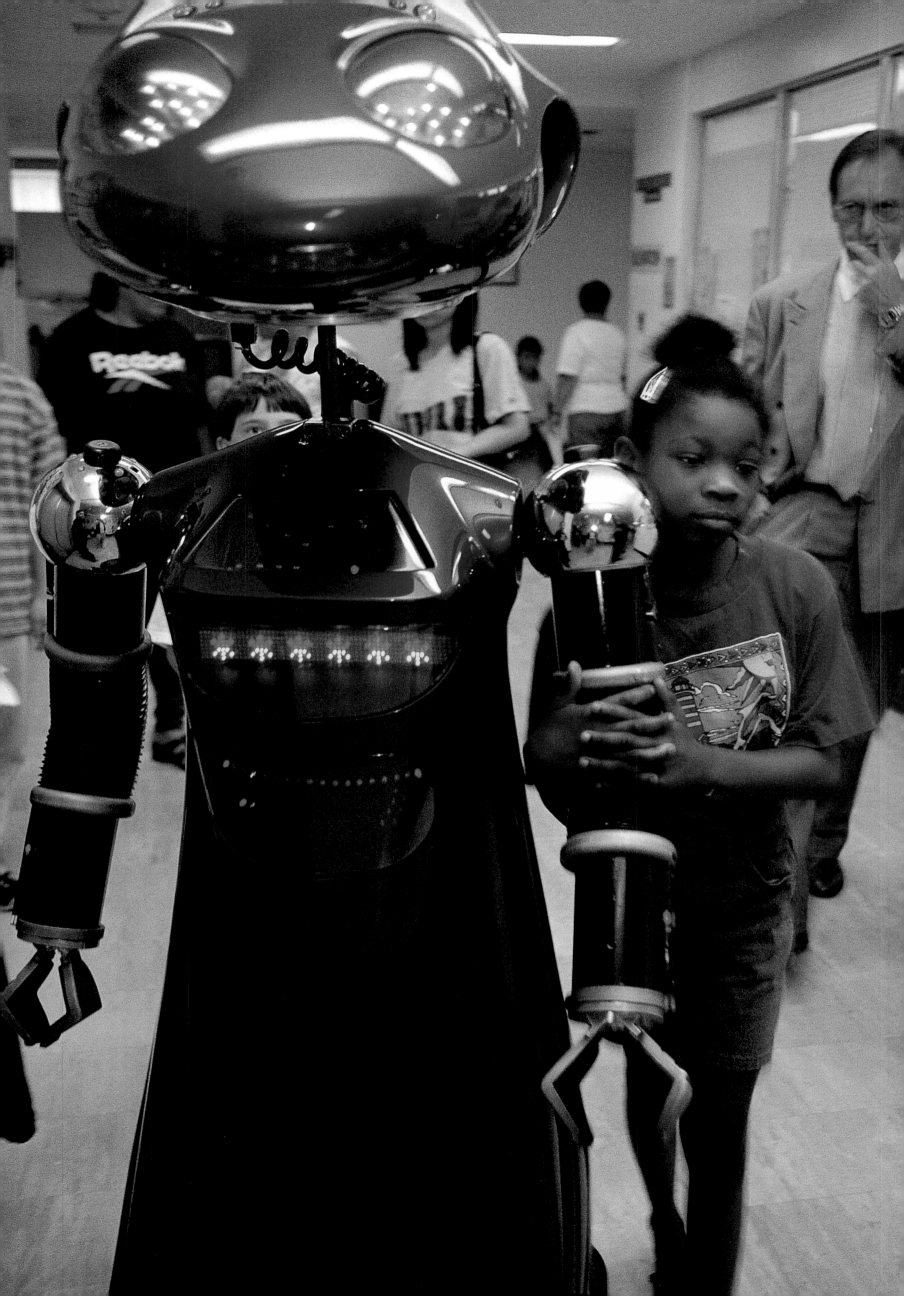

◀ **NEW YORK, NEW YORK**

Brightly colored ergonomically rounded robots are helping mental health professionals reach out to children with emotional problems. Similar programs rely on animals like dolphins and dogs, because, as inventor Robert Doornick observes, "Patients more willingly let down their defense mechanisms with an apparently nonhuman entity."

At Governor Hospital, 11-year-old Jamie Quinones strolls down the hall of the children's psychiatric unit with SICO, the robot. Doornick follows closely behind and speaks into a miniaturized microphone hidden in his hand, acting as the robot's voice. At the same time, he controls SICO's movement with a wireless remote that he keeps in his pocket.

SICO, a custom-designed robot that cost approximately $500,000 to build, visits dozens of hospitals and clinics around the United States each year. The children come out of their shells around the robot, hugging and kissing it or dancing on its platform. Doornick notes that even after he removes the panels and shows the children the machinery inside, they still react to the machine as if it were a real person.

Photo by Misha Erwitt

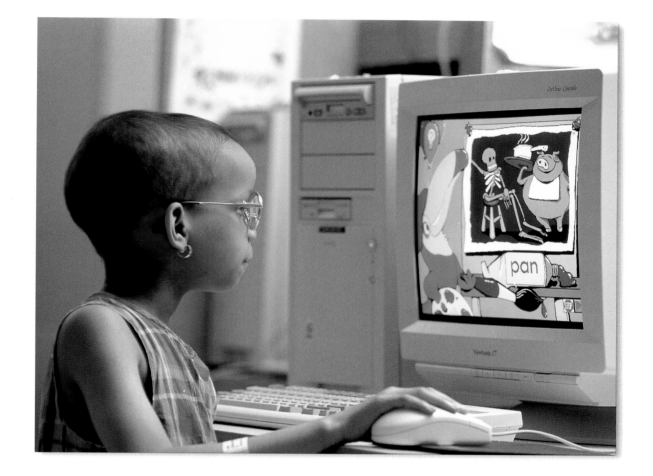

△ ▷ **MEMPHIS, TENNESSEE**

Children come from around the world to seek medical treatment at St. Jude's Children's Hospital. The hospital's Learning Center helps the children keep up with their classmates back home, and two full-time elementary teachers work on-site using computers featuring the latest in educational software.

At right, seven-year-old Carlos Tomasso-Saavedra submits to the playful pen of cancer unit director Keith Gregory. Laser beams cross Carlos' head, positioning him for his treatment session. Minutes later, radiation will attack the cancerous cells in his brain, guided by a newly developed linear accelerator that helps avoid damage to healthy tissue. St. Jude's was the world's first hospital to use the linear accelerator system.

Photos by Shelly Katz

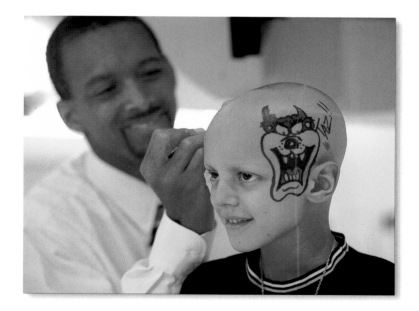

Blind since birth, five-year-old Amy Stewart learns to read by computer—keeping up with the sighted kids in her first-grade class. The computer converts written lessons into Braille print-outs. Computers can't yet replace the human eye, but advanced technology is enabling the blind to join a world previously inaccessible to them. Kent Cullers, a prominent astrophysicist who is also blind, observes, "I interact as many other people do nowadays, through their machines. And the wonder of the technology is that I can do the job just as well as many other people can."

Photo by Barry Lewis

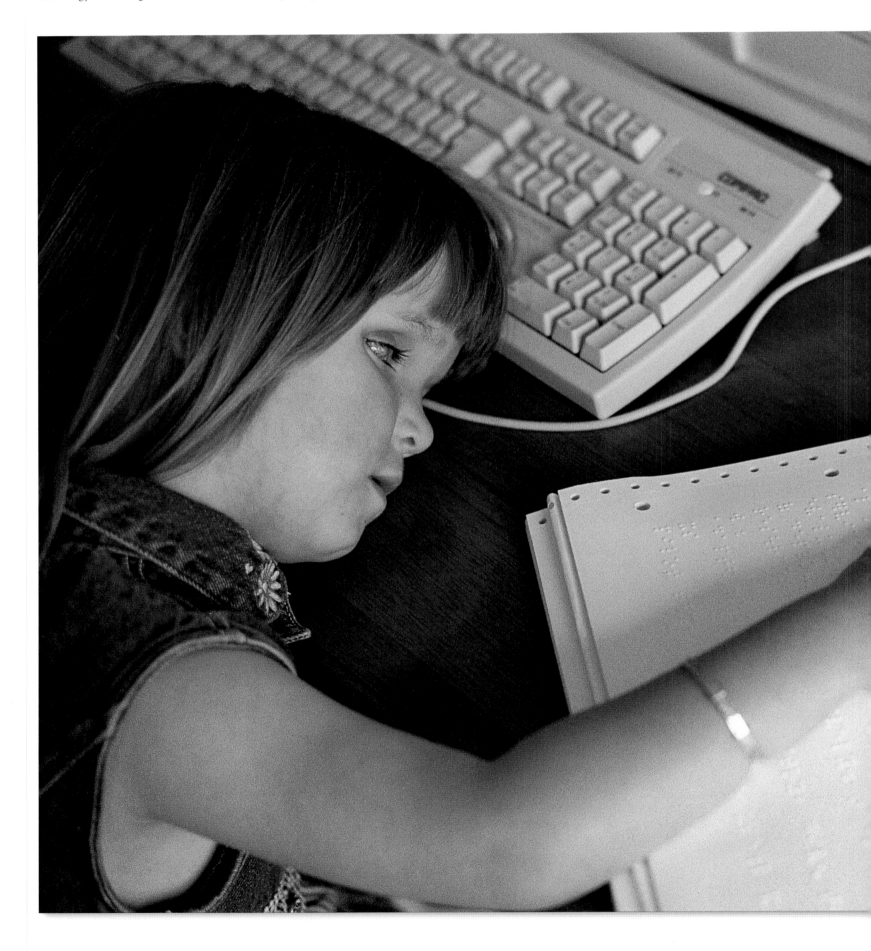

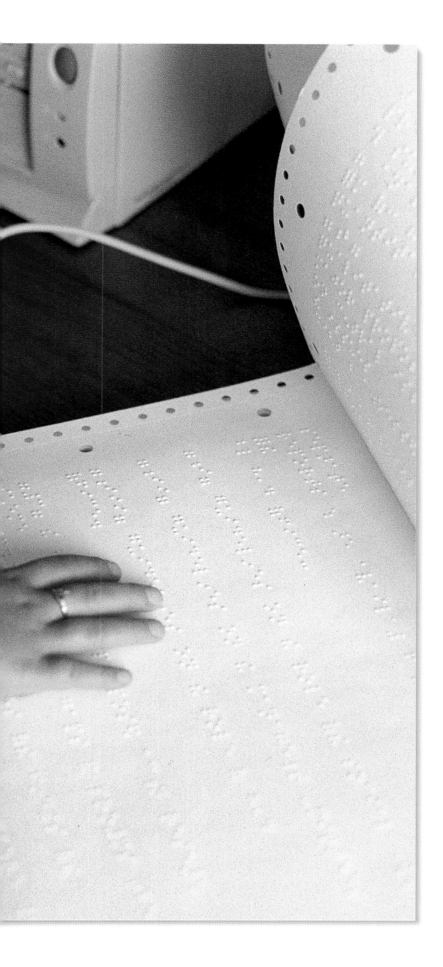

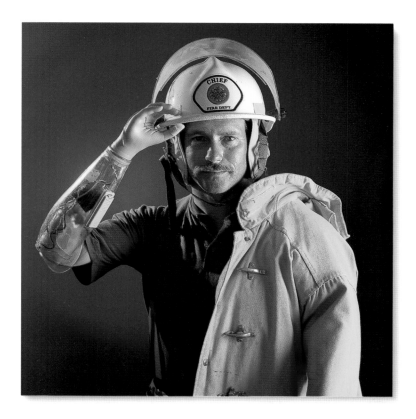

▲ **OKLAHOMA CITY, OKLAHOMA**
"We're just at the Model-T stage in bionics," says inventor John Sabolich. But it's a stage that has already made a big difference to volunteer fire chief Ken Whitten (*above*), who once again can feel the heat. Sensors in Whitten's latex fingers instantly register hot and cold, and an electronic interface in his artificial limb stimulates the nerve endings in his upper arm, which then pass the information to his brain. The $3,000 system allows his hand to feel pressure and weight, so for the first time since losing his arms in a 1986 accident, he can pick up a can of soda without crushing it or having it slip through his fingers. Similar leg and foot prosthetics allow some of America's four million amputees to feel their artificial feet touching the ground. Sabolich, who led the design team for the new prosthetics at the NovaCare Company, eventually hopes to develop prosthetic devices indistinguishable in operation and appearance from flesh and bone.
Photo by Doug Hoke

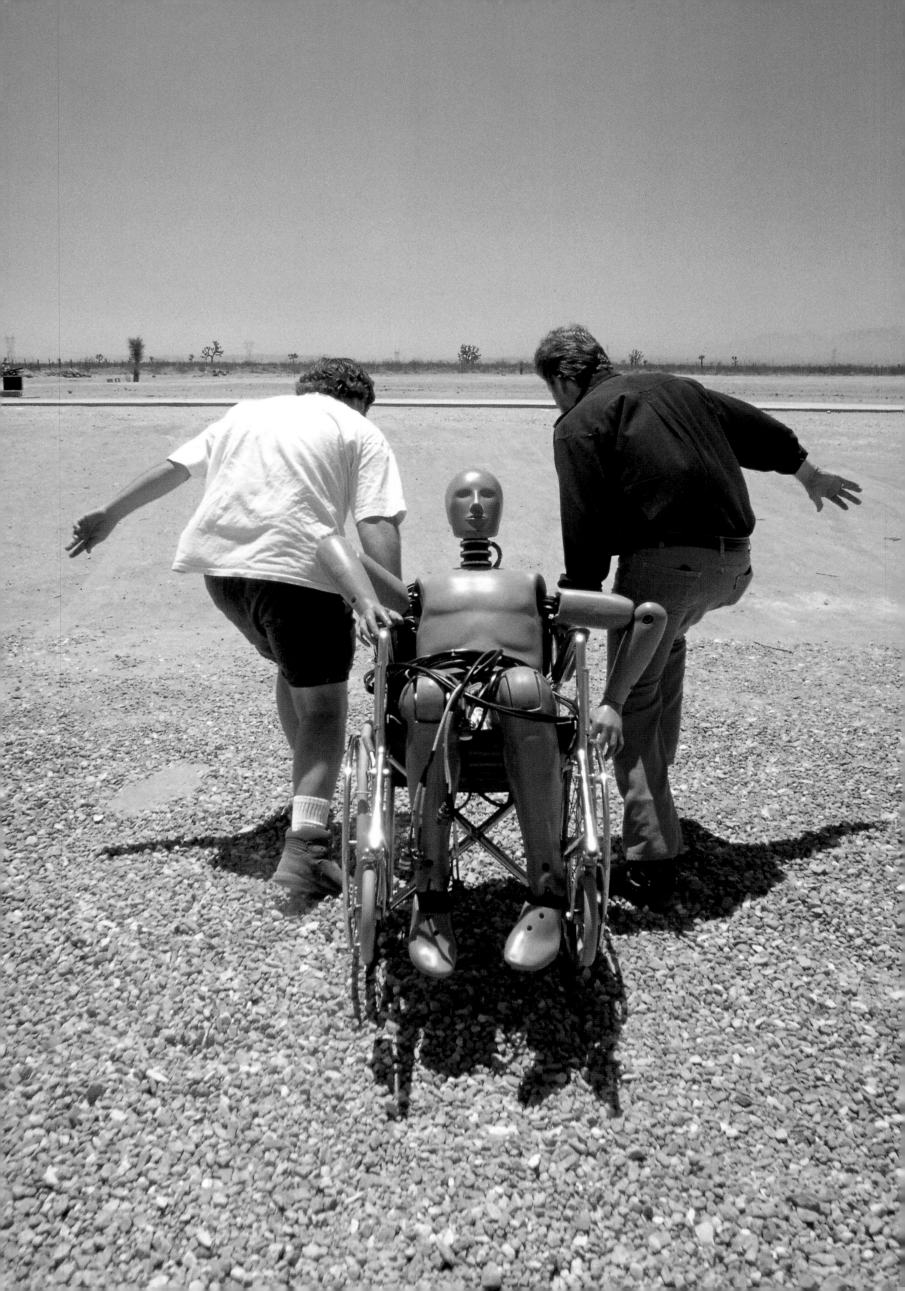

◄ ▶ Adelanto, California

Over the past 30 years, some real dummies have helped reduce the U.S. traffic fatality rate by two-thirds. This ATD unit (Anthropomorphic Test Device) is on his way to a controlled collision in the southern California desert. During the car crash, nearly 100 transducers embedded throughout the dummy will instantly relay data to engineers studying auto safety. These ATD tests have led to a wide range of safety features, including steering wheel assemblies that absorb energy, "penetration-resistant" windshields intended to prevent passengers from flying out, dashboards contoured to the angles of the human body and the mandatory use of child-safety seats.

In addition to microprocessor-based technology used in the ATD tests, chips are also now a key component in the majority of cars themselves, helping to save lives on the road by triggering antilock brakes and activating air bags on impact. Today's most advanced automobiles have as many as 200 microprocessor-controlled functions, a number sure to escalate in coming years. Future features will include radar cruise controls that automatically maintain a safe distance from nearby cars, air bags that adjust their inflation force depending on the weight of the driver and passenger, and dashboard speed warnings linked to road and weather conditions.

Photos by Alan Berner (left and top, right) and Jonathan Williams (right)

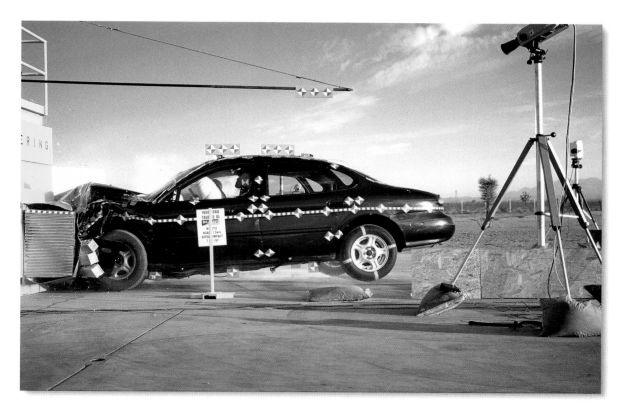

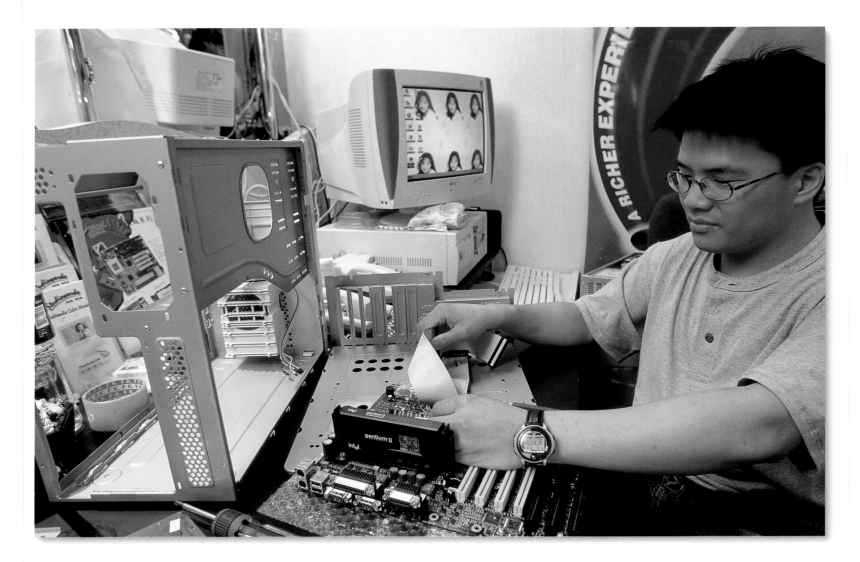

▲ HONG KONG, CHINA

Computers to go: Customers around the world are now able to custom order their computers, specifying the amount of memory, disk-drive size and even selecting the CPU. In Hong Kong, vendors like Matthew Chan custom-build systems on the spot. Business is also lively on the Web, where American PC manufacturers are now selling millions of dollars' worth of computers a day.
Photo by Jeffrey Aaronson

▷ NOVATO, CALIFORNIA

Rescued by firefighters from a burning house, this laptop was melted shut and written off as dead until the disk doctors came to the rescue. Chris Bross, a "recovery engineer," specializes in retrieving data from damaged hard drives. "We're data sharks," says President Scott Giordano of Drive Savers, a company where Bross and nine other engineers work their magic. When computers anywhere in the world are damaged by fires, floods or one of those maddeningly random crashes, they swing into action. Only data that has been magnetically scrambled is out of reach. "Prying open this computer to extract the drive," says Bross of the fire-damaged laptop, "was like harvesting a pearl from an oyster."
Photo by Charles O'Rear

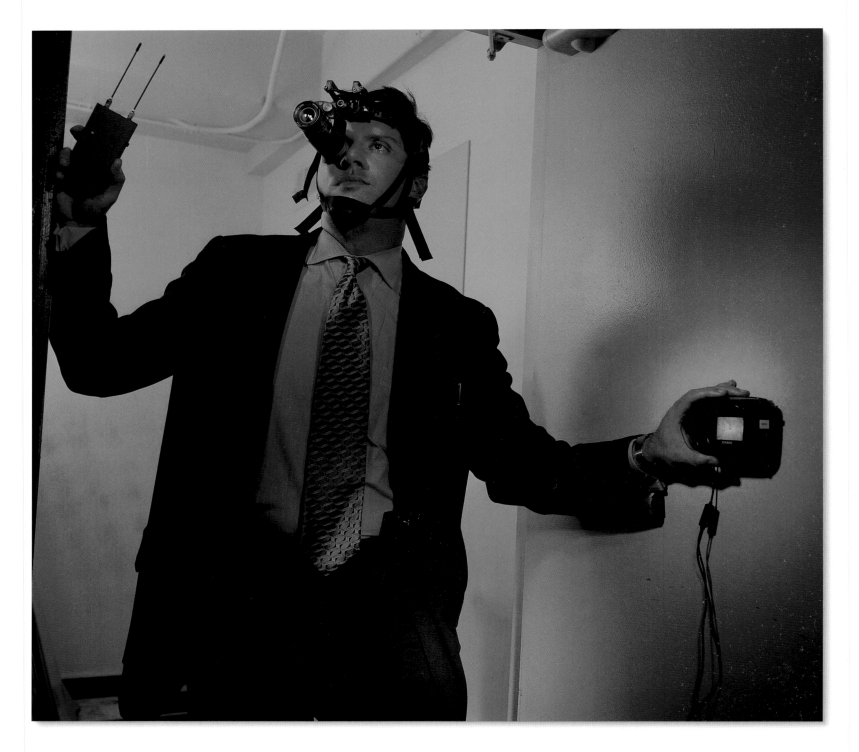

▲ **NEW YORK, NEW YORK**

Spies-R-Us! It used to be that only James Bond could afford those techno-toys cherished by generations of moviegoers. Now, almost anyone can equip themselves in gear befitting a 007. Look carefully: the pen in Robert Wendt's breast pocket is a sensor that detects hidden listening devices; the watch is actually a digital camera; and the tie conceals a video camera capable of transmitting images to either the monitor in Wendt's left hand or to a remote receiver. What's more, Wendt's walkie-talkie scrambles communication, making eavesdropping impossible; a wireless receiver, lodged in his ear canal, allows him to listen to instructions from afar; and his eyepiece provides him with perfect night vision. Even in the post–Cold War era, there is steady demand for chip-based spying and counter-spying devices. In fact, the Federal Bureau of Investigation says that industrial espionage costs the U.S. economy $100 billion annually, which is good news for Wendt's company, Quark International. "I think we've got a recession-proof business here," boasts Quark Vice President Greg Graison.

Photo by Theo Westenberger

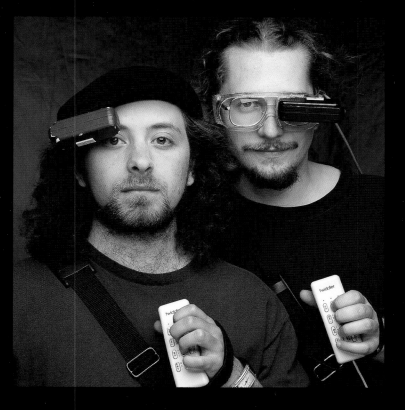

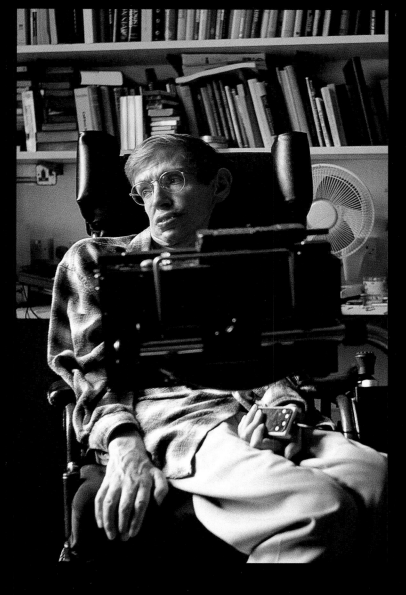

▲ CAMBRIDGE, MASSACHUSETTS
Blurring the line between
human and machine,
Massachusetts Institute of
Technology students Bradley
Rhodes and Thad Starner, who
call themselves "cyborgs,"
wear their computers every
waking hour. "I can do every-
thing I once did on the desk-
top," says Starner, at right, who
carries his hard drive in a
satchel around his shoulder,
uses a hand-held keyboard and
sports an eyepiece that is actu-
ally a computer monitor. But
wearers of the experimental
device aren't looking just to run
spreadsheets on a street corner,
check their e-mail while riding
the bus or write a memo at a
cocktail party. "The computer
should sense my personal con-
text," says Starner. Translation?
"Let's say I'm visiting a strange
city. The computer keeps my
daily schedule and knows I
have a one o'clock lunch date.
So at about 12:45 it will remind
me of the appointment and dis-
play a list of local restaurants
for me to choose from."
Eventual uses for wearable
computers in daily life may, of
course, be wildly different. Like
the telephone, which was origi-
nally invented to broadcast
symphonies into the home,
many technologies end up
being used in ways their early
proponents couldn't have begun
to imagine.
Photo by Sam Ogden

▲ CAMBRIDGE, ENGLAND
It's a stark example of
technology unleashing human
creativity. Without the complex
computer system Dr. Stephen
Hawking controls at the touch
of a button, his genius would be
silenced. The astrophysicist was
struck in 1963 at the age of
21 by amyotrophic lateral
sclerosis, an incurable nervous
system affliction also known as
Lou Gehrig's disease. He has
since lost the ability to speak
and to move most of the mus-
cles in his body. Hawking
continues to write and lecture
by spelling out words on his
wheelchair-mounted PC. He
holds a clicker in his left hand,
while a synthesizer translates
his words into speech at about
15 words a minute. A wireless
modem hooks the computer up
to the Internet, and computer-
driven controls help him open
doors, switch lights off and on
and turn on the television in his
home. Rather than feeling
isolated, Hawking says, "I must
be one of the most connected
people in the world."
Photo by David Modell

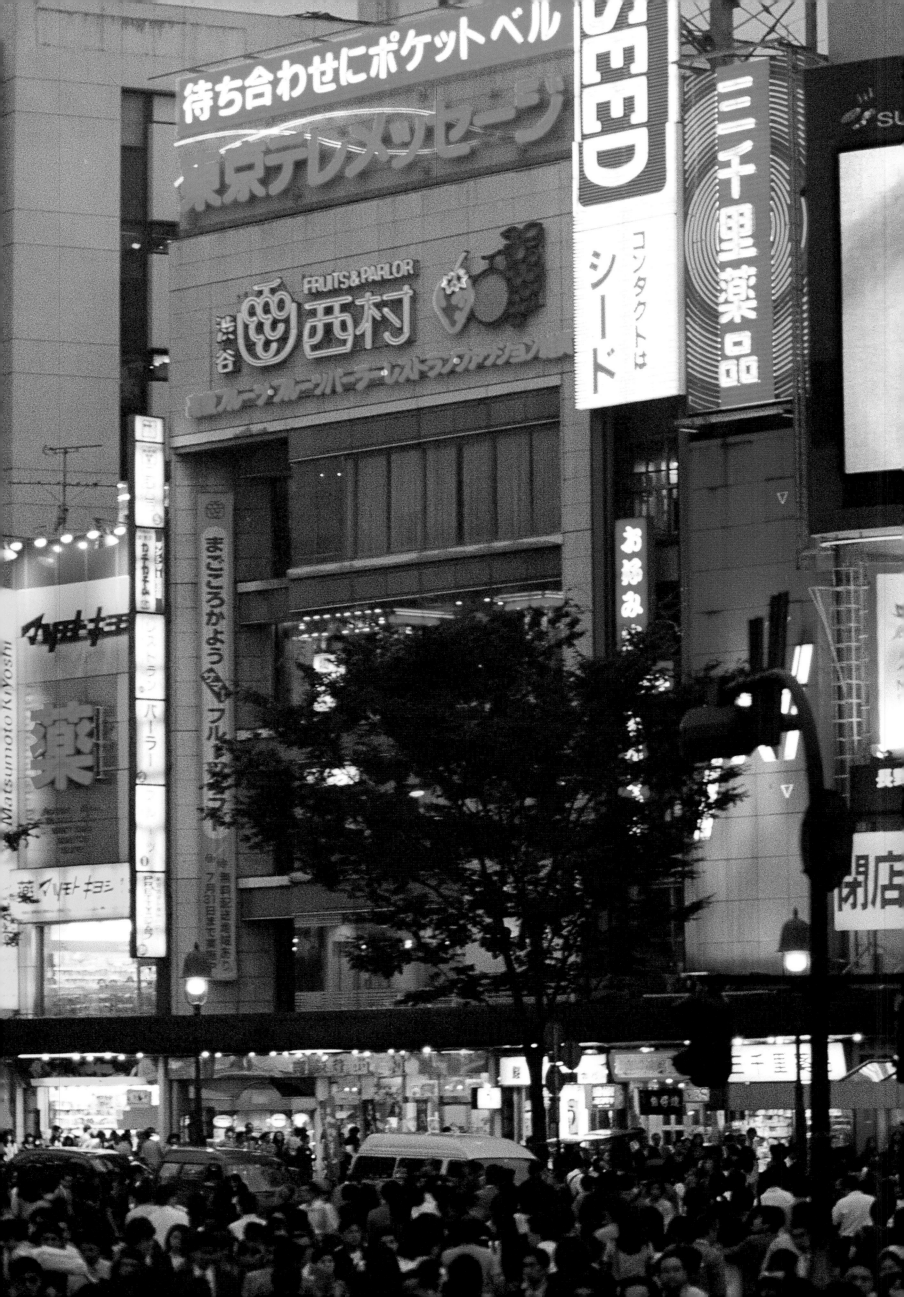

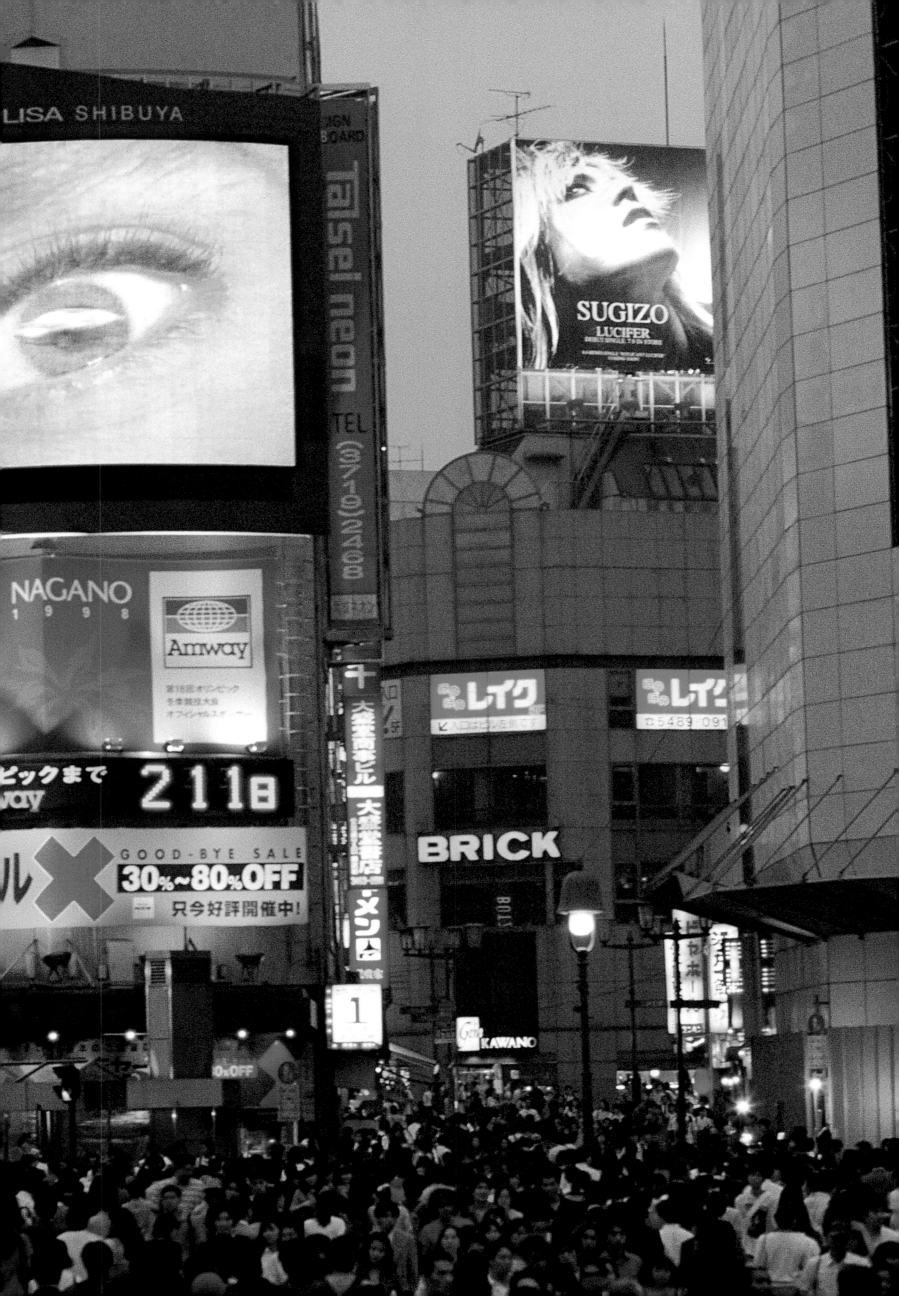

◀ **TOKYO, JAPAN**

Keeping an eye on Tokyo, a 22-by-28-foot TV screen called "Super Lisa" looms over an evening crowd in the capital, alternately flashing advertisements and news headlines. Technology's real eyes are less obvious, but far more intrusive. While few people would dispute the conveniences that modern technology offers, a growing number worry about the dark side, the fact that this same technology is now capable of watching and recording our every move. A few troubling examples: the average New Yorker is photographed 20 times a day by small security cameras at ATMs, in elevators, on street corners, at the mall and in restaurants. Market researchers use sophisticated databases to track buying habits and then to flood mailboxes and e-mail accounts with junk mail tailored to individual tastes. Web sites record what site visitors come from, how long they stay and where they go after leaving the site. Supervisors can legally read an employee's e-mail at work, without telling the employee. Impassioned debates about what constitutes privacy in modern society will continue at least until ethics catch up with technology.
Photo by Torin Boyd

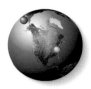

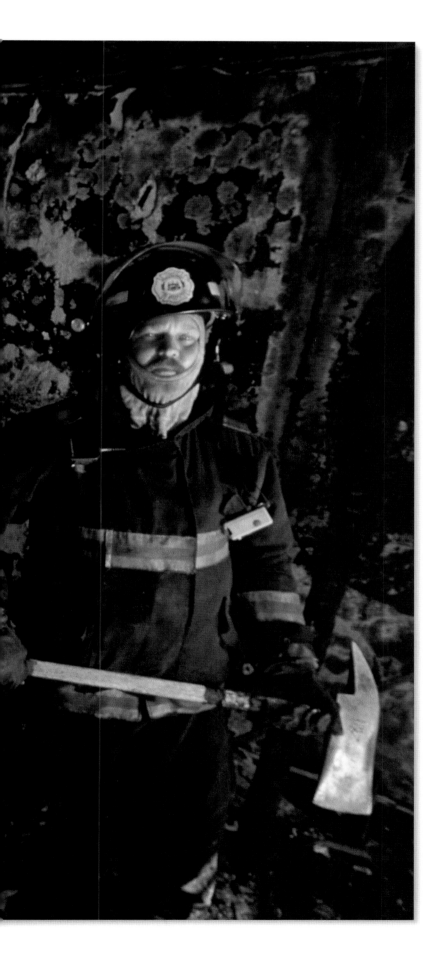

◀ **PHILADELPHIA, PENNSYLVANIA**
As searing heat, roaring flames and suffocating smoke fill a building, firefighters search frantically—and often blindly—for the fire's source and for victims trapped inside. Now, revolutionary new helmets allow firefighters to *see through* smoke. By using infrared sensors and small digital video screens, the helmet—here worn by Gregory Brown of the Philadelphia Fire Department— locates the source of heat and even gauges the level of liquid in tanks of flammable gases or liquids. A heat-sensing ceramic chip responds to infrared energy released by a heat source, and a processing unit worn in a fireproof belt pouch converts the chips' data readings to clear, smoke-free video imagery of the room. Comments Rochester, New York Battalion Chief Ralph Privitere, "This kind of technology could radically enhance our ability to save people's lives."
Photo by Nick Kelsh

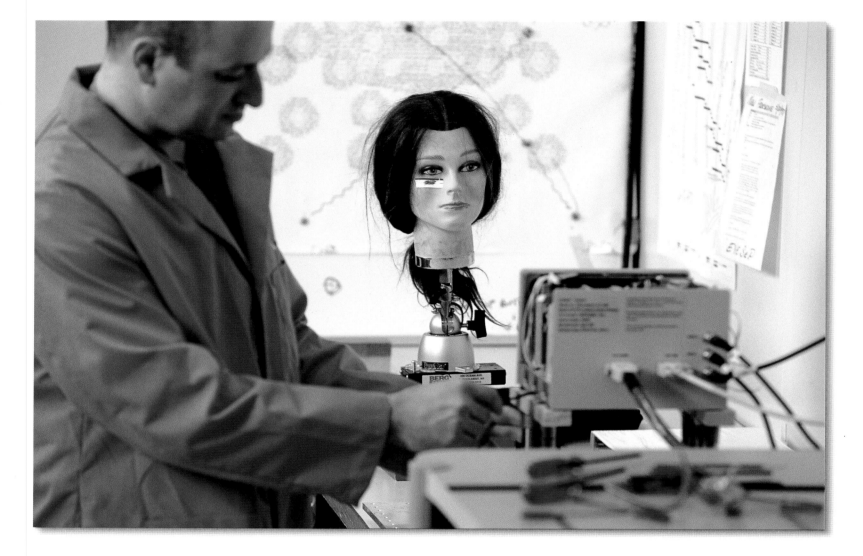

▲ **MOORESTOWN, NEW JERSEY**
Fast cash in the blink of an eye. PIN numbers and passwords will soon be obsolete at banks worldwide due to a little-known fact: the iris is the body's most unique physical structure, more so than even a fingerprint. Engineers at Sensar Inc., along with NCR Corp., have begun making ATM machines that will identify you by scanning your iris as you stand in front of the machine. Digitally encoded images of the human iris provide a highly accurate, easy-to-use and virtually fraud-proof means of identity verification. In the future this technology will allow PC users with cameras to conduct secure transactions on the Internet. Sensar Inc.'s Gary Green calibrates the cameras that are used to read the iris.
Photo by Nick Kelsh

▲ JOHANNESBURG, SOUTH AFRICA
The government of South Africa had a really big problem. Despite the fact that all citizens over the age of 60 are entitled to receive a monthly pension payment, in the KwaZulu region, nearly all of the 320,000 eligible recipients have no address or bank account. To compound the problem, the majority are also functionally illiterate. As a result, many pensioners were left without support for months at a time. Because of difficulties in identifying the rightful recipients, attempts at cash payouts were thwarted by rampant fraud and payments to fictitious, deceased or underage pensioners. In addition, the pensioners had no method of cashing their checks, except at local stores, which charged a usurious fee.

In short, the government was faced with figuring out how to pay the correct pensioner the correct amount, on time, every month, at a convenient location. The solution turned out to be something right out of a science fiction movie.

Now, on the first of every month, a caravan of specially equipped mobile banks mounted on Nissan 4x4s arrives in villages throughout the region. The pensioners line up and place their finger on a biometric sensor. The Identix Touchsafe Scanner verifies not only the individual's fingerprints, but also measures the finger's temperature to protect against fraudulent use of so-called "death" (amputated) fingers. In the three years since the program was initiated, fraud has

been completely eliminated. Initial skepticism, not surprising when dealing with an elderly, rural, illiterate and nontechnology-oriented population, has turned to absolute delight as the pensioners realize they are being paid their full pension on time, on a predictable day each month.

An unanticipated side effect of the pension payout system is the establishment of informal markets. Each payout point has become a trading and social center for a few hours every month. Traders now follow the mobile payment vehicles and stop at each point to offer their wares of chicken, rice and basic necessities.

In the United States, similar systems have met with less enthusiasm. Although there is a successful fingerprint system being

used today to distribute welfare payments in Connecticut, Americans in general view the process of being fingerprinted negatively. "Right now, most Americans think of fingerprints as a method to find criminals," says Ken Tyler of Biometric Identification Inc., whose company is the leading U.S. manufacturer of computerized fingerprint ID systems. "But soon we'll think of our fingerprints as a way to protect us from criminals."
Photo by Mark Peters

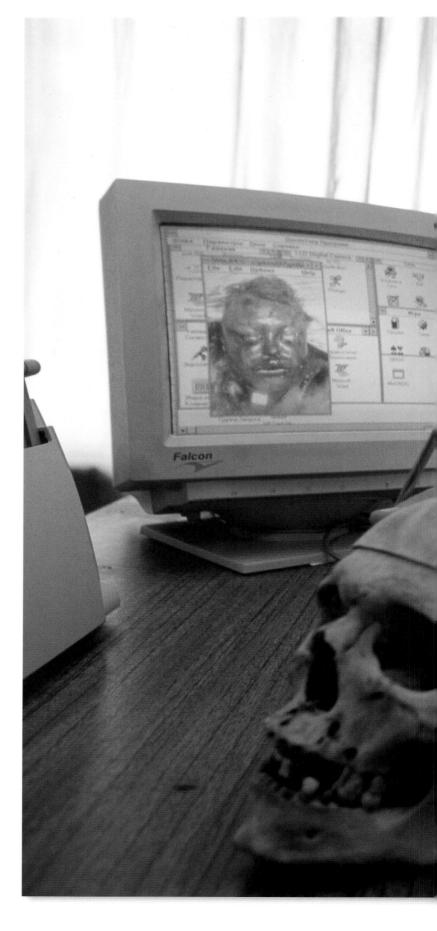

▲ NEW IBERIA, LOUISIANA

If it weren't for the Internet, Beau Arceneaux might still be living in a dilapidated mobile home in Texas, forced to fend for himself and believing that he had been abandoned. Instead, the teenager now lives comfortably with his mother and her family (*above*), more than a decade after he was kidnapped.

Beau (*top, left*) was just a toddler when he was abducted by his father after a bitter divorce in which his mother won sole custody. He grew up a few hundred miles from his mother's house, while the FBI searched for him in vain. His distraught mother, Becky, by then remarried, took her case to the *Oprah Winfrey Show*, plastered Beau's face on billboards and milk cartons, and asked God each night to "watch over him and let him know that someone loves him."

The break came when a neighbor let Beau use her computer. Friends he made in an Internet chat room read between the lines of his e-mails when he spoke of his mother. Suspecting Beau had been abducted, they contacted the National Center for Missing and Exploited Children on his behalf. Three months later, Becky got the phone call she had long prayed for: Beau had been found alive, and was coming back to her. After years of separation,

http://missingkids.org

mother and son held each other in an embrace neither will ever forget.

There are thousands of other missing children scattered around the country. The Center for Missing and Exploited Children's Web site, www.missingkids.org, logs about 30,000 hits a week and features a database searchable by height, weight, time and location of a child's last sighting. The center also uses technology donated by IBM, Sony, Intel and Infotec to create "age-progression" photographs: a picture of a child abducted at age seven, for example, can be morphed to show what the child probably looks like at age twelve. Nearly 100 abducted children have been reunited with their families thanks to these computer-enhanced images.
Photo by Annie Griffiths Belt

▼ **ROSTOV, RUSSIA**

Because of his conviction that the dead deserve a name, Russian forensic expert Alexander Panov has developed a sophisticated database that allows him to rapidly match unidentified skulls to lists of missing persons. Panov gathers information from unclaimed bodies brought to the Rostov Forensic Bureau in southern Russia and then has the computer cross-check a database of people missing and presumed dead, looking for a match. During the past five years, he's given the dignity of identity to more than 100 bodies. In the United States, forensic scientists have taken the process even further. By analyzing data collected by scanning hundreds of living faces, Dr. Murray Marks, at the University of Tennessee, has created a computer program capable of extrapolating the features of a person's face from the shape of their skull.
Photo by Gerd Ludwig

Staying in Touch

Ivar Bore has two windows open on his desktop computer, and there is a crisis brewing in each. In window one, he is remotely attending to a floating oil rig, one of StatOil's 19 rigs positioned along the Norwegian oil shelf, which today supplies 60 percent of Europe's oil reserves. In the other window, his two daughters are squabbling over who gets to choose the TV channel during their one-hour lunch break from school.

It's just another day in the offices of StatOil, northwest Europe's largest crude oil producer. Ivar and other engineers in Stavanger, Norway, where the summer sun stays high until after 11:00 P.M., monitor the performance and troubleshoot most problems of their ships via videophone-enabled personal computers, effectively eliminating the need for engineers to be posted on every vessel. Like the Norme, the company's newest drilling ship, each of StatOil's 19 production ships employs a host of digital technologies ranging from a Global Positioning System, which helps the ships precisely locate oil well heads installed on the ocean floor, to computer-controlled anchors that keep the ships from drifting as they pump.

But for 40-year-old Ivar, who was widowed two years ago, the technology at his fingertips allows him to seamlessly juggle the two very different worlds that require his attention. His PC equipped with ProShare Technology enables him simultaneously to be at work and to be in

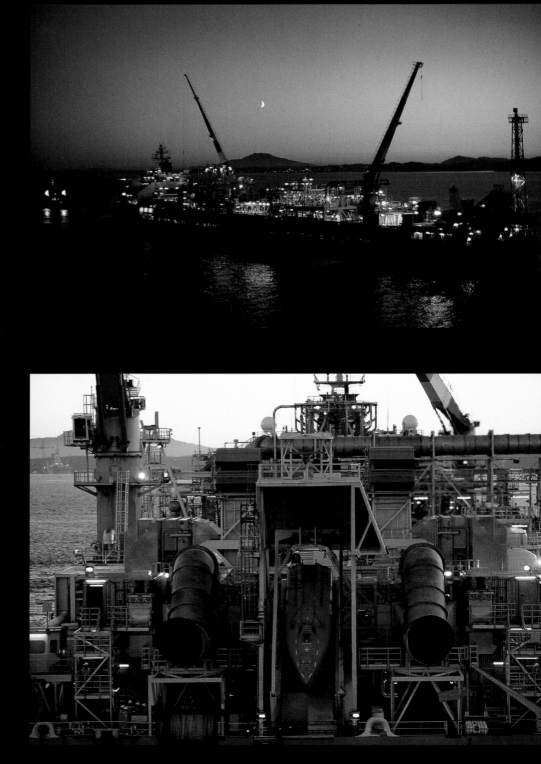

touch with his three children at home. The children say it's made a big difference in their lives since their mother died.

"I like to draw pictures for my dad," says eight-year-old Kjersti. "They make him happy." Ivar receives drawings and calls several times a day at work from Kjersti, 14-year-old Marianne and 17-year-old Ole, which reassure him that everything is OK.

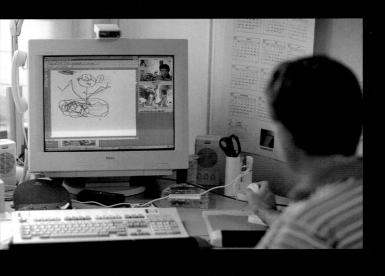

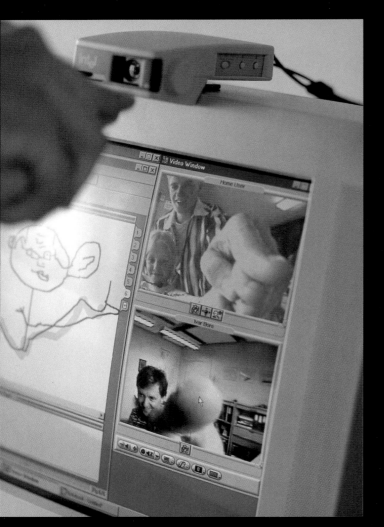

And because the computer setup at home is identical to the one in Ivar's office—part of a company program to offer a second system to each of its 15,000 employees—workers unable to go to the office can still get the job done. "Giving a PC to an employee means you no longer distinguish so sharply between working hours and leisure time," notes an article in the StatOil company magazine. A double-edged sword, perhaps, for employees who cherish time away from work. But for Ivar, it allows him to be in touch with both of his very important worlds simultaneously. "The videophone is great, especially for sorting out arguments. The two girls argue a lot, like most sisters do." The downside is small: "My Kjersti chats online with people all over the world," he says, as he downloads her latest drawing (*top, left*). "In Norway we pay for even local phone calls by the minute so my phone bills are getting pretty big." But if it's the price for having a computer that keeps him in touch with his family, it's one this single father pays gladly.

Photos by Michael Lange

George Jetson often talked to Mr. Spacely by videophone, but video-conferencing today happens with a machine 1960s cartoon writers never imagined: the personal computer. Here Army Lieutenant Frank Holmes, stationed in Bosnia, talks to his wife, Amanda, and daughter, Morgan, 5,000 miles away in North Carolina. The smooth images that reunited the family ran over normal phone lines between computers running ProShare Technology.

Holmes, who hadn't seen Morgan since just after her birth three weeks earlier, says, "the best part about the videophone was seeing how beautiful the two most important women in my life are." That's exactly the reaction the army brass wanted from the pilot videoconferencing program. Launched on Father's Day in 1997, it was used by almost 200 soldiers in Bosnia, including several who saw their newborn children for the first time.

Will videoconferencing become standard issue on U.S. military bases abroad? "Don't rule it out," says Holmes' commanding officer, Lt. Col. John McDonald, who adds, "This was the single greatest morale boost for my troops in a long time."
Photos by Lori Grinker (below and bottom, left) and Cindy Burnham (top, left)

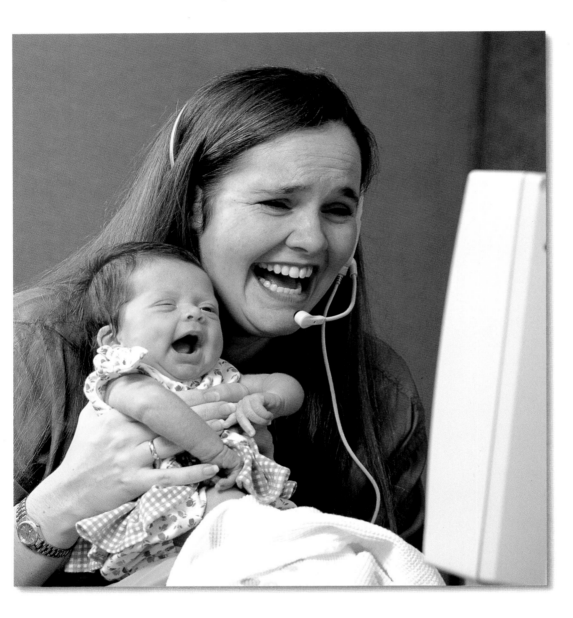

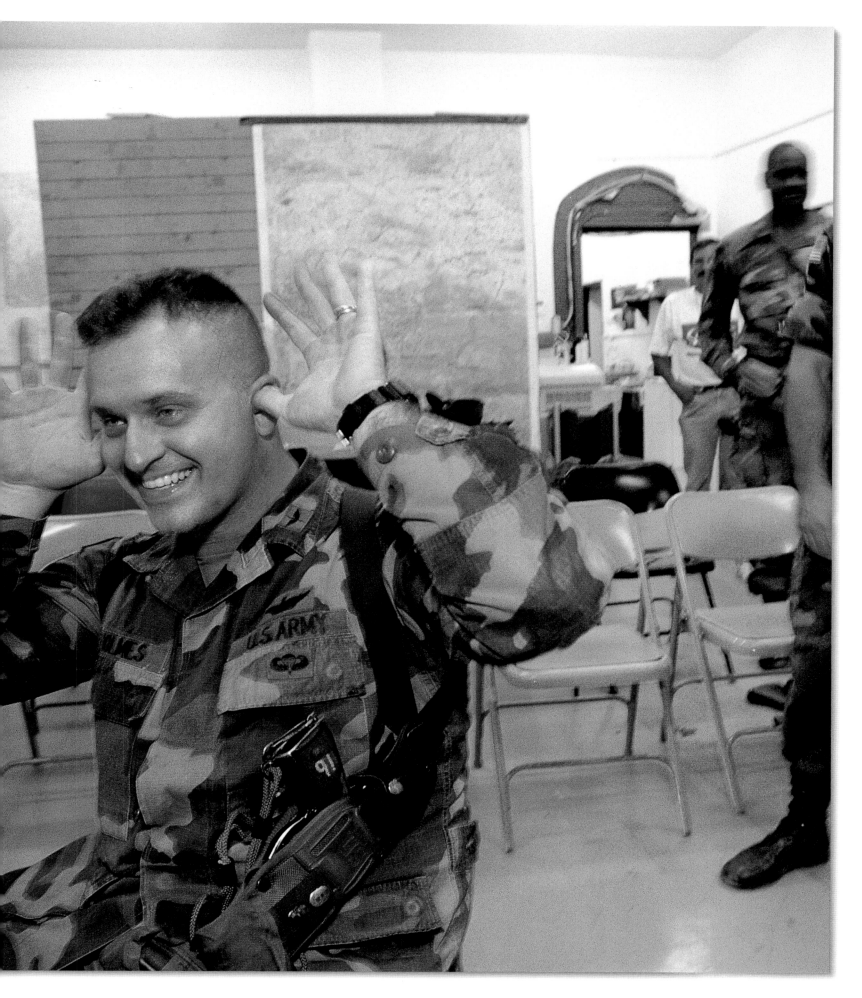

Children of
the Night

"The moon is my friend," says five-year-old Katie Durbin, who suffers from xeroderma pigmentosum (XP), a genetic disease so rare that it's unknown to many doctors. Severely blistered by any contact with the sun's ultraviolet rays, almost all the victims of this disease will die of melanoma while they're still in their teens or early twenties.

Until recently, afflicted children and their parents struggled in isolation while searching for a way to cope with the condition, dealing not only with the symptoms but also with the psychological burden of the children never being able to leave their homes while the sun is out. But in 1995, Caren Mahar, whose young daughter has XP, started a Web page (www.xps.org/home) for families wanting to share information about the disease. The site not only provided the latest news, but also family-to-family tips for coping.

A sense of community formed because of the site, and out of it came Camp Sundown, a summer camp that brings the children and their parents together to help fight loneliness, isolation and fear.

Camp Sundown in Poughkeepsie, New York, turns the world upside down for two weeks every year: campers, including friends and relatives who don't have XP, sleep by day and play by night. While the kids frolic, their parents compare notes and build on the support they've given one another online. A frequent topic of

http://www.xps.org/

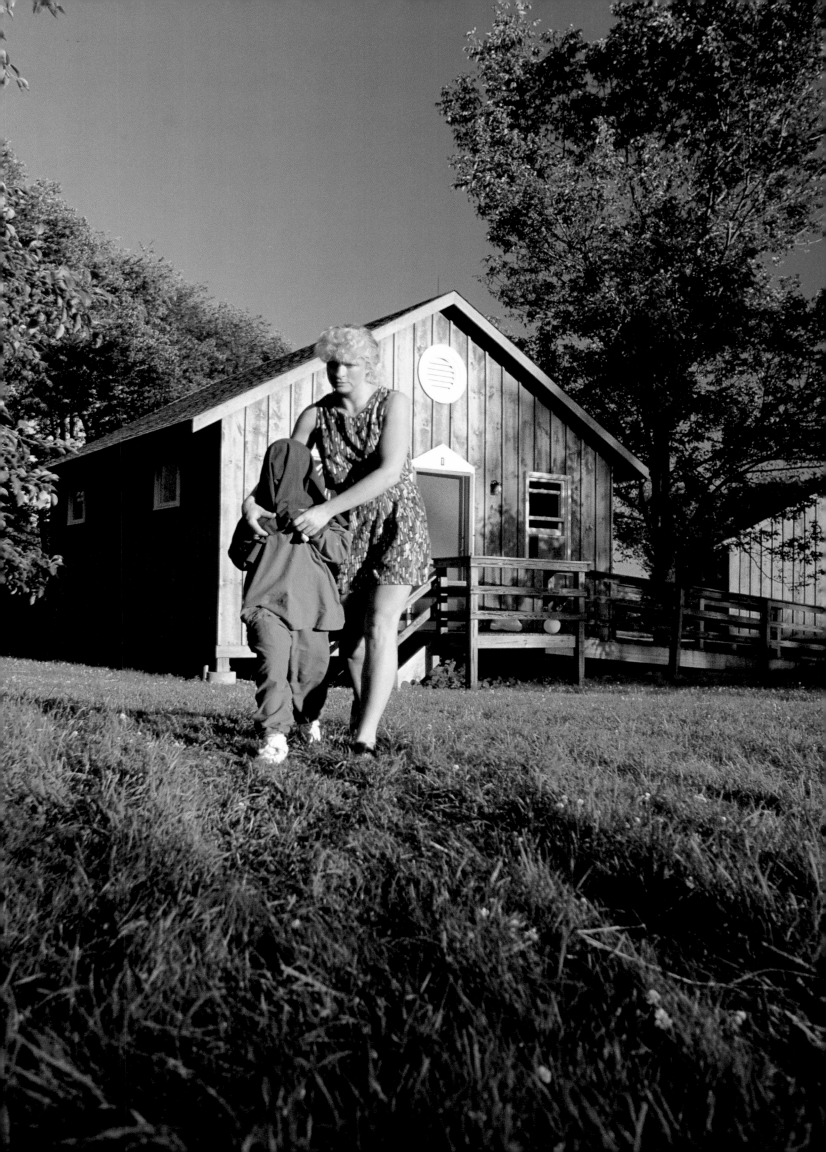

Pigmentosum Society, founded by Caren Mahar in 1995 in the hopes of spurring research toward a cure or effective treatment within the next 15 years—a crucial window for the XP kids at Camp Sundown.

Spirited from the house (*previous page*) at dusk like a captive escaping to freedom, five-year-old Katie Durbin and her mother head for the lodge.

Katie Mahar plays with her computer at Camp Sundown (*below*), where the windows are blanketed with garbage bags to prevent deadly sunlight from leaking through. Unshielded fluorescent lights also damage the skin of XP kids, so even at night they never visit fast-food outlets or shopping malls. To avoid halogen head-lights blistering their eyes, most wear sunglasses when riding in the car.

During the school year, Katie joins her classmates every day by videophone. Friends who talk to her by videophone or visit her after school enter a strange world: the tinted windows of her house are covered with blinds and curtains, and Katie is covered with sunscreen every

waking hour—six to eight coats of it a day in the summer.

Nighttime is wrestle time for campers (*bottom left*), some of whom are siblings of XP sufferers who have been spared the disease. It's by moonlight that campers take a pony ride, swim in the pool and sing silly songs. Meanwhile, their dedicated parents use the best of today's technology to gain strength from one another while shining the light on a rare disease, one whose victims once lived in searing loneliness.
Photos by Nicole Bengiveno

HONG KONG, CHINA

Access to quick information about a patient's history can mean the difference between life and death, especially if a victim is unconscious or incoherent. In Hong Kong, patients such as 84-year-old Ting Sik Mui (*right*) safeguard themselves by carrying a card in their wallets, which can contain the equivalent of an entire filing cabinet—about 2,000 pages—of a patient's medical history.

Each "patient record card" can include written records, images such as X-rays or MRIs, and even oral reports on a patient's condition. After Dr. Chu Yuk Chun finishes examining Ting, his observations will be entered on her card as well as on paper files for backup. A card, displayed by nurse Law Wai Fong (*above*) at Queen Elizabeth Hospital, can be read using an optical card reader and a desktop computer. Patient record cards are also being adopted by hospitals in the United States, England, South Korea, Brazil and the Philippines.
Photos by Jeffrey Aaronson

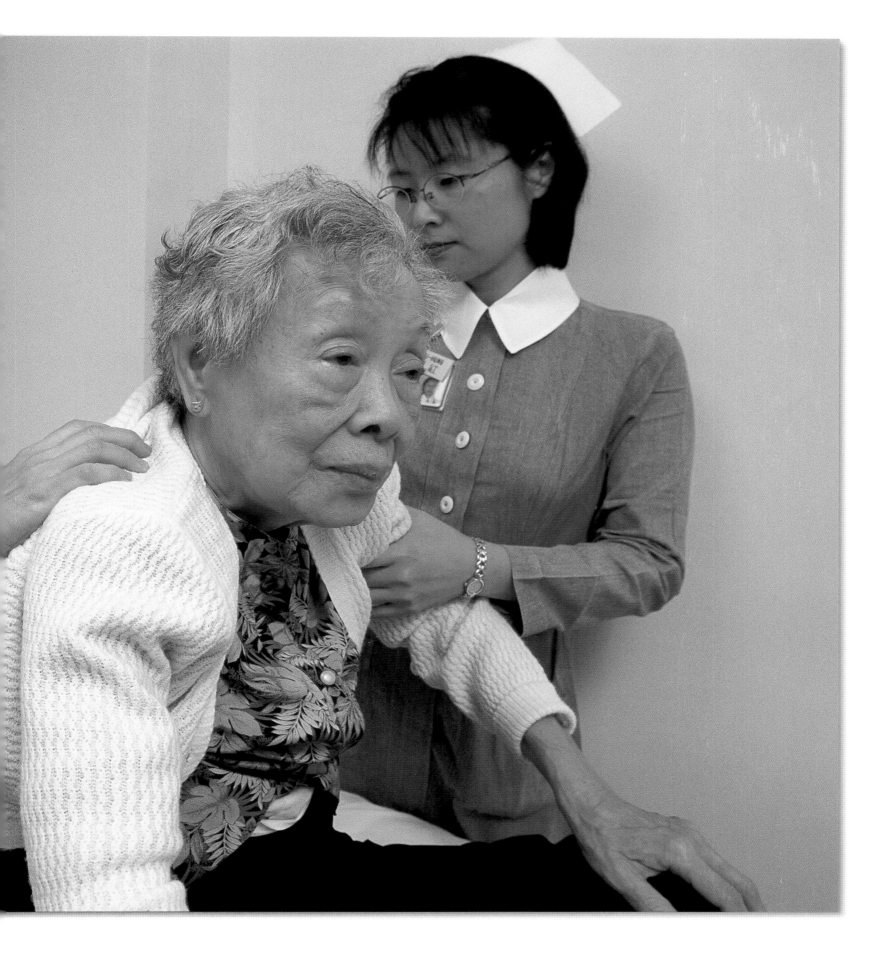

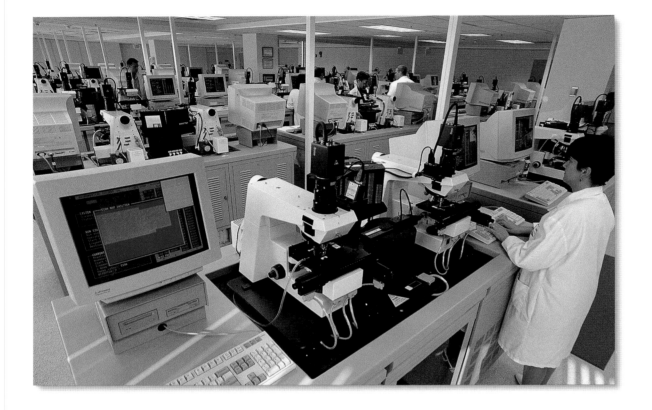

▲ UPPER SADDLE RIVER, NEW JERSEY

Many applications of new technology save time and money; Papnet saves lives. Cervical cancer, the most common cancer afflicting women worldwide, is also the most treatable if detected early by a Pap smear. Abnormal cells, captured and examined on a slide under a microscope, are caught by technicians known as cytotechnologists. Typically, a cytotechnologist looks at 100 slides a day. Unfortunately, abnormalities may be missed by even the most skilled technicians, since each slide may have up to 300,000 cells, of which only a dozen may be abnormal. Enter Papnet, which uses a robotic microscope, digital image processors and a neural network (*top*) to catch cells that deviate from the norm. These suspicious cells are mapped onto a

grid (*above*) and displayed on a high-resolution monitor, where a cytotechnologist can study them in detail. The system, introduced in late 1995 and now in use by more than 200 labs across the country, increases the accuracy of a Pap smear by up to 30 percent.
Photos by Stephanie Maze

▷ TASHKENT, UZBEKISTAN

Nearly two-thirds of the 150 million blind or severely visually impaired people in the world would be able to see, if only they had the right medical treatment. "We can't operate on the thousands of people who need treatment in every place we visit," says Dr. Garth Taylor, an ophthalmic surgeon who has taken 55 trips to developing countries with the humanitarian group ORBIS, a group of doctors who travel around the world in a flying eye surgery hospital. "But the most important thing is the training we are providing to local doctors."

The specially modified DC-10 also serves as a teaching clinic. Volunteer doctors (*right*) transplanting a cornea use digital cameras attached directly to their surgical instruments, and larger ones suspended above the patient, to allow local doctors in an adjacent room to watch operations as they are performed. With a two-way microphone system, the doctors can ask questions throughout the surgery.

Improved chip technology has made the cameras "much better, much smaller and much sharper," says Dr. Taylor, whose headgear bears the flag of his native Canada. "The cameras allow as many as 150 spectators to see exactly what I see. By training the local doctors, they can help more people after we leave."
Photo by Carol Bates

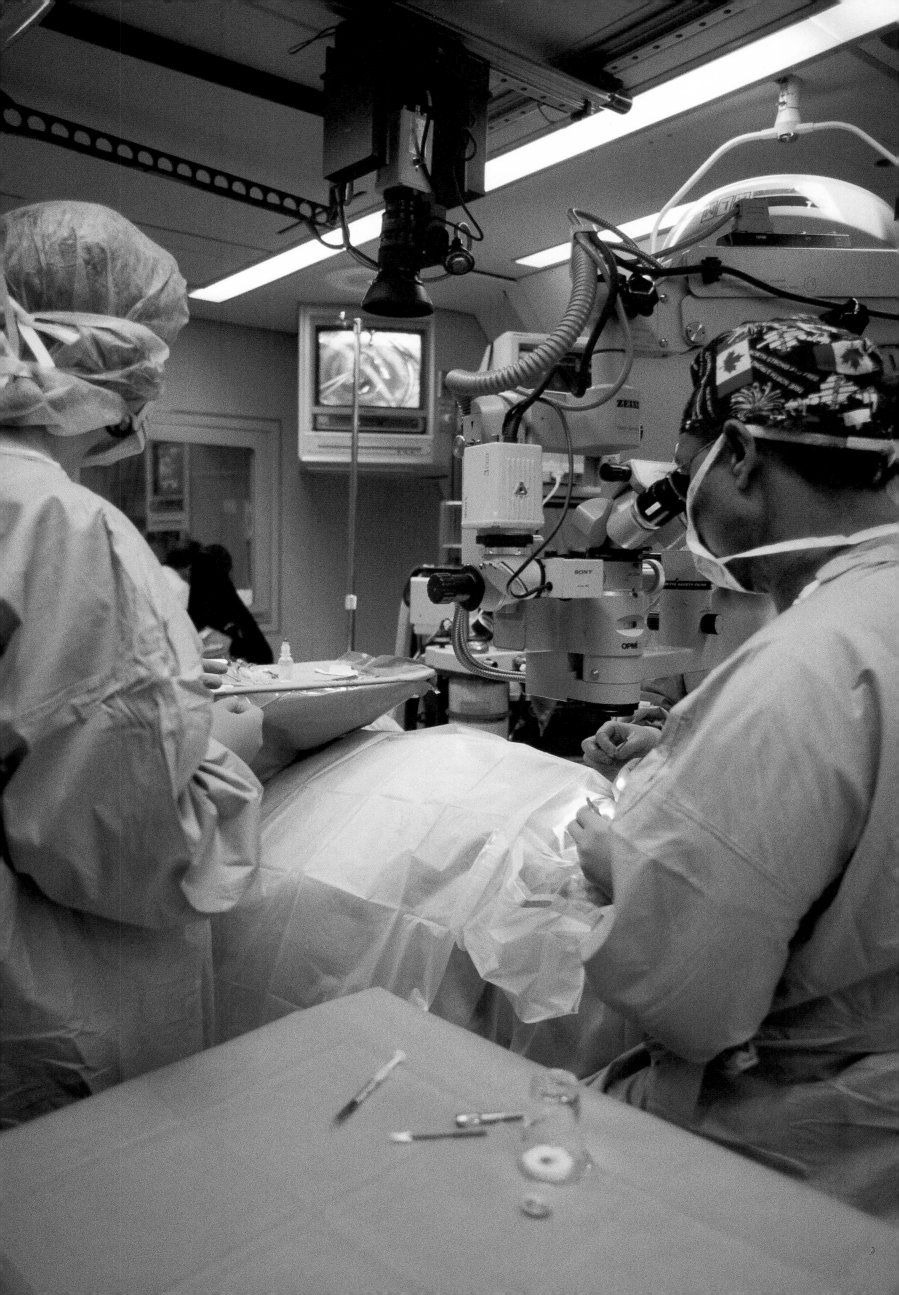

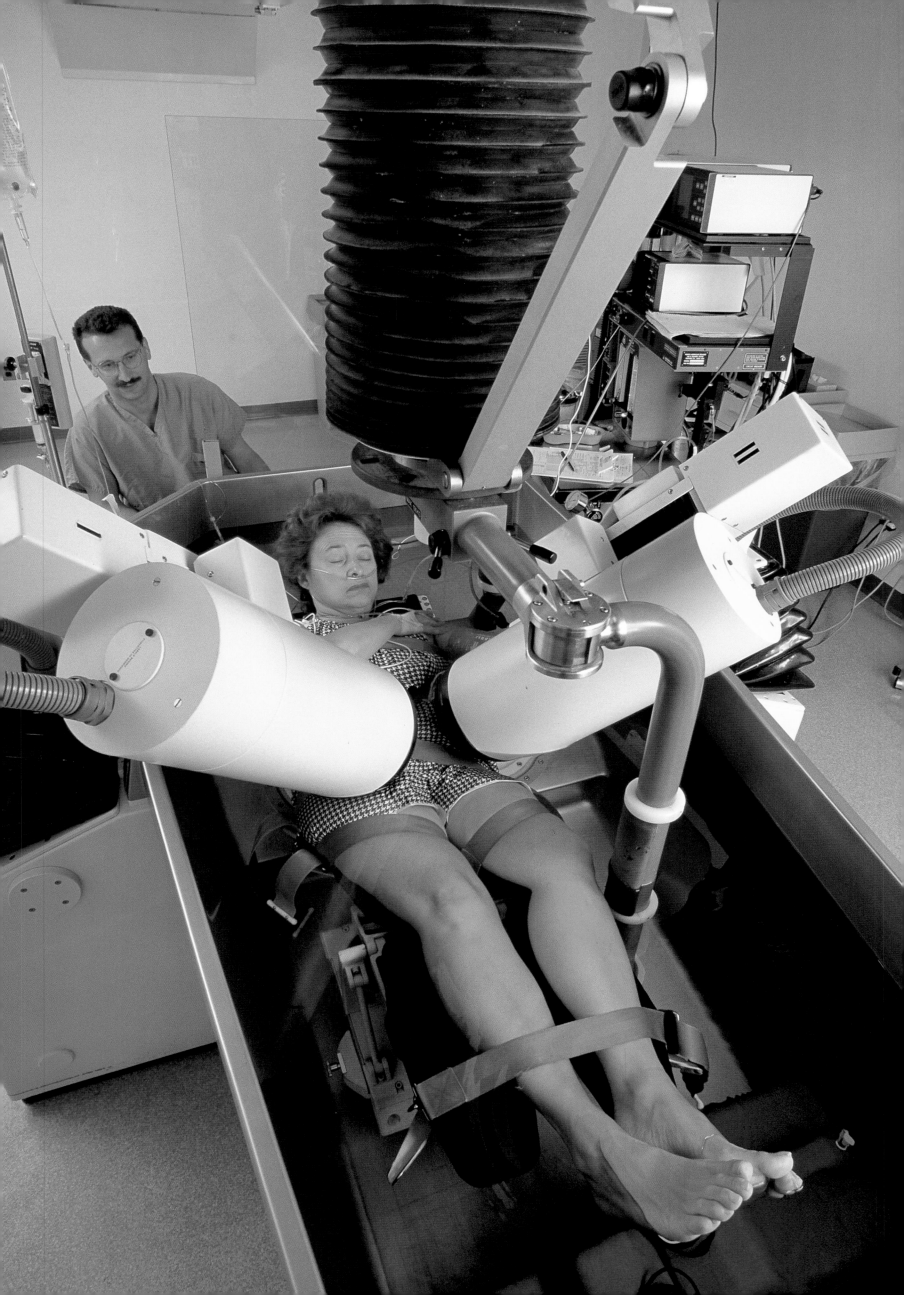

"The world's most expensive bathtub," as one doctor calls it, takes the sting out of an excruciatingly painful medical condition. Vilma Covell undergoes treatment at the Mid-Atlantic Kidney Stone Center in a $1.6 million tub where computerized X-ray units are used to pinpoint the exact location of her kidney stone. Powerful acoustical shock waves, created by an underwater spark between two electrodes, are precisely aimed to shatter the stone in a treatment that lasts about 30 minutes. Surgery, an alternative treatment for kidney stones that don't pass from the body naturally, requires a hospital stay of up to a week, with another month of recuperation. With shock-wave therapy, a patient can leave the hospital right after the procedure.

The science behind the Extracorporeal Shockwave Lithotrispy (ESWL) procedure was discovered by accident when German aerospace engineers noticed that sound waves, the result of raindrops hitting the wings of planes traveling at supersonic speeds, created pockmarks inside the aircraft. Medical researchers then learned to harness and focus these waves to shatter kidney stones, transmitting the force through water and body tissue without affecting the surrounding bone or muscle.
Photo by Nick Kelsh

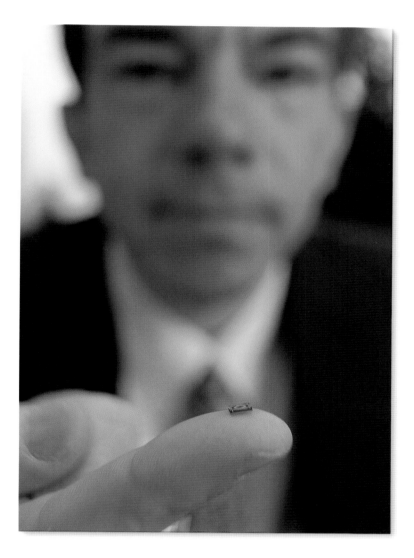

▲ SNOWBIRD, UTAH

A powerful pump no larger than a contact lens may someday be implanted in patients to automatically dispense medication for people with a wide variety of ailments. Dr. Michael Huff, an electrical engineering professor at Case Western Reserve University, holds on the tip of his finger a microprocessor complete with valves that can precisely administer intravenous drugs (IVs) with a level of accuracy unparalleled by today's standards.

With so many advances in medical technology, it's hard to believe that today's IVs are administered by nothing more than a plastic tube pinched together to dispense medicine.

This primitive means of delivering drugs forces many doctors to give their IV patients 50 to 75 percent more drugs than necessary to ensure that they receive at least the minimum dosage. The cost of this unnecessary medication is staggering, considering the explosion in IV usage over the last few years to treat everything from cancer to AIDS.

Huff sees the immediate use for his pump in IV therapies, but as a diabetic, he also hopes that someday it can be implanted along with a reservoir of insulin that can be dispensed as needed. The pump is designed to last up to 10 years.
Photo by Lori Adamski-Peek

PHILADELPHIA, PENNSYLVANIA
Forget about how TV cops do it; in real life fingerprints have rarely helped in solving crimes. Typically, fingerprints are useful only when police already have a suspect whose prints can be compared to those found at a crime scene. It involves a painstaking manual comparison, pulling fingerprint files from a paper archive (*right, top*) and trying to match them.

But now, an automated identification system uses a computer database (*right, bottom*) to compare fingerprints against eight million stored prints in only 75 minutes—a search that would take more than 40 years to conduct manually. When suspects are booked in Philadelphia (*below*), their prints are scanned directly into the database and their photographs are entered into an electronic mug book. After the cops dust a crime scene, they run the prints through the database in search of a match. "It used to be about a one-in-a-hundred chance that prints found at a crime scene would be useful in solving a crime," says Lt. Harry Giordano of the Philadelphia Police Department. "Now it's more like one in five." The very first week the system was in place, the department cracked a 17-year-old case from a partial fingerprint found on a pack of cigarettes.
Photos by Nick Kelsh

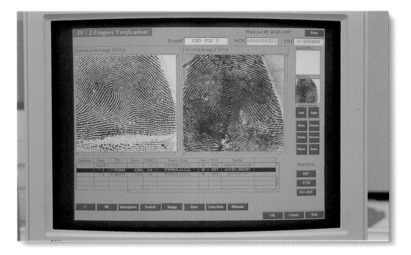

SAN JOSE, CALIFORNIA

Like Wild West sheriffs with recovered sacks of gold, detectives from the San Jose police force's High Tech Detail display the booty recouped from crime gangs preying on the technology industry. On average, these modern-day stagecoach robbers steal close to $1 million a week from the high-tech community, and once they've run off with the loot, the robbers don't leave much of a trail. Snatched in armed "takeover raids," stolen components blend anonymously into the computer industry's brokerage-like gray market. According to police experts, the precious jewels of the computer industry can change hands five or six times

within hours of being stolen. "The worst part," says unit chief Sergeant Don Brister, "is that to meet an order deadline, manufacturers often are forced to buy back parts that they know were stolen from their own facility." Luckily, the good guys may finally be getting the upper hand. Last year, 140 warrants were issued to arrest one large gang that turned out to be responsible for more than 50 armed robberies of computer equipment in two years. Since the bust, armed robberies in Silicon Valley have plummeted from two a week to less than one a month.

Photo by Steve Liss

LONG BEACH, CALIFORNIA

It may look like a kayak, but it's actually a high-tech, undercover surveillance vehicle. Coast Guard Captain Edward Page patrols close to the action in the waters off Long Beach in his snug 18-foot kayak. Like an undercover cop, Page uses his ordinary-looking kayak to get closer to other vessels than he could in a ship emblazoned with the Coast Guard emblem. But don't be fooled—his boat is as wired as most other Coast Guard vessels. He charts his position with a hand-held Global Positioning System device, backed up by a radio beacon, which uses radio waves as a locator. He reports to base via cell phone, or in case that fails, a UHF radio.

Photo by Sarah Leen

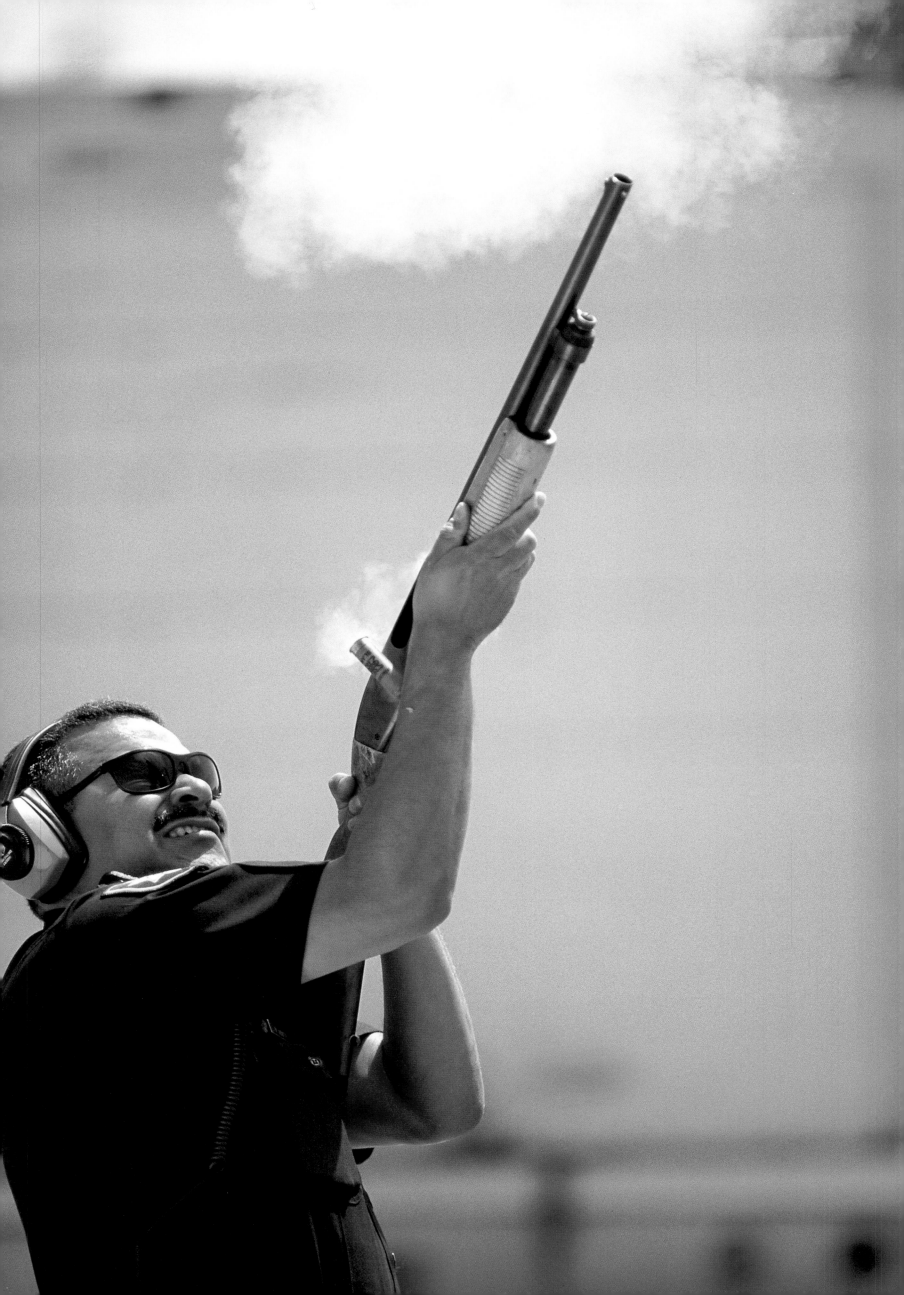

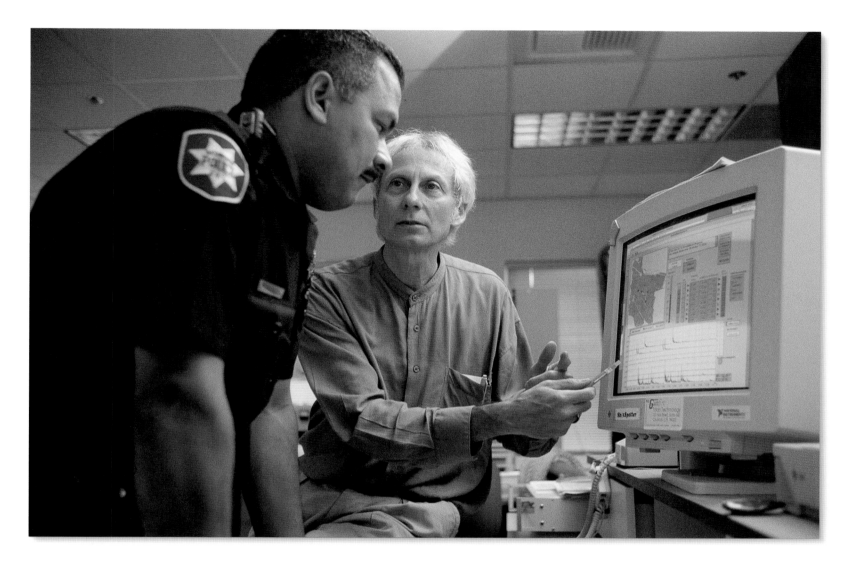

◄ ▲ ▶ REDWOOD CITY, CALIFORNIA
The sound of urban gunfire is unmistakable, yet it is often impossible to pinpoint its source because the sounds echo up streets and off buildings, confusing eyewitnesses and police alike. But thanks to a new software program called the Shot Spotter, police can now track the location of gunfire to within 50 feet. Officer Walter Monti (*left*) fires two 12-gauge shotgun blanks over an area of Redwood City, and within seconds the gunfire is traced on a computer at police headquarters (*right*). As Robert Showen, President of Trilon Technology, explains to Officer Monti (*above*), the Shot Spotter relies on acoustical sensors placed atop tall buildings and telephone poles throughout the city. The sensors detect and measure the sound of gunfire and send the data to headquarters. It's a vast improvement over interviewing witnesses minutes or even hours after the gunfire to try to identify its source. "Now," says Redwood City Police Captain Jim Granucci, whose department is the first in the world to test the Shot Spotter, "if someone commits a crime involving gunfire, we can dispatch officers to the scene instantly and catch them with the gun almost literally still smoking." *Photos by Kim Komenich*

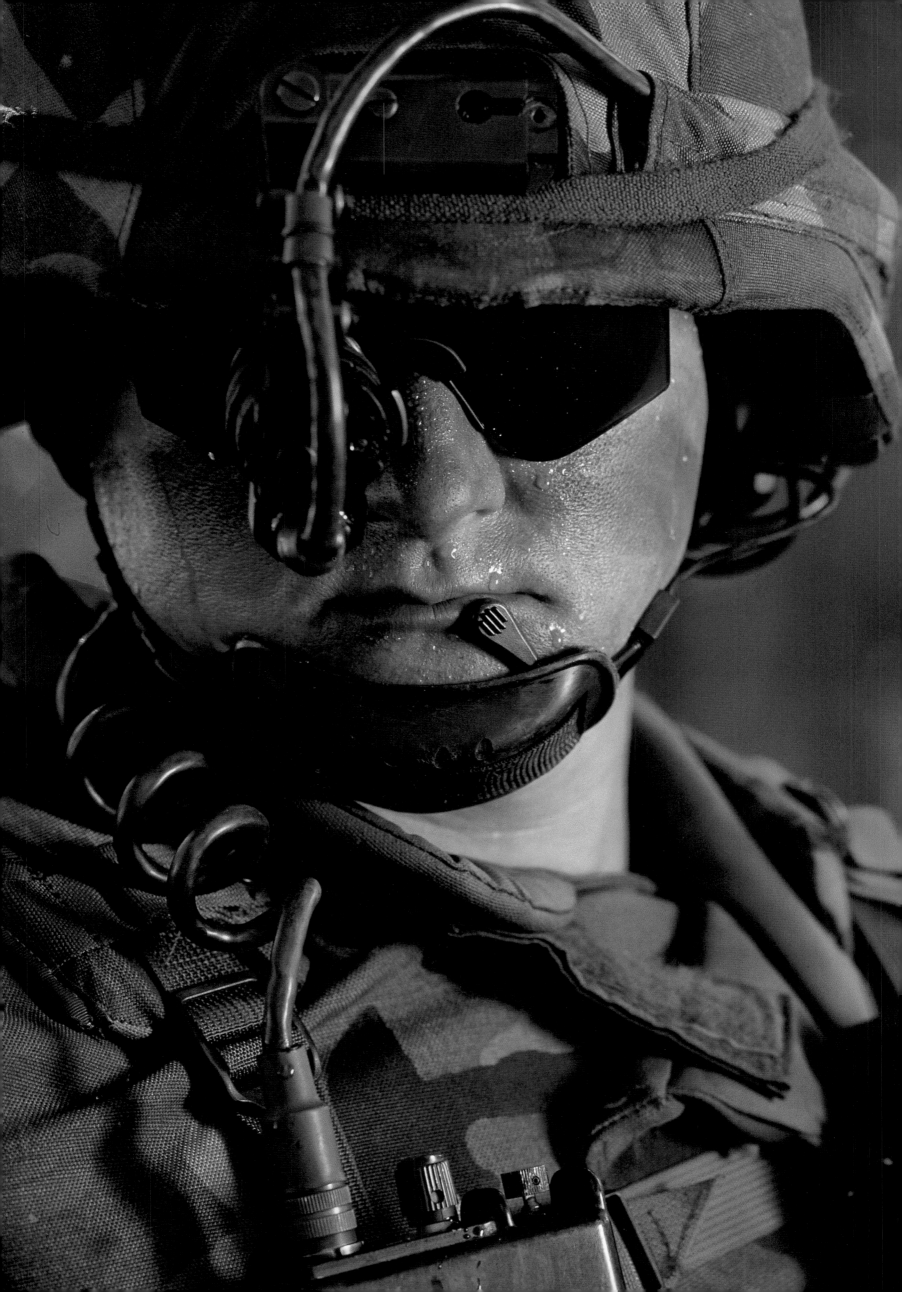

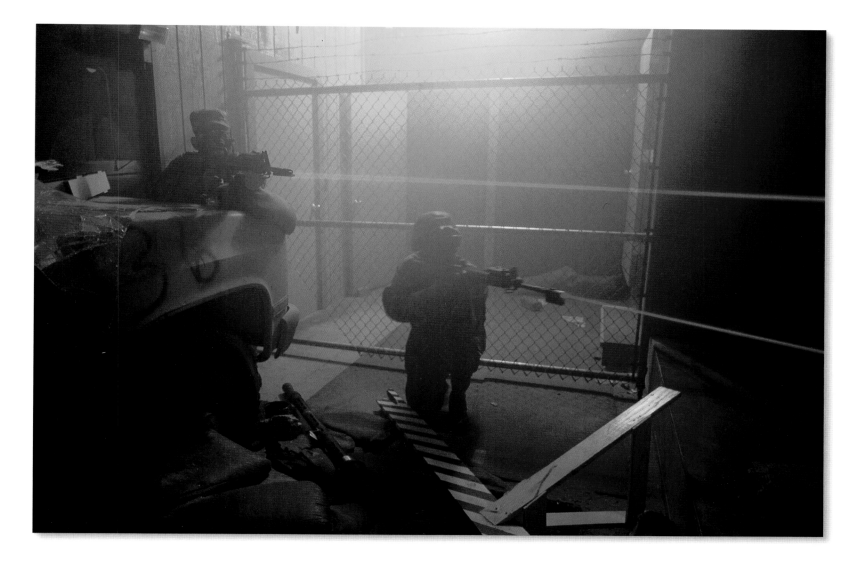

◀ **COLUMBUS, GEORGIA**
Fighting man for the twenty-first century, Sergeant Scott Decker tests high-tech equipment that the U.S. Army hopes to have in the field by the year 2000. At the U.S. Army Infantry School, there is no more wondering if that silhouette peering from behind a tree is the enemy; it's easy to identify fellow soldiers via a helmet-mounted microphone and an earphone connected to a radio system. No more losing your bearings in enemy territory, either. The lightweight computer in Sergeant Decker's backpack features a Global Positioning System that feeds into the eyepiece display over his right eye, showing him his precise location. His rifle includes a built-in digital compass and a digital video camera capable of sending instant images back to base, so his commanders can look over his shoulder while he's in the field.

Throughout history, military innovations have often seeped into civilian life—Medivac helicopters, GPS devices and even the Internet were originally invented for the military. That's not to say that one day we'll all be sporting similar gear as we go about our lives, but already cameras called webcams are showing up in kindergartens so that parents (and even grandparents on the other side of the country) can access a page on the Web to get a reassuring glimpse of their kids at pre-school.
Photo by Karen Kasmauski

▲ **COLUMBUS, GEORGIA**
Modern warfare does not stop with the setting of the sun, and today's digital warriors must be prepared for battle around the clock. At Fort Benning, the U.S. Army's "Own the Night" program is developing high-tech devices to help American fighting forces keep the upper hand— even in the dark.

In use throughout today's army, rifle-mounted laser range finders and targeting devices (*above*) help soldiers locate enemy positions in total darkness, without compromising the soldiers' position. The infrared laser, only visible to users wearing special goggles, determines the range of the target, while a second laser enables accurate targeting.

Other night-vision equipment in development includes binocular night-vision goggles to aid helicopter pilots on low-altitude missions; monocular night-vision eyepieces for ground soldiers on reconnaissance; thermal viewfinders for circumnavigating combat vehicles during the night and low-visibility battlefield conditions; and even radar identification of critical targets from unmanned aerial vehicles flying behind enemy lines.
Photo by Karen Kasmauski

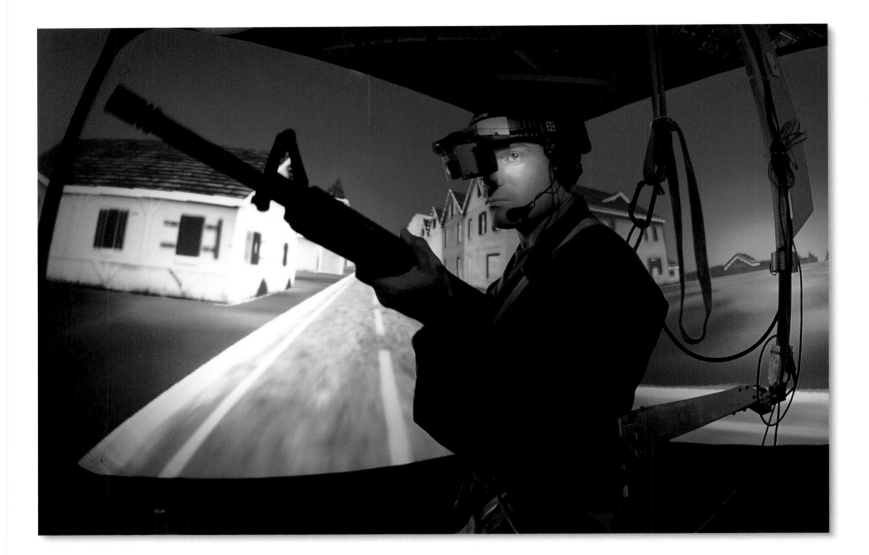

▲ COLUMBUS, GEORGIA

"The infantryman's role," according to Colonel Lawrence White, "has always been and will continue to be *up front and personal* in the midst of the brutality of combat." Today, combat is frequently taking soldiers into urban settings like Mogadishu, Somalia, where 27 U.N. peacekeepers were killed in 1992. In addition to developing specialized weapons systems for urban and close-quarters combat, the army is employing virtual-reality simulators to expose soldiers to a variety of combat environments, including night scenarios.

Using the Dismounted Infantry Combat Simulation Treadmill (*above*), Sergeant Marc Turchin practices with the latest "land warrior" combat equipment in a virtual city. Using a head-mounted computer screen, Turchin is able to check his position, see computer-generated maps of the battle zone and track the positions of friendly forces. The video trainer presents a variety of battle situations and tests his ability to identify and eliminate enemy forces without harming civilians. A similar system is used to train combat crews of the M1 Abrams Tank and M2 Bradley Fighting Vehicle.

"Tomorrow's technology in the hands of today's soldier makes him more lethal and more likely to survive," says Colonel White, Chief of Staff at the U.S. Army Infantry Center. "He's more likely to return home in one piece."
Photo by Karen Kasmauski

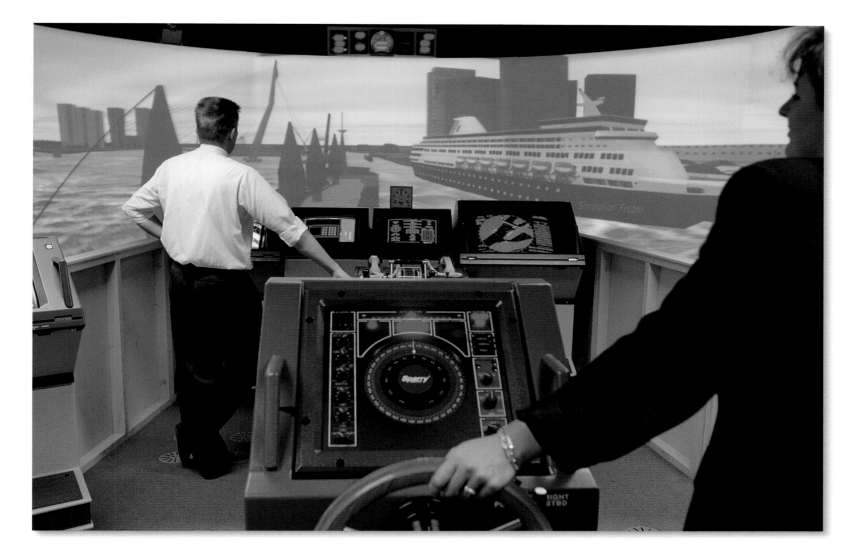

▲ **ROTTERDAM, NETHERLANDS**
Seconds away from a disaster, the young captain at the helm tries to steer a container ship away from a collision course with an oil tanker off its starboard bow. Lives and fortunes are at stake, not to mention the young captain's career. Just as the two ships are inches away from collision, the scene in front of the captain fades out and he finds himself staring at a dark blue wall.

Today, at the Marine Safety Center, navigation simulators similar to those used to train airline pilots use giant screens to provide hands-on practice for learning to navigate the world's major ports. Instructors use the computer-generated displays to subject their budding captains to a variety of weather and visibility conditions, altering the sounds, the pitch of the water and the obstacles students are likely to face. U.S. Navy officers receive training at similar centers in Rhode Island and California.
Photo by Rudi Meisel

The Farmer and the Dell

The words "computer" and "farmer" may not sound like they belong in the same sentence, but on the plains of Middle America, the roar of tractors is merging with the hum of disk drives. More and more farmers are turning to technology to revolutionize an industry desperate to find new ways to increase yields and profits.

If half the fun of test-driving new farm equipment is getting dirty, Caterpillar Inc. is a spoilsport indeed. New models of the company's vehicles are designed and tested in a virtual reality room (*right*) at the University of Illinois in Urbana-Champaign, where the soil is digital, and that black edge on the horizon isn't an approaching storm, it's where the screen ends.

At the virtual reality center, a 10-by-10-by-9-foot room housed at the National Center for Supercomputing Applications, graduate student Pete Hatch tests Caterpillar's biggest earthmover, the 990 Wheel Loader. As Pete scoops up dirt and dumps it in a pile, the engine roars and backup signals sound, adding to the realism of the experience. In the background a virtual dump truck speeds through the area, testing the visibility limitations of the 990's cab design. Before switching its testing program to the virtual reality center, Caterpillar built full prototypes of all vehicles in development—a costly and time-consuming process. Now, because the company can find problems and correct them before actually building a

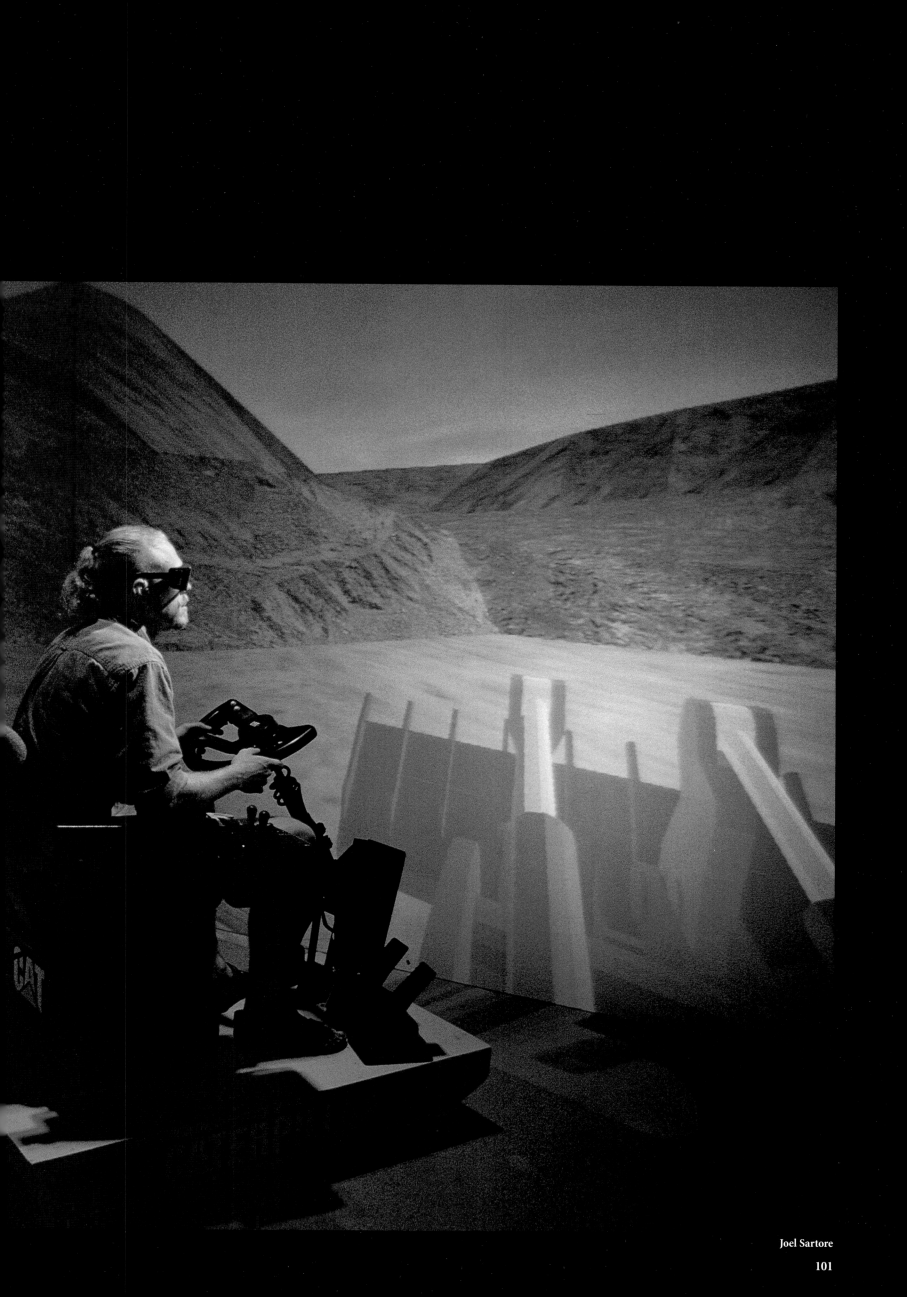

Joel Sartore

Henry A. Barrios

obstetricians to check the health of a human fetus, Greg Hermesmeyer emplo[?] ultrasound to gauge the meat and fat co[?] tent of a cow (*top, left*). Livestock managers use the $10,000 system primarily [?] cattle, sheep and pigs to identify high-quality animals for breeding.

Determining when to breed is anoth[?] matter. Farmers still have to inspect a cow's uterus manually, but figuring out which cow's uterus to examine is now much easier, thanks to electronic anklet[?] (*bottom, left*), which serve as pedometer[?] to measure a cow's activity level. The mo[?] active a cow, the more likely she's in hea[?] and ready to breed. These Israeli-design[?] electronic ID tags, which are read by remote antennas in each stall, transmit data to a central computer, allowing dai[?] farmers to automatically record the dai[?] amount of milk produced by each cow.

Poultry processing (*right*) moves more quickly with a wearable computer[?] system, demonstrated here by Chris Johnson at Atlanta's Georgia Tech Research Institute. Johnson wears a com[?] puter the size of a cassette tape recorde[?] around his belt, viewing data on the screen mounted on his forehead. Voice recognition software allows him to ente[?] pertinent information hands-free; he ca[?] repair machinery by following step-by-step instructions projected on his eye-piece. Someday, for workers in poultry plants and other automated industries, these technologies will mean that filling out paperwork on the factory floor will [?] as easy as talking into a microphone.

Freeing farmers from planning thei[?] day around radio broadcasts or watchin[?] the Weather Channel, a satellite news se[?] vice transmits real-time weather reports and local farm prices to about 110,000 subscribers nationwide. The informatio[?] is beamed skyward from two centers run[?] by the Data Transmission Network (DT[?]

[?]ehicle, the time to bring a new machine [?]o market has been halved from seven [?]ears to three and a half.

Back at the barn, the cows don't milk [?]hemselves—yet. Even so, life in the fields [?]nd barns today would be unrecognizable [?]o a farmer of a generation ago. With the [?]elp of microchips, for instance, farmers [?]est the moisture content of corn without [?]aving to pick a single ear; a hand-held

digital moisture meter tells them when the harvest should begin. And tractors equipped with on-board computers and a satellite-linked Global Positioning System automatically dispense precise amounts of fertilizer and pesticide, allowing each square foot of tillable land to receive the same measured care as a backyard vegetable patch would.

With the same technology used by

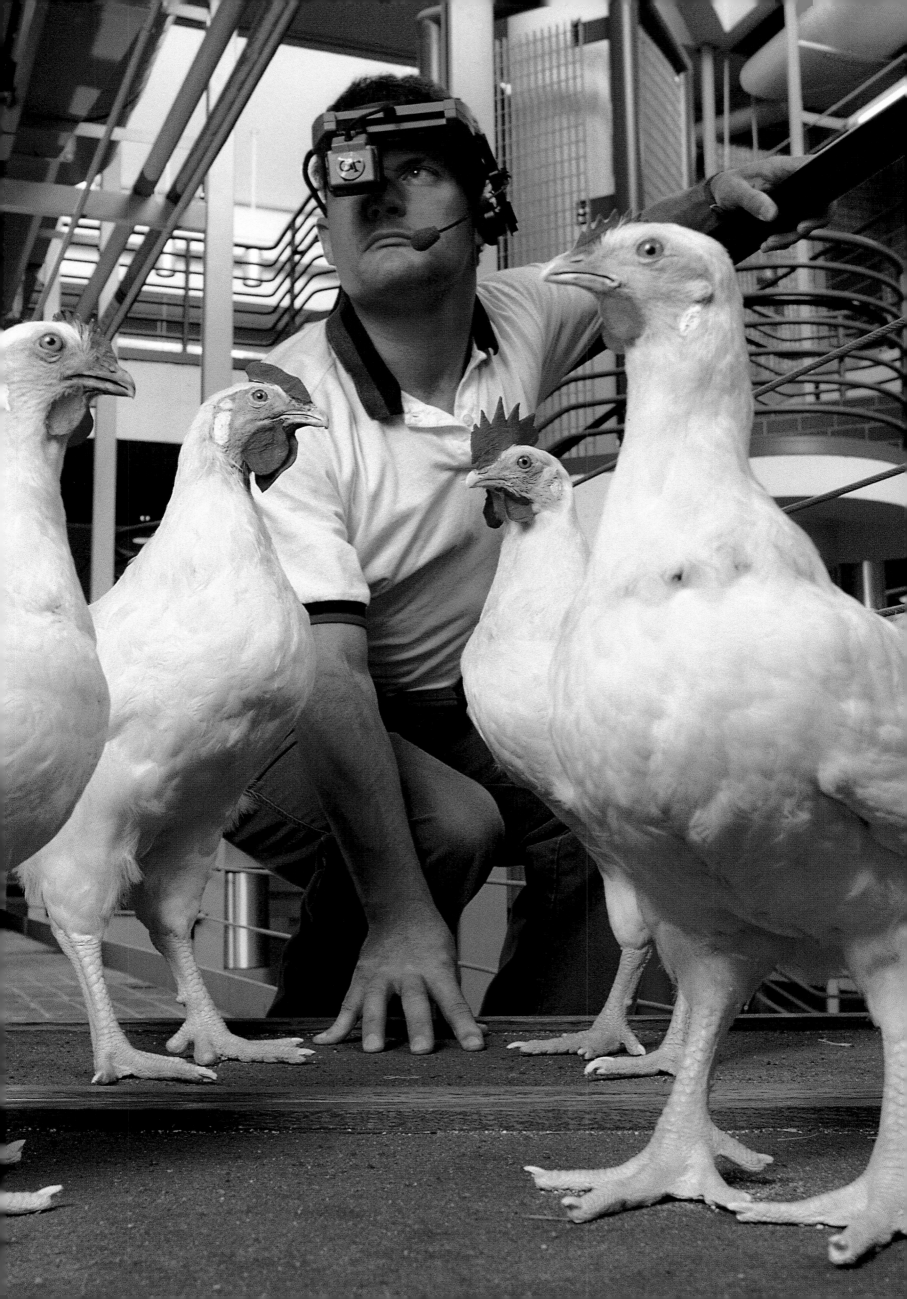

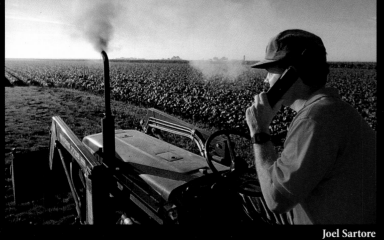

Joel Sartore

John Gaps III

▼ **BALTIMORE, MARYLAND**
Danger! Danger, Will Robinson! Floating in liquid space, a future shuttle crew member practices with Ranger, a repair robot being put through its paces at the University of Maryland's Space Systems Lab pool. The solar-powered Ranger is designed to repair damage to a shuttle craft under real-time direction from technicians back on earth, hopefully sparing shuttle astronauts the danger of space walks. As with many joint efforts between humans and machines, each has its own strengths. Says Rob Cohen of the Space Systems Lab, "The point is to use the machines to do the hazardous and repetitive tasks and to free up the humans to concentrate on tasks requiring quick thinking and manual dexterity."
Photo by Michael Bryant

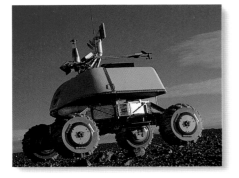

◄ **ATACAMA, CHILE**
Nomad, one of the brawny next generation of robot explorers, rolls over sand and rocks in the Atacama Desert, a moonscape where rain falls once a century. Visitors to Pittsburgh's Carnegie Science Center were able to direct Nomad's movements from 5,000 miles away as they followed its progress on a giant video screen. The robot traveled more than 15 miles autonomously, without any direct or remote control. All told, Nomad covered about 130 miles over 40 days.
Photo by Glenn Hernán Arcos Molina

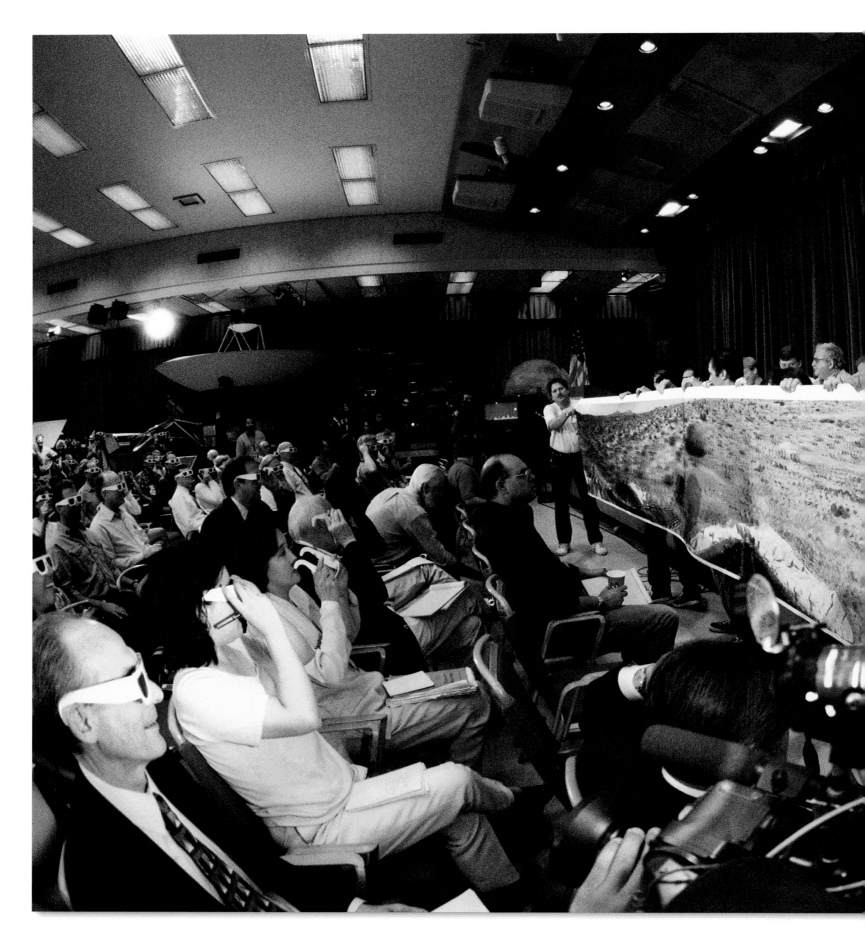

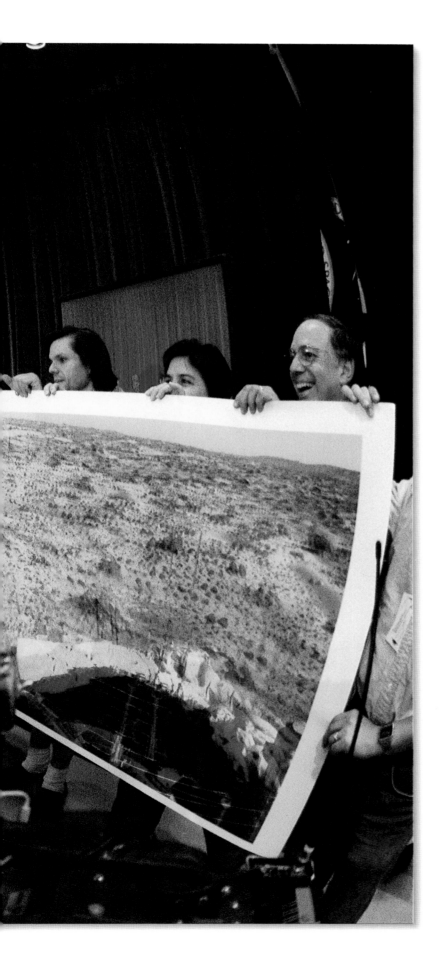

◀ **Pasadena, California**

A photograph that awed the world is unfurled at Jet Propulsion Laboratory, where exultant researchers donned 3-D glasses for a better view. The panoramic photo of Mars was taken by Sojourner, the toy-sized, 22-pound rover controlled by earth-bound scientists using a pokey, 9,600-baud radio modem. Most astounding of Sojourner's technical feats, perhaps, is that it is powered by a slow microprocessor, the Intel 80c85. The Pentium II processors used in personal computers today are well over 100 times faster.

Photo by Steve Krongard

▲ **Ares Vallis, Mars**

Nearly thirty years ago, when Neil Armstrong took those famous first steps on the moon, the world gathered around television sets, watching in awe as Armstrong stepped out onto the lunar surface. On July 4, 1997, when Sojourner made the first foray on Martian land, millions of earthlings were again watching a screen in awe—but this time it was a computer screen. Web watchers, hungry for information on the red planet, visited various Mars Web sites and logged an unprecedented 47 million hits over a four-day period. Unlike passive television viewers of the past, Web watchers were able to download pictures only seconds after they were transmitted from Mars, don 3-D glasses for a 360-degree online view, read about Martian geology, check the latest weather conditions on the planet, or even chat online with planetary scientists.

Photo courtesy of NASA

http://www.jpl.nasa.gov/

◀▲ **184 MILES ABOVE THE EARTH**

Space exploration has been a boon to modern technology. Many of the experiments on the space shuttle have helped in the further development of the microprocessor by testing properties of semiconductor elements in a near-zero-gravity environment.

Columbia astronauts Michael Gernhardt (*above*), Robert Crouch (*top*) and their colleagues record their observations on laptop computers, each of which is more powerful than the computer that guided Apollo 11 when Neil Armstrong first stepped on lunar soil in 1969.

Photos courtesy of NASA

▷ **MAUNA KEA, HAWAII**

Small as a distant star in the night sky, astronomer Andy Perala is dwarfed by the mechanism of the world's most powerful telescope, the Keck II. The telescope's mirror automatically adjusts each of its 36 hexagon-shaped segments to a setting with an accuracy of 30 nanometers—or about 1/1,000th the width of a human hair. According to astronomer Gary Channan, the Keck's ability to focus on distant galaxies is comparable to "aiming 36 rifles at a dime from 50 miles away."

Photo by G. Brad Lewis

To Infinity and Beyond

by Michael S. Malone

In the Spring of 1965, Dr. Gordon Moore pulled out a sheet of logarithmic graph paper and began to plot the complexity of the circuits that had recently been integrated onto slivers of silicon. He noticed that during each of the first few years of the integrated circuit revolution, the number of transistors and resistors that fit onto a chip had nearly doubled, to the point where the newest circuit contained a total of about 60 components. Making the bold extrapolation that this rate of progress would continue in a predictable pattern, he projected that by 1975 microchip complexity would increase a thousand-fold, to some 60,000 components in a single circuit, a prediction that was realized with surprising accuracy.

But Moore's prediction did more than just stun his audience. Moore's Law, as it has been called ever since, had detected the hidden metronome driving the technology age: that the number of transistors on a chip doubles every two years.

If, in 1965, you had known nothing about the forces propelling our civilization except Moore's Law, your predictions about life at the century's end would likely have proven more accurate than with any other combination of indicators. Moore's Law has given us an extraordinary gift: we know how and when the future will arrive.

This remarkably accurate cycle tests existing companies to see if they still have the mettle, and in the process keeps the good ones perpetually young. It revives entrepreneurship, creating openings for new companies led by people with innovative ideas. It instills in the market a willingness to try anything new, and thus creates a demand for the fruits of this biannual revolution.

This cycle has become so refined, so enmeshed in our daily lives, that it has become as omnipresent and as deeply felt as the seasons. Now, the unveiling of a new generation of

▶ TOKYO, JAPAN
No longer the province of science fiction, robots—like WABOT-2, created in 1984 by Ichiro Kato of Waseda University—read sheet music well enough to play simple tunes on an electric organ. On a more practical note, many of the 500,000 so-called "robots that work" worldwide perform dangerous and repetitive tasks on automobile assembly lines, land mine recovery missions and on jobs requiring the cleanup of nuclear waste. Researchers expect that while future anthropomorphic robots will continue to work in conditions that are dangerous to humans, such as underwater and in outer space, they will also be able to perform less risky tasks as well, such as helping out with housework and providing assistance to the growing elderly population.
Photo by Kaku Kurita

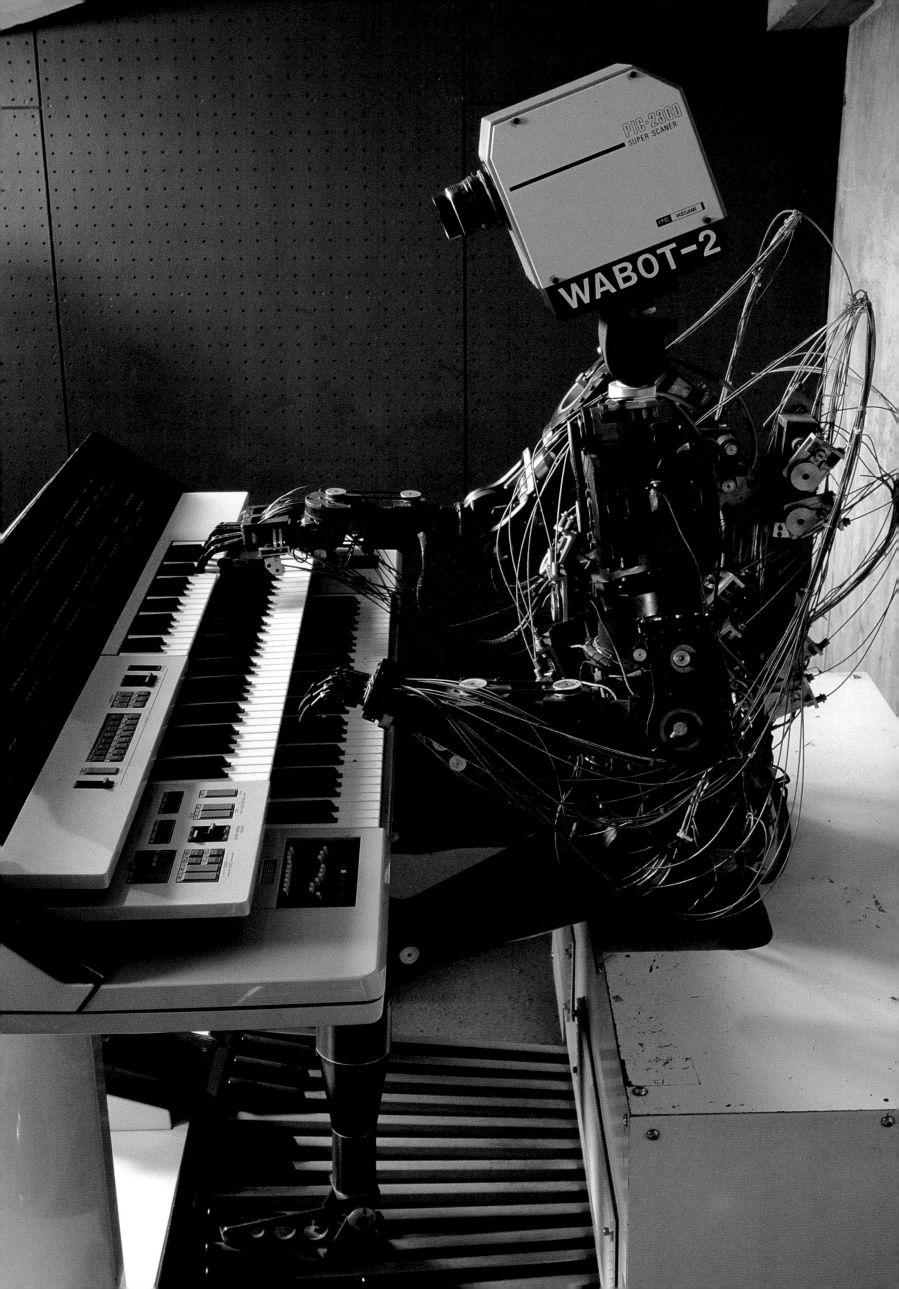

◀ **MANCHESTER, ENGLAND**

The $9 pocket calculators used by school children around the world today have many times more capability than "Baby," the 1,200-pound computer originally built in 1948 at an-adjusted-for-inflation cost of $180,000. The first calculating machine capable of running a program stored in its own memory, Baby runs on switches and glass vacuum tubes rather than on microprocessors or even transistors. If a common desktop computer were designed today using Baby's crude technology, it would cover about 50 acres, or approximately 75 football fields. The original Baby (*below, left*) is being tested and restored to celebrate its 50th birthday in 1998.

Photo by Michael Freeman

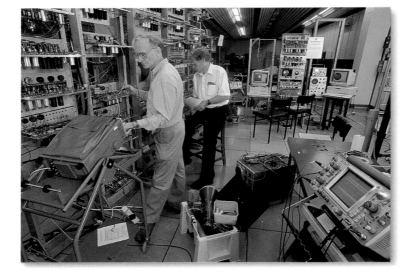

microprocessor is treated like a royal birth, with press conferences serving as the public christening for thrilled onlookers around the world. We now grow impatient if a new application—an operating system, a consumer product, a computer—slips a few months beyond its appointed date.

In September 1997, during an extraordinary week in electronic history, Intel announced that it had found a way to double chip capacity, and IBM proclaimed that it had found a way to plate chips with copper, further increasing their capacity and speed. Within 24 hours, Moore's Law had taken a huge leap. At the semiconductor level, we had just gone from the Sopwith Camel to the P-51 Mustang, and the reaction was: "But, of course."

And perhaps nonchalance is the proper reaction to the rate of change we live with today. For all we know, it's quite possible that everything that has happened since Dr. Moore drew his graph could be merely a prelude before the real symphony begins.

But what a prelude it has been. Today you can buy greeting cards containing processors with more computing power than the world's largest computers in 1971. Microprocessors are so ubiquitous and inexpensive that we now embed them under the skin of our pets, sew them into clothing and attach them to light bulbs, running shoes, ski bindings and jewelry.

That's one side of Moore's Law: hold performance steady and the price falls, so that the most powerful chip of ten years ago costs a fraction of what it once did. But the other side of Moore's Law is equally profound: hold the price steady and

▽ **ALBUQUERQUE, NEW MEXICO**
"It's like breaking the sound barrier," says Intel President Craig Barrett of computing's latest achievement— the teraflop. The world's fastest computer, nicknamed Janus, covers 1,500 square feet at the Sandia National Laboratories; it's powered by more than 9,000 Pentium® Pro processors that work together in a method called Massively Parallel Processing. What does one trillion operations per second mean? Imagine this: every person in the United States would have to work nonstop with a hand calculator for 125 years to equal one teraflop of computation. Numbers aside, the best news about the teraflop-capable system is that it will be used primarily to simulate the effects of nuclear explosions, eliminating the need for live (and ecologically damaging) tests of the powerful warheads.
Photo by Tony O'Brien

Ever since the very first computer was built, the machines have been shrinking—from room size, to refrigerator size, to laptop size, to the fingernail-sized chips that help simplify our lives. Now scientists are intrigued by the promise of an even smaller computer, one made of DNA.

Professors at the University of Rochester are working to develop a computer consisting of DNA strands that could process more information than all of today's supercomputers combined, using only a billionth of the energy of a laptop.

"By the end of this century," says assistant professor Mitsu

Ogihara, seen here examining a DNA chart with colleague Animesh Ray in the background, "we hope to have a simple DNA computer capable of adding two-digit numbers. That may seem like a minor development, but it's an important first step."
Photo by Joe Traver

▶ CAMBRIDGE, MASSACHUSETTS
By the year 2020, scientists estimate that there simply won't be any way to cram more transistors onto a chip made of silicon. So now they're looking at other materials, including fluids like water.

Professor Neil Gershenfeld (*below, right*) of the MIT Media Lab's Physics and Media Group is one of a group of scientists around the world experimenting with possible solutions. Gershenfeld is working with an early prototype of MIT's quantum molecular computer. Radio-frequency signals are used to manipulate the atomic spins in the molecules contained in a fluid. It is possible to do an arbitrary computation using a sequence of pulsing signals radiating from the spinning molecules. Not only does this have the potential to replace chips, but it also may lead to dramatically faster computers.
Photo by Sam Ogden

performance skyrockets. In 1975, the Intel 8080 microprocessor cost about $300. It was powerful enough to run the Altair, the first personal computer. Today, that same price buys a sixth-generation descendant of that chip, a Pentium II processor, with enough power to direct the Pathfinder on its exploration of Mars, generate scenes for a computer-animated motion picture or manage a Web site receiving 10 million hits per day.

Many futurists predict that seven generations from now, the descendants of these chips—for the same price—will construct software agent "avatars" with human characteristics that will act as our personal assistants, helping us shop, planning our days and organizing our lives. These chips will also bring speech recognition to word processors and order-entry systems. They will generate 3-D wall-sized graphics for television, teleconferencing, even custom-made movies. They will direct our vehicles for maximum safety and create virtual worlds we will walk through. They will instruct our children, monitor our health, replace lost body parts and, through a grid of billions of sensors, connect us to the world in ways that we can only dimly imagine.

Will Moore's Law ever tire of its relentless change? Engineers and physicists have often expressed doubts about how long the miracle of Moore's Law can last. And yet, each time we approach a technical wall, it miraculously crumbles.

LEGO® is not what it used to be. Thanks to the "programmable brick," an experiment in toy design at MIT's Media Lab, children can now build robots that dance to music, toy animals that run away from light and cars that race around rooms avoiding the furniture.

Using a simple programming language called LOGO, young children, like the two below building a musical robot with brick inventor Mitchel Resnick, can program the chip-driven toy to perform simple tasks and to respond to sound, light or touch. As the children design their toys, they learn the

Today the concern is over the basic laws of physics themselves: as the alleyways and gates on the surface of the microprocessor shrink to atomic levels, what happens then? Is the atom the final, unsurpassable barrier?

Perhaps, but only to the world of the silicon microprocessor. Already, scientists are making critical breakthroughs in new processor technologies involving everything from quantum switches to growing human neurons on silicon sheets to computers made entirely of DNA strands. These last are, metaphysically at least, the most compelling of all.

Finally, if the optimists' predictions about Moore's Law are correct and we are still only at the beginning of the Microprocessor Age, what does that portend about humankind a century from now? Will our descendants even think like us? Will they view time and space and the world around them in a manner so completely different that they won't even be able to imagine our lives? The one thing we can be sure of is that the world of our children will be as different from today as our world is from that of our grandparents.

basics of computer logic and simple constructs like "if x happens, then run y," hopefully preparing them to compete in a rapidly changing world.
Photo by Sam Ogden

▼ CAMBRIDGE, MASSACHUSETTS

Someday your great-grandchildren will be stunned to learn that there was a time when the clothing people wore didn't have computers woven into the fabric. "How did your house know you were home, Grandma? How did your friends know where you were, Grandpa?" It may sound far-fetched, but just

try explaining to your 12-year-old that your parents couldn't page you to tell you dinner was on the table. Working toward the day when technology is *literally* woven into the fabric of our lives, MIT student Maggie Orth dreams of "wash-and-wear computers," in which the fabric itself—such as the silver cloth behind her head, a natural

conductor—serves as a processor. The shirt might be the keyboard; pockets, tiny disk drives; collars might double as speakers. Orth hopes to have working prototypes of her futuristic and functional fashions within two years.
Photo by Sam Ogden

◀ **SAN FRANCISCO, CALIFORNIA**
Talent meets technology in San Francisco's Multimedia Gulch, where members of the band known as D'CuCKOO practice for an upcoming gig. Band members built their own instruments—each of which features a Musical Instrument Digital Interface, or MIDI, which sparked the age of modern electronic music with its invention in 1983. MIDI helps musicians turn their instruments into anything from a guitar to a tuba with the flick of a switch, and to insert pre-recorded digital music on command. When the self-defined "cybertribal" group performs, audience members bat around a giant MidiBall—jamming with the band with each touch.
Photo by Andy Levin

▲ **SAN FRANCISCO, CALIFORNIA**
Rather than seeming cold and artificial, the display of artist Alan Rath's own face, hand, eye or mouth emanating from a barren cathode ray tube often creates an uncanny lifelike presence—one of the reasons his "video sculptures" are in great demand in the international art world.

An MIT graduate who merged his programming and aesthetic skills, Rath creates sculptures that pose questions for the viewer and reflect his belief that the lag between technological innovation and our ability to cope with its implications creates an unresolved tension that permeates our lives. While in the Industrial Age machines were designed to enhance the power of the physical body—helping us to lift heavier weights, to move faster or to project our voices around the world—in the computer age, our machines amplify the process of thought allowing us to see ourselves and our world in a digital mirror.

Some of Rath's enigmatic pieces, like *Wall Eye IV*, respond to the environment: triggered by an embedded light sensor, the eye closes when darkness falls. Rath's work, which is collected around the world, reflects his belief that art should reflect the age in which it's created. "For me," he says, "using electronics as the raw material for my work is analogous to artists 50 years ago using steel."
Photo by Denise Rocco

▼ **BRONX, NEW YORK**

Like stretching a piece of string between two cans, a series of curvilinear tubes designed on computers by artists Bill and Mary Buchen are allowing kids like Amanda Gonzalez at P.S. 23 to whisper secrets to each other from across the playground. Public schools sprinkled throughout New York City feature the Sight and Sound playgrounds, which also include echo chambers, bronze drums and wind chimes. On a larger scale, Information Age inventors have tackled the noise pollution created by the Industrial Age's technology. Scientists are developing chip-driven devices to create inverse sound waves on jetliners and factory floors, canceling out the deafening roar. For the consumer market, top-flight headphone companies are testing earphones based on the same principle, capable of analyzing ambient noise and generating "anti-noise" to block it out.

Photo by Misha Erwitt

innovators such as Michael Bloomberg, Jeff Bezos and Bill Warner used technology to compete in business arenas dominated by billion-dollar companies. As brash upstarts they each relied on the ability of computers to leverage their ideas and created services that larger, more established competitors weren't providing. In every corner of the world, thousands of entrepreneurs are hard at work stoking the world's economy as they convert their dreams into marketable realities.

▲ LEXINGTON, MASSACHUSETTS
Your phone rings and a friendly, efficient voice reminds you that you have a meeting in 10 minutes. She tells you there are five new messages, plays them for you and connects you directly with the callers. While you are returning calls, your assistant comes on the line and whispers in your ear that your son needs to speak with you urgently—a message only you can hear. It may sound like the perfect assistant, but it's actually an "intelligent agent" named Wildfire, a piece of software that lives on the phone network and helps manage the average 60 phone calls a day made by many business executives.

Wildfire was invented by Bill Warner, the man who revolutionized the editing of movies and TV programs in the mid-eighties with his Avid digital video-editing system. Now Warner is back, running circles around bigger companies that have labored for years to bring voice recognition and computer intelligence to the telephone. Today companies like Pacific Bell are licensing Wildfire's technology and offering it as part of their new PCS cellular phone service.

Says Warner, "Years ago, you picked up the phone and were greeted by a friendly hometown operator who knew you and the people you called most often. Someday soon dial tone will be a thing of the past, and when you pick up your phone, you'll hear Wildfire say, "What can I do for you?"
Photo by Seth Resnick

▲ LONDON, ENGLAND
Too much information is as useless as none at all, according to the man who, 15 years ago, saw an opportunity to use computers to create order out of chaos. Michael Bloomberg credits the success of his Bloomberg News, a wire service with 70 worldwide bureaus, to taking data that is publicly available and making sense of it, organizing it for people who don't have time to condense it themselves.

Every year more than 75,000 stock analysts, money managers and journalists subscribe to Bloomberg's financial news service, paying $1,200 a month for the lightning-fast news and analysis that come from the dedicated computer terminals bearing his name.

In his obsessive quest to slice and dice information, Bloomberg has also successfully launched Bloomberg Radio, Bloomberg Information Television, two Bloomberg magazines, Bloomberg Press and most recently Bloomberg Online.

Although his media empire is third behind Reuters and Dow Jones, many believe the name Bloomberg already carries the same cachet as the names of media moguls Ted Turner and Rupert Murdoch.
Photo by David Modell

▲ SEATTLE, WASHINGTON

It reads like the story of David and Goliath. Jeff Bezos, 29 years old, quits his job on Wall Street, packs up his possessions and heads West with his wife, MacKenzie, not sure where they will live or what they will do. Along the way he writes a business plan based on his belief that rather than replacing books, the Internet is the place to sell books. He decides to create a virtual bookstore, the largest in the world. He names it Amazon.com after the world's largest river, and in a matter of months, Bezos is featured on the front page of *The Wall Street Journal* for pioneering commerce on the Net. Since Bezos has no retail store, his costs are low and he offers best-selling books at 20 to 40 percent discounts. Aside from 2.5 million books, the Amazon site provides services unique to the Web, such as book reviews written by customers, pointers to similar books based on previous purchases and an automatic e-mail service that alerts book lovers to new releases in their areas of interest.

Bezos takes Amazon public in March of 1997. Seven months after the IPO, the stock more than triples and the company is valued at more than $1.4 billion. Finally, the sleeping giants of the retail book world wake up and go head-to-head with the tiny start-up. The next chapter is yet to be written....
Photo by Natalie Fobes

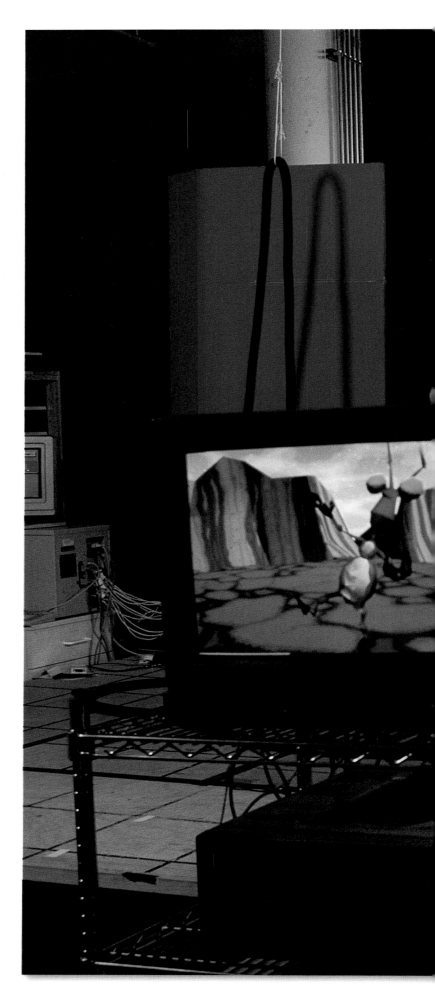

▲ LONDON, ENGLAND

Techno-magician of the silver screen, George Lucas is behind the camera for the first time in 20 years, directing the first in a series of three "prequels" to his *Star Wars* trilogy. Beginning with *Star Wars* in 1977, Lucas forever changed the field of computer-generated special effects with his company, Industrial Light and Magic. Some of the top-grossing movies of all time, including *ET, Raiders of the Lost Ark* and *Jurassic Park,* were made possible by the technology at ILM. Now, more than 70 percent of all full-length feature films incorporate digital effects. Lucas also created the first nonlinear editing system, EditDroid, which laid the groundwork for today's digital systems. "I haven't used an editing machine with film on sprocket holes for eight years now," noted Lucas in an interview with *Wired* magazine. "I don't think I could do it. It would be like going back and scratching things on rocks."
Photo by Keith Hamshere

▷ SAN FRANCISCO, CALIFORNIA

Like a puppeteer pulling a marionette's strings, "performance animator" Emre Yilmaz wears a bodysuit laden with sensors to create the on-screen movements of Reginald the Bug. A tracking computer in Protozoa's studio follows each of Yilmaz's movements, which are then digitized by a second computer running graphics software. Animated features of old required more than 20,000 drawings for every 15 minutes on screen. With performance animation, 15 minutes on screen can be created in…15 minutes.
Photo by Andy Levin

▶ **HOLLYWOOD, CALIFORNIA**
Five years in the making, the Jurassic Park River Adventure takes moviemaking to the next level—a theme park ride reminiscent of a film's most memorable scenes. Scot Burklin helps oversee the ride at Universal Studios, where fully automated, "animatronic" dinosaurs roar, lunge and even spit at riders in passing boats. Paleontologists, robotics engineers and $100 million helped Universal translate the illusion of the movies to a realistic five-and-a-half minute ride.
Photo by Dana Fineman-Appel

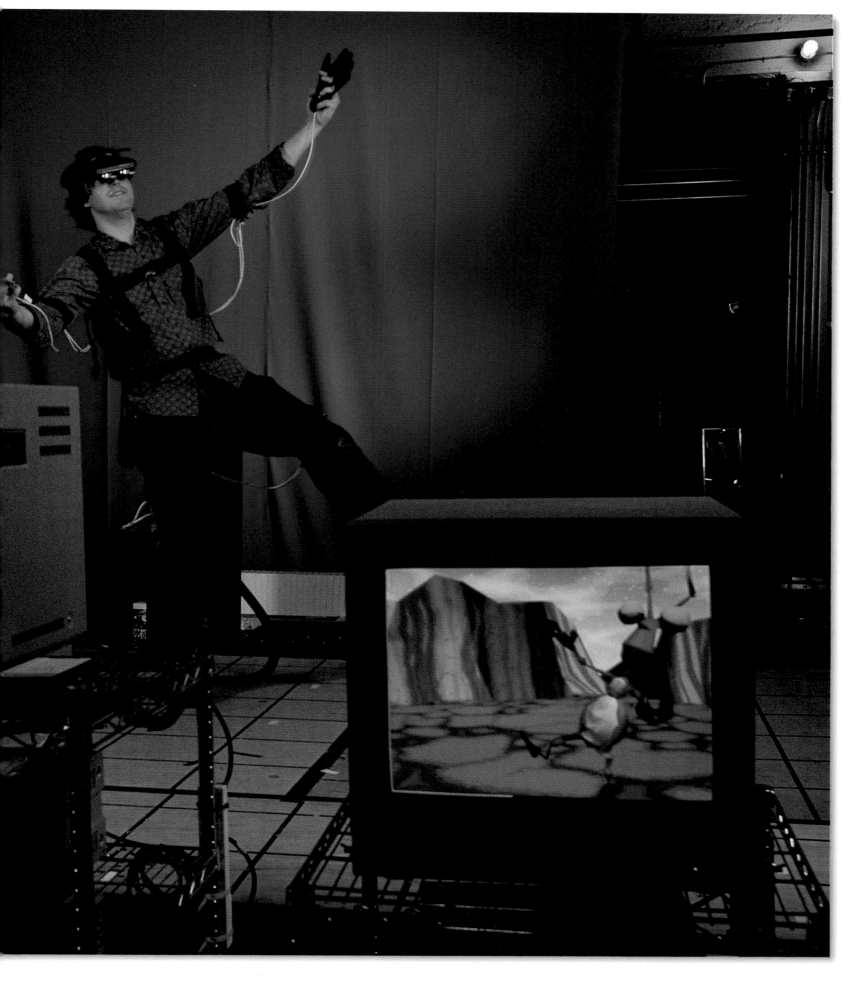

◀ **BRISTOL, CONNECTICUT**
Roller coasters past and present stand side-by-side at Lake Compounce, the nation's oldest amusement park. The wooden Wildcat in the background, built in 1927, relies entirely on gravity and momentum for its power, once a chain pulls it to its first peak. Skid brakes are used to bring the 45-m.p.h. ride to a stop. Zoomerang, built in 1997, relies on computers to start, power and stop the ride. Nervous riders are calmed by knowing that the Zoomerang is rigged with a series of sensors that monitor the location of the train and bring it to a stop at the nearest braking point, should any problems arise.
Photo by Bradley E. Clift

▲ **LINZ, AUSTRIA**
Superman no longer has the air to himself. Flying through the nighttime sky, a visitor to a virtual reality center dives and soars effortlessly over the cities and countryside, thanks to a computer-driven flight simulator. Reacting in real time to the position of her arms and the position of her body, the computer in the visitor's backpack generates and projects a 3-D wraparound image on her goggles, giving her the illusion that she really is able to fly like a bird.

By the time this flier's grandchildren are ready to visit their first amusement park, the entertainment may be no further away than their telephones or computers. Virtual attractions will someday exist solely in high-speed computers and will no doubt be customizable for each user. Since the "rides" won't have any physical parts, they'll be much cheaper to build and safer to ride than today's roller coasters and Ferris wheels.
Photo by Lois Lammerhuber

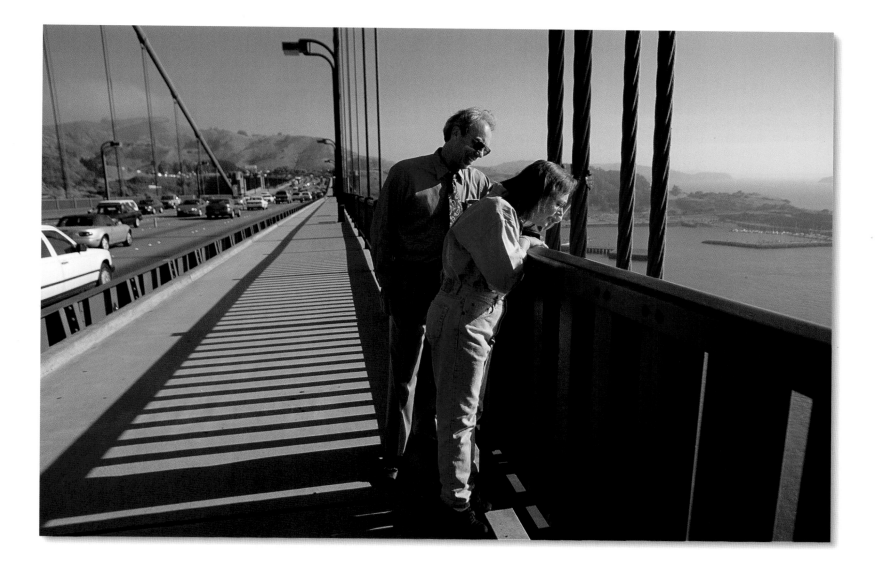

◀ ▲ SAN FRANCISCO, CALIFORNIA
Palms no longer sweaty, throat no longer gripped by panic, Barbara Teixera peeks over the edge of the Golden Gate Bridge at the rolling Pacific Ocean 250 feet below. Until recently she wouldn't have dared look: she suffers from acrophobia, the terror of heights that keeps people from climbing ladders, riding in ski lifts and glass-enclosed elevators or even walking across elevated bridges. Teixera vanquished her fear with virtual reality, using a simulated 3-D environment created by computer, to work up her courage before stepping out onto the real bridge.

Her guide, psychologist Ralph Lamson, was an acrophobic himself until discovering a virtual reality exhibit at a technology fair in 1993. Unexpectedly trapped in a virtual tall building, with virtual floor-to-ceiling windows, Lamson remembered that what he was "seeing" wasn't real and looked down, surprisingly fear-free. Cured of his own phobia, Lamson now puts patients in virtual simulations of their worst fears (*left*), talking them through their fright as he follows along on a television screen and monitors their heart rate and blood pressure. Lamson says most acrophobics begin to conquer their lifelong fear in

one or two 50-minute sessions— drastically different from the months, even years, of intense cognitive or behavioral therapy traditionally used to treat phobias.

Lamson plans to expand his "virtual therapy" to sufferers of claustrophobia, obsessive-compulsive disorder, fear of public speaking and agoraphobia (the fear of leaving the house). Teixera, for one, is a believer: "Before this treatment," she says, "there's no way I could have even walked across the bridge—much less looked over the edge."
Photos by Charles O'Rear

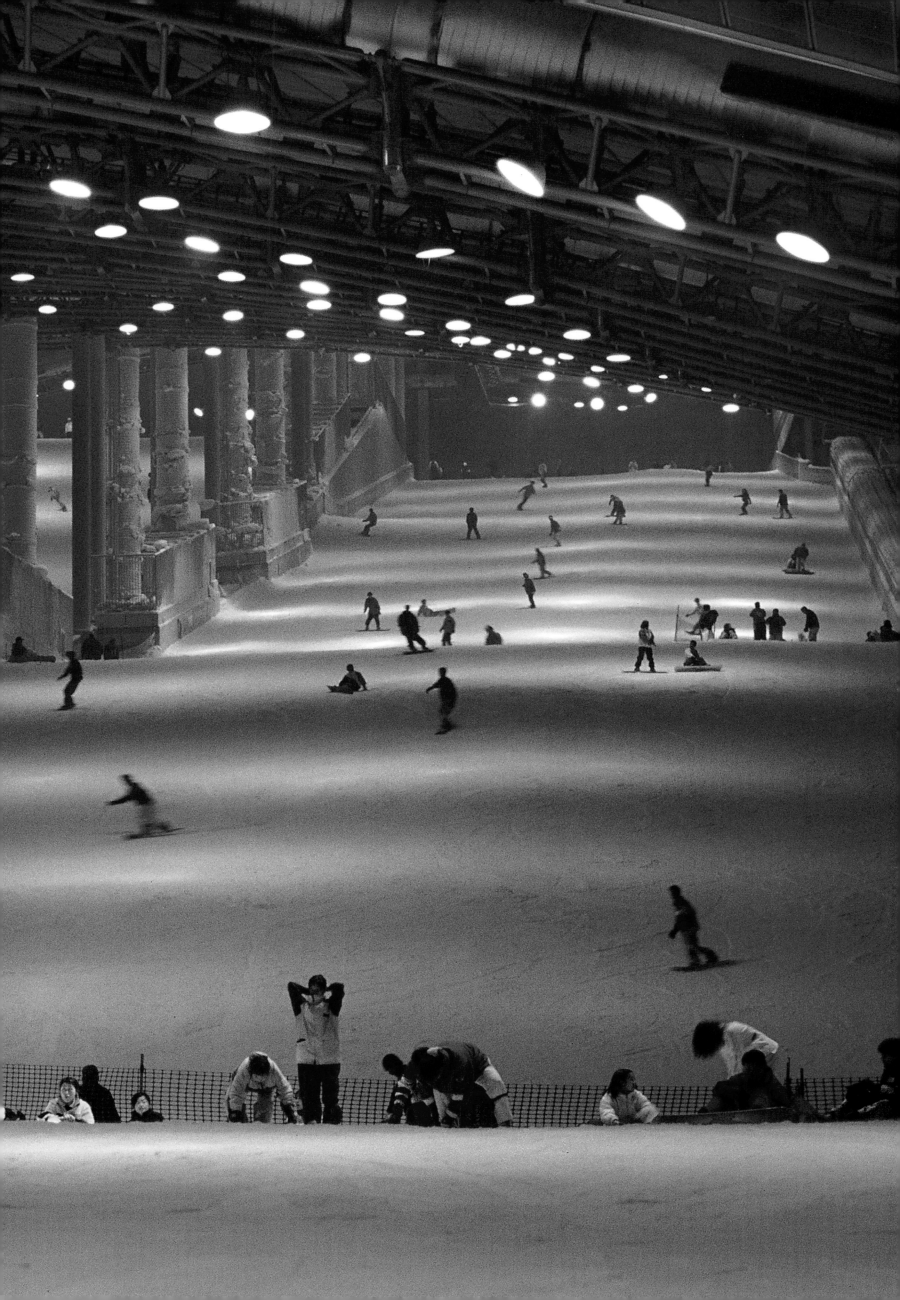

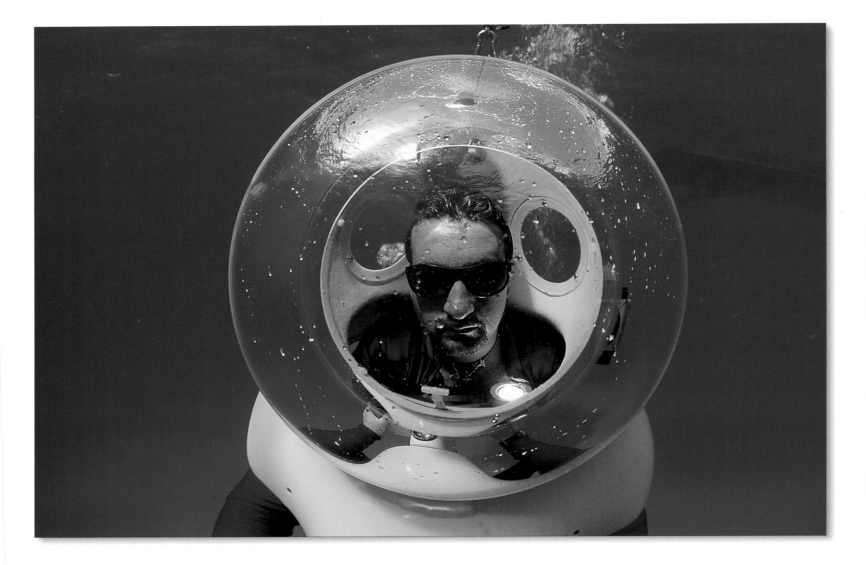

◀ FUNABASHI CITY, JAPAN
It's winter all year round for ski buffs who don't want to spend hours in traffic getting to the slopes. Just outside of Tokyo there is now a computer-driven indoor winter sports facility—the largest in the world. Built inside a building as tall as the Statue of Liberty, SSAWS uses microprocessors to keep the snow falling, the lifts running and the temperature at a cool 26°F. Skiers and snowboarders carry magnetically encoded debit check cards that calculate only the time they actually spend on the slopes and charge them

accordingly. The cards also allow visitors to charge all their meals, souvenirs and equipment rentals. Sure, the system is cool, but powder junkies looking for a quick fix come for the runs: 490-meters long with an 80-meter drop.
Photo by Torin Boyd

▲ ▶ BIMINI ISLAND, BAHAMAS
Sea Hunt was never like this. Off Bimini Island, master scuba diver Bob Cohen takes an underwater scooter drive with the Breathing Observation Bubble (BOB). Only certified divers can operate the BOB, which pipes air from a tank under the handlebars into an acrylic dome—replacing a diver's face mask and breathing apparatus. Wireless technology lets riders talk to other BOBsters darting through the water nearby, as well as to armchair divers above in a boat or back on shore. Their

energy saved from not having to kick, divers can stay submerged almost an hour with the BOB. Like most modern scuba gear, the BOB features a computer that tells riders when to come up and calculates decompression times for a safe return to the surface. The Kuwaiti military has had their own fleet of BOBs built for harbor patrol, customized in navy blue, with speargun racks and wireless communications devices built in.
Photos by David Doubilet

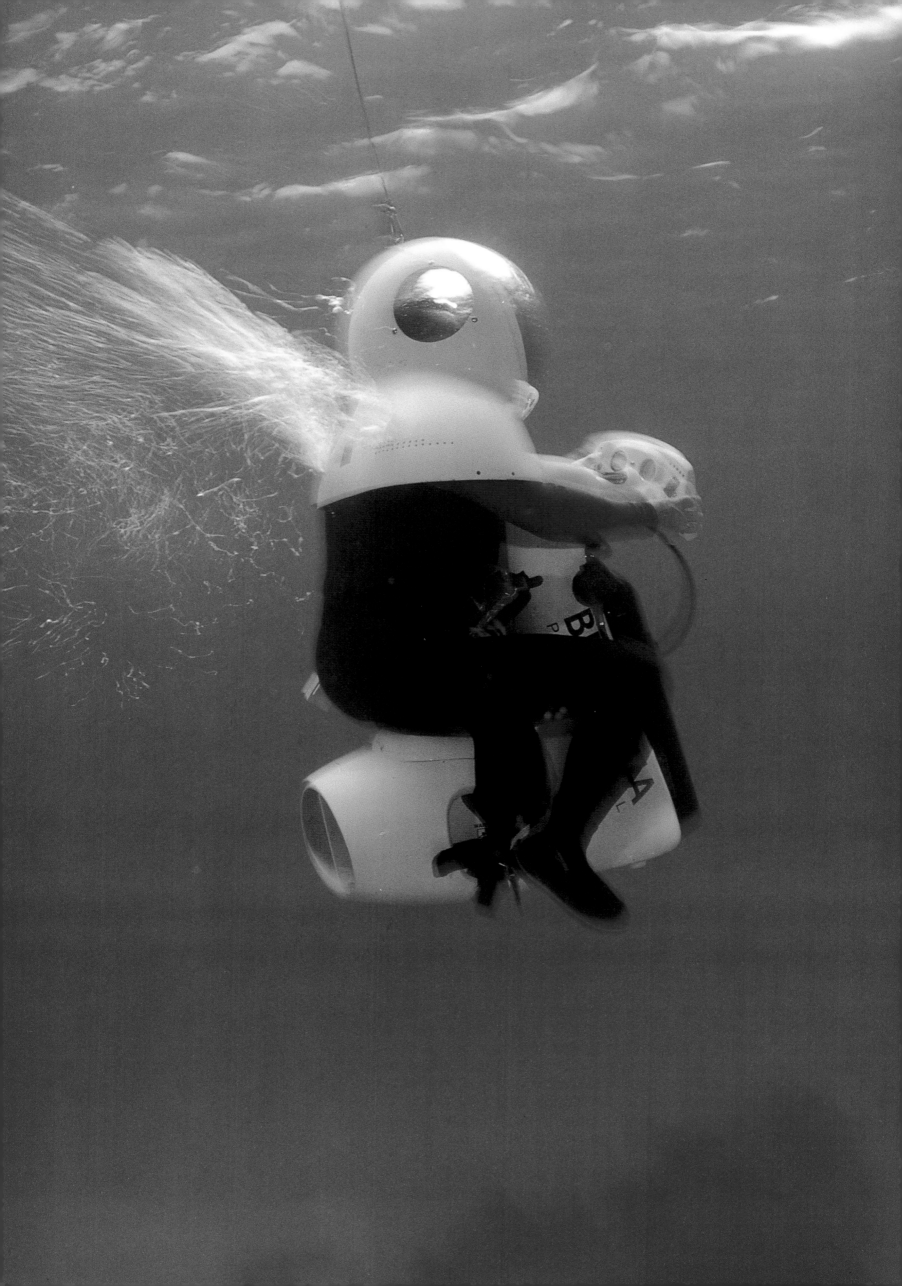

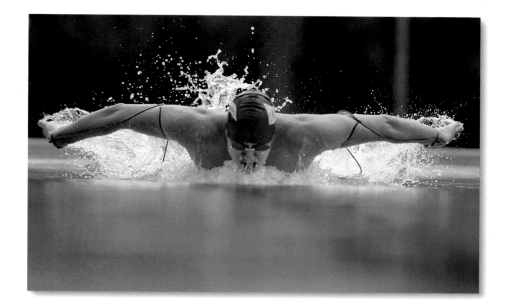

When a split second spells the difference between victory and defeat, swimmers looking for an edge over the competition can now use tiny half-ounce sensors that give them instant feedback on their power and their stroke rate, length and velocity. Tethered by a 60-foot wire to a poolside computer, athletes like Florida state champion Tyler Townsend train under the watchful eyes of their coaches, who carefully study real-time performance graphs generated by the PC. The Aquanex system, devised by Dr. Rod Havriluk, allows coaches and swimmers to analyze almost imperceptible nuances in a swimmer's stroke. After graphing Townsend's style in the two events, Havriluk found that, unlike most swimmers, the champion swimmer generates more arm power in his butterfly than in his freestyle. "If he learns to apply that strength to his freestyle," says Havriluk, "he'll almost certainly decrease his time."

Photos by Bill Frakes

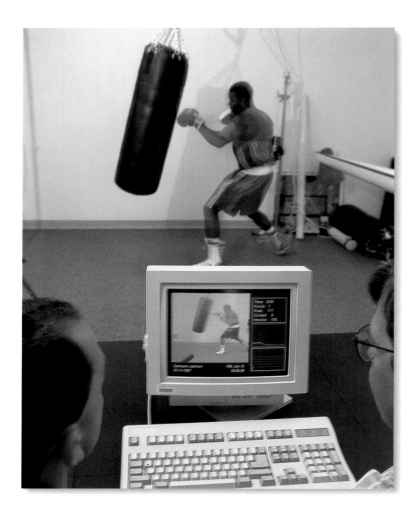

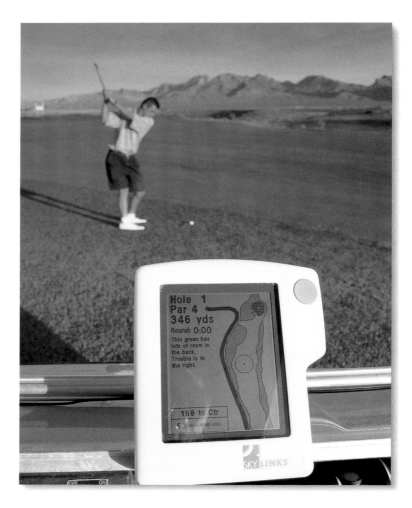

▲ COLORADO SPRINGS, COLORADO

This punching bag is anything but passive. Pummeling the smartest punching bag on earth, Olympic boxer Kerry Deshawn Jackson works out at the United States Olympic Training Center, where about 350 athletes train daily. The bag, designed by the center's Thomas Westenburg, is outfitted with a sensor designed to gauge the force of a pugilist's punches. The information is graphed on a computer along with a video of the training session, so that a boxer studying his performance later can see each punch—and analyze its technique—while simultaneously measuring its power.
Photo by Jay Dickman

▲ LAS VEGAS, NEVADA

Pastoral and timeless, golf is nonetheless getting its day in the high-tech sun. Busy golfers in many cities can visit a downtown health club and play a virtual round. And those who do make it out to the course find technology has come along for the ride. Video screens mounted on carts at the Badlands Country Club display course information as a golfer moves from hole to hole—especially helpful for those playing the course for the first time. Back at the pro shop, course managers use SkyLink's Global Positioning System to track every cart out on the links, sending e-mail to a cart's screen to deliver personal messages or to ask dawdlers to speed up. Marketers love the screens, using them to place advertisements to the captive and often affluent audience.
Photo by David Hiser

▶ FAR HILLS, NEW JERSEY

The U.S. Golf Association makes sure that new gear meets their stringent standards. At the USGA Research and Test Center in New Jersey, cameras record the light that bounces off the 28 reflectors on Bryan Marks' body as he swings. The information gathered from the cameras is used to render a 3-D model, which is used to measure the force the club places on the body's joints—information needed for any new club seeking the USGA seal of approval. Before purchasing the latest iron, players might want to heed the words of Frank Thomas, director of the test lab: "You can't buy your game. With all of our high-tech testing we've found that you're much better off practicing than buying a new piece of equipment."
Photo by Stephanie Maze

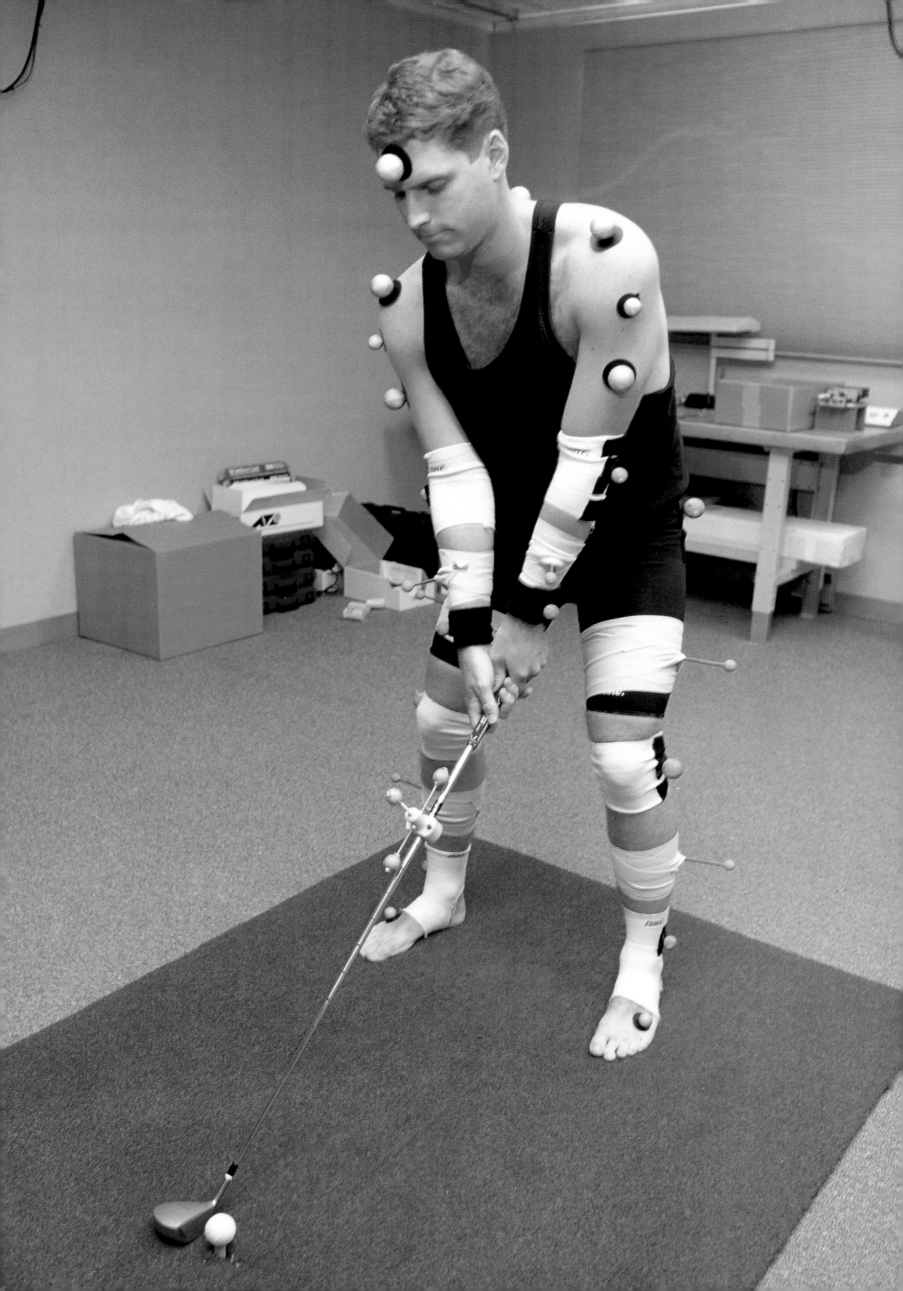

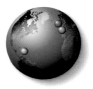

▲ **MANCHESTER, ENGLAND**

The word "javelin" comes from the Irish term for "forked stick," which raises the question: what's the Irish word for a "forked stick with a computer inside?" While this javelin doesn't really have a full, built-in computer, it does have a half-ounce force meter that sends signals via a guitar pickup to a laptop. The force meter measures acceleration 2,000 times a second, allowing javelin tossers to gauge their power and hone their technique. Co-inventor Tim McKee, checking the computer at Metropolitan University while Sean Burgess throws, says he's developing ways to use the force meter with other ancient sports, such as the hammer throw, the discus and the shot put. Track and field rules limit the device's use to practice sessions, but someday, if it's ever approved for competition, the "smart javelin" could be used to provide sports fans with even more statistics to chew on.

Photo by Michael Freeman

▷ **MAYAGUEZ, PUERTO RICO**

Judging the graceful gait of a Paso Fino or "refined gait" horse is no longer a matter of opinion. The movement of these rare show horses (only 5,000 remain on the island) has traditionally been evaluated visually and by the measured sound the animals make as they step. A new device created by researchers at the University of Puerto Rico allows breeders and judges at horse competitions to now evaluate the horses electronically.

As a horse walks across a plank laced with sensors, the hand-held device analyzes the horse's step. The device is used for training riders, for educating judges and for making breeding determinations.

Photo by Héctor Méndez-Caratini

▷▷ **BIRMINGHAM, ENGLAND**

Precise timing sensors are built into the starting blocks at an international track meet in Birmingham, England. The goal: to guarantee an equal start by the sprinters, while improving spectators' sight lines since the track is cleared of electronic cameras and other timing devices. A microprocessor in the sensors monitors minute changes in foot pressure to time each sprinter's departure; individual speakers in each block amplify the sound of the starter's gun, eliminating the miniscule advantage gained by being closer to the gun.

Photo by Mike Hewitt

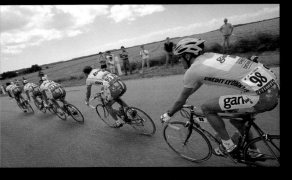
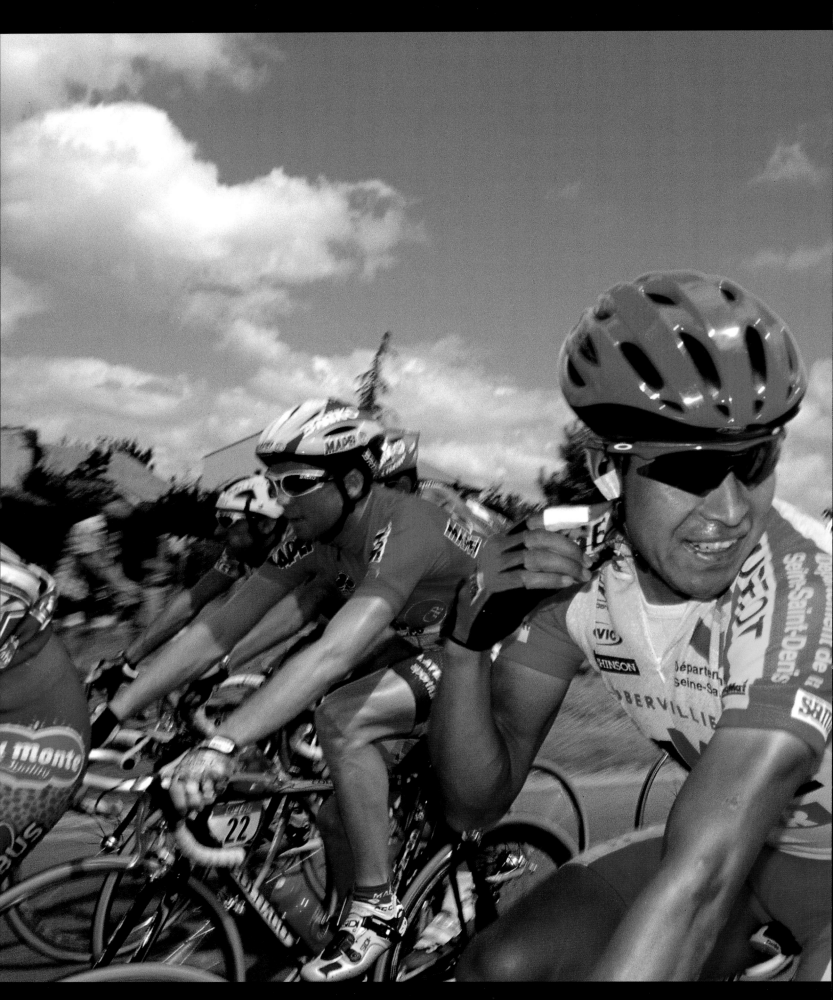

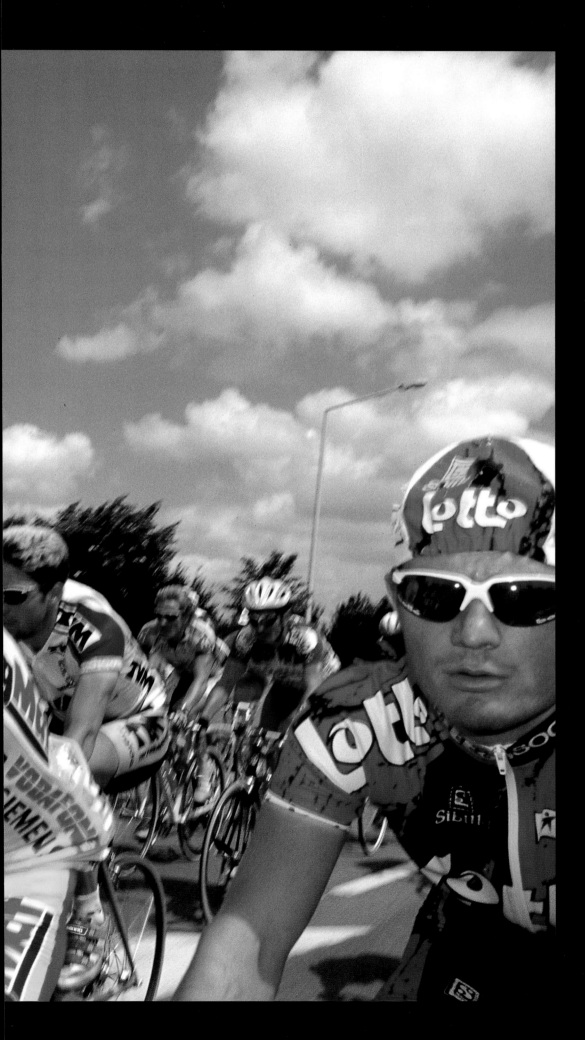

Racing into the Future

Wind at their backs and technology on their wrists, the world's premier cyclists speed through the Bordeaux countryside in the annual *Tour de France*. In their quest to win the coveted yellow jersey, worn each day by the race leader (*above, left*), riders like Mexico's Miguel Arroyo (*left*) use tiny wireless earpieces to hear instructions from their coach and ultra-light heart monitors with digital displays on their wristwatches. While training for the historic 2,000-mile race, first held in 1903, many cyclists use an elaborate series of body sensors to transmit information about their pulse and exertion rates to eager coaches monitoring their progress from laptop computers in the backseats of vans. During the race, online cycling fans wired to the World Wide Web can now follow the 21-day race minute-by-minute from anywhere in the world. It's part of a growing trend in sports and adventure, especially for events that don't attract live television coverage. As one sports entrepreneur put it, "With the Internet as our stadium, we can have an audience of millions."

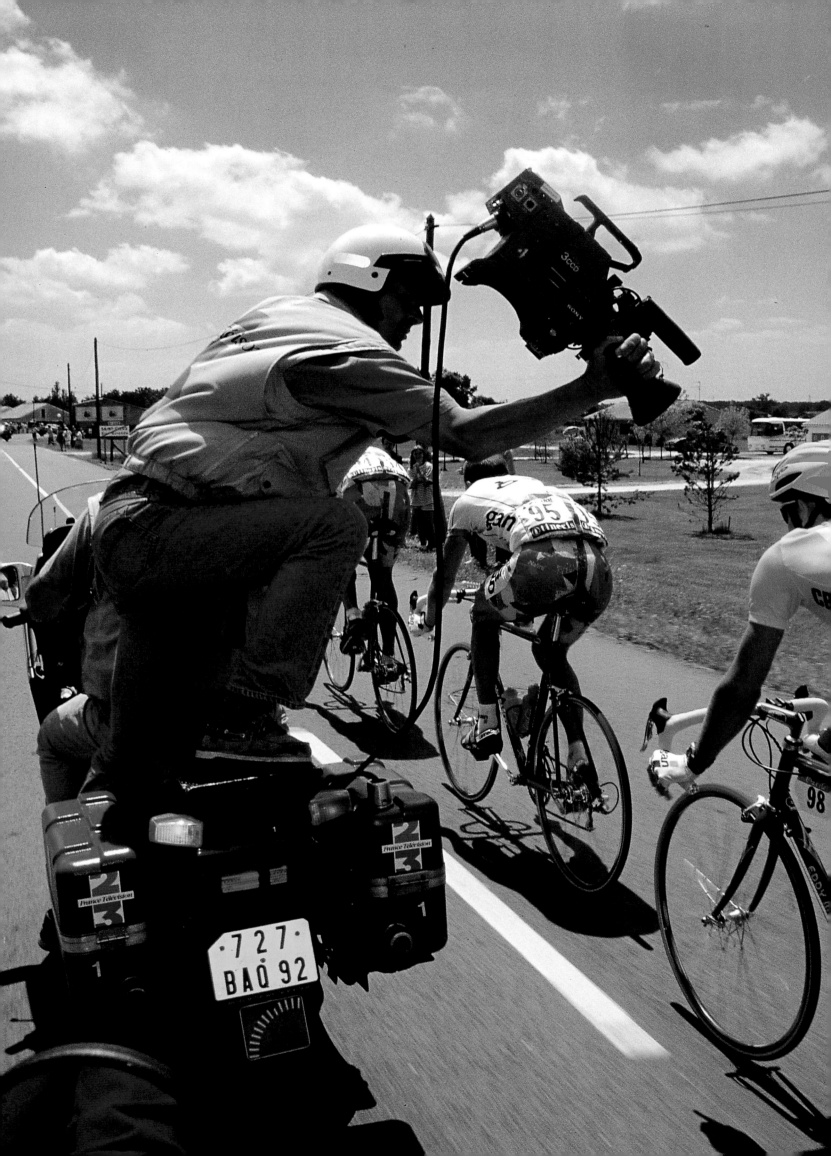

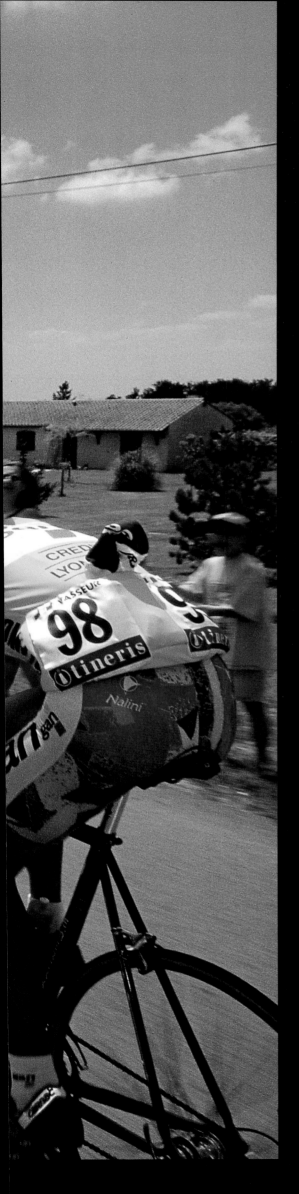

Videographers (*left*) and mobile computing operators (*above*) upload race information to more than 20 Web sites. Cycling aficionados who visit the official *Tour de France* site (www.letour.com) can download maps and images of the terrain of each day's course, as well as up-to-the-minute positions of each rider. A database offers information on specific teams, plus the individual 198 riders in the race, as well as the history of France's most beloved sporting event.

Sports-related sites are among the Web's most popular, led by Starwave's ESPNet. Events that unfold over several days with an ever-changing locale, such as the *Tour de France*, are ideal for Web coverage, as are adventure events held in remote places such as the North Pole or Mt. Everest. In the multiday race known as Eco-Challenge, teams race through jungles, down rivers and over mountains to see who can cross the terrain the fastest, using a combination of mountaineering, hiking, horseback riding and whitewater rafting. A site reporting on the 1997 race, held in Australia, pulled in an average of 150,000 hits daily for the 11-day competition.

Photos by Michel Deschamps

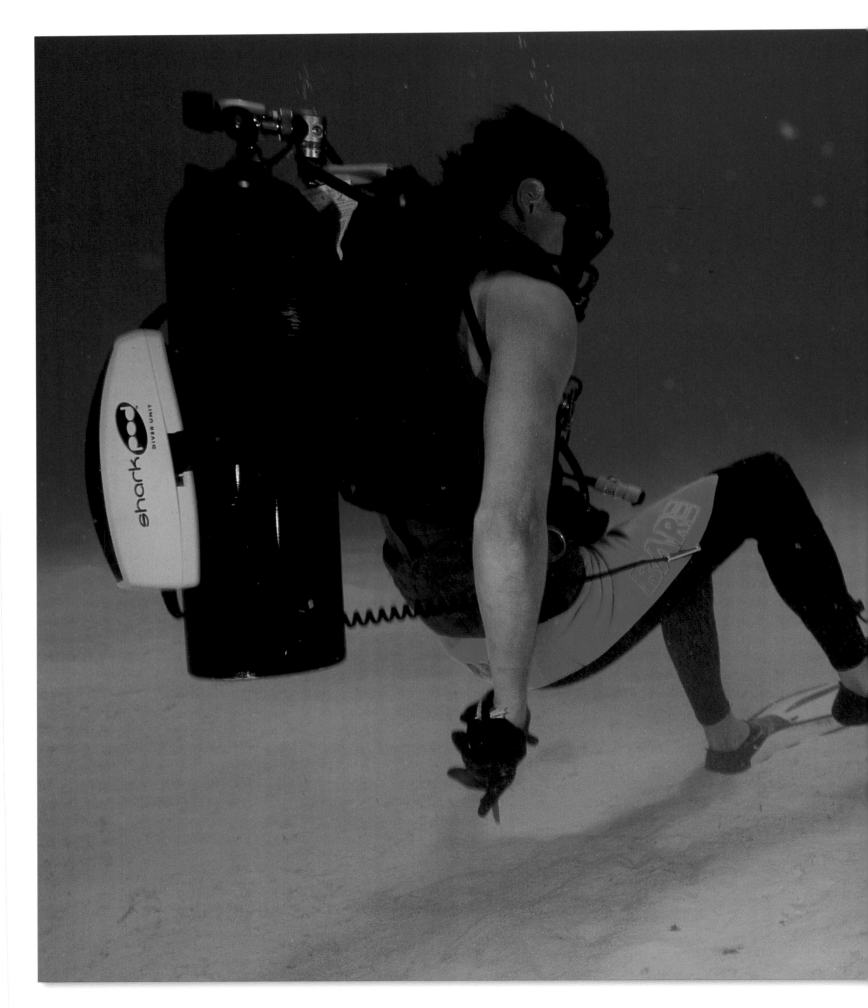

◀ **BIMINI ISLAND, BAHAMAS**
Electro-shark therapy keeps an underwater predator at bay. Originally developed in South Africa to protect divers in treacherous waters, a microchip in the diver's backpack activates two electrodes—one on the diver's back, and one attached to his fin—to generate a 92-volt force field. The pulsing charge repels sharks to a distance of 21 feet because of their hypersensitivity to naturally occurring electrical fields (which help them navigate). In the past, the only protection for divers was a one-bullet waterproof shotgun. Now divers and sharks can co-exist. The long-term goal is to replace the chain-link shark nets along South Africa's popular Natal Coast beaches, which currently entangle and kill more than 1,000 sharks a year, with a large-scale electronic force field that will repel sharks without causing harm.
Photo by David Doubilet

▲ **SAN FRANCISCO, CALIFORNIA**
Take one, and the pill will call your doctor in the morning. MIT student Bradley Geilfuss, a guinea pig for human endurance, prepares to swallow a radio transmitter that will send information about his metabolism via wireless modem to fellow students during his participation in the San Francisco Marathon.

By the time the race begins, the transmitter will have worked its way to Bradley's intestinal tract and will be ready to measure and transmit his body temperature, heart rate and other vital signs. In addition to the pill, there is a GPS receiver on his shoulder, a heart monitor strapped to his chest, a computer and cellular modem hidden in a fanny pack and even accelerometers in his shoelaces to count his footsteps. Despite the extra weight, Geilfuss finished the marathon in under five hours.
Photo by Denise Rocco

◀ ▲ SAN FRANCISCO, CALIFORNIA Live tonight, on the Internet, it's… kick-boxing? In cyberspace the name of the game is attracting eyeballs. And with the emergence of the Web as a true entertainment medium successfully competing against TV, video rentals and the movies, cyberpromoters are always looking for new ways to attract visitors to their sites. Web events have ranged from President Clinton's inauguration, to the Mars Pathfinder exploration, to even a Psychic Drag Queen Festival hosted by the late Allen Ginsberg.

The jury is still out as to whether a live sports event held in an unlikely location like a cyber-cafe will really ever become the *Seinfeld* of the Internet, but the Web is going through the same kind of experimental stage characteristic of all emerging media.

Each time a new medium is invented, it often imitates the medium that came before: early radio simply put vaudeville shows and live concerts on the air, and early movies were merely stage plays filmed from the perspective of the audience. And in these young days of the Web, TV is a model—though not the only one—as entrepreneurs cast about to find ways to attract an audience.

At Internet Alfredo, which bills itself as "San Francisco's first and only 24-hour cybercafe," a webcam captures the action and sends real-time images of the kick-boxing match to a site on the World Wide Web. After the bout, cafe owner Alfredo Lusa conducts an interview with boxer Alex Fairtex, which is broadcast live over the Web. The feet don't fly every night at the Alfredo, where visitors typically come to rent time on computer workstations, scanners and CD burners—or just to hang out.
Photos by Andy Levin

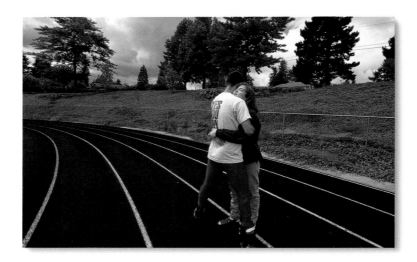

▲ ▶ LACEY, WASHINGTON

Tony Volpentest has been hailed as one of the world's fastest men by Olympic gold medal sprinter Michael Johnson. Born with no hands, no feet, and only partially formed arms and legs, Volpentest runs the 100 meters only 1.5 seconds under the world record. The future of athletic competition may one day include head-to-head contests between athletes like Johnson and Volpentest. The world record holder in the 100 meters for disabled athletes, Volpentest (*above*), embraces his wife Alison before flying down the track.

Many ultra-light artificial arms and legs are already being designed and manufactured with the help of sophisticated computer modeling programs similar to those used by engineers to reduce wind shear on airplanes. That raises a bionic philosophical question for the twenty-first century: will disabled athletes, using the latest in computer-created equipment to help them compete, actually have an advantage over their able-bodied counterparts?
Photos by Natalie Fobes

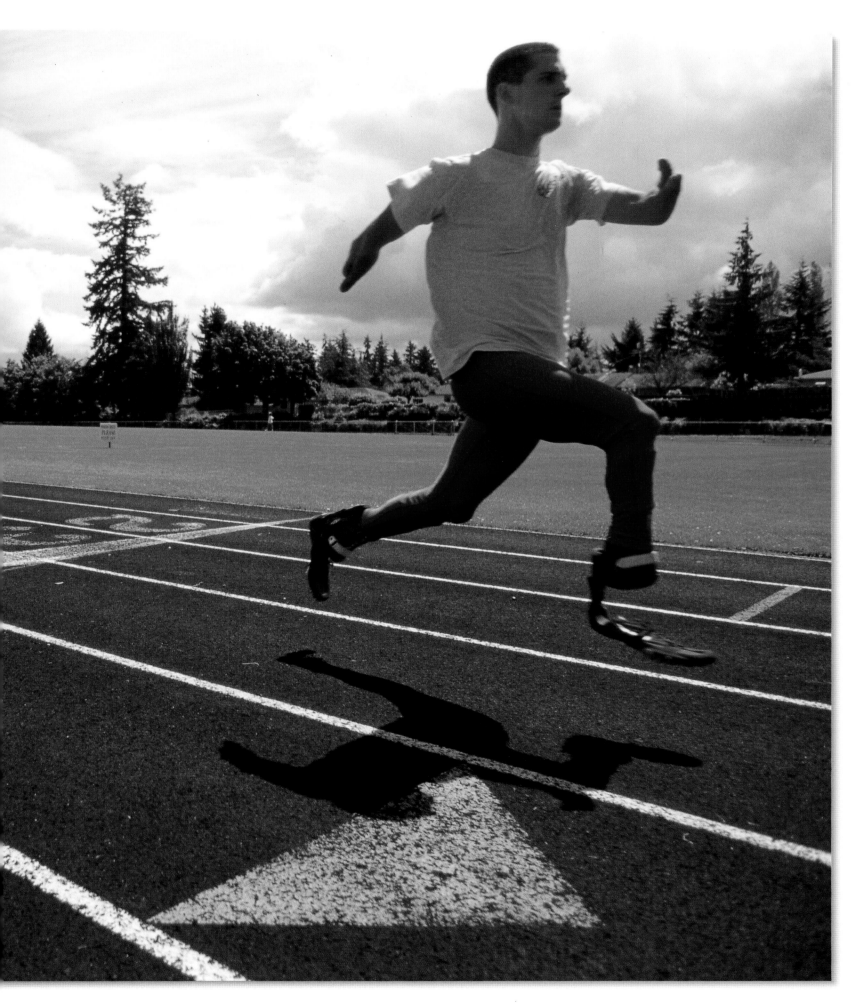

A Whole New Ball Game

Invented in the nineteenth century, base-ball is barreling full steam ahead into the twenty-first, with technology providing baseball fans with new ways to experience the game. Atlanta's Turner Field showcases many of baseball's most exciting high-tech features—no surprise, perhaps, for a team owned by media pioneer Ted Turner. The news from Georgia is clear: as our national pastime moves into the next century, it's going to be a whole new ball game.

When fans arrive at the stadium,

they're greeted by a 22-by-16-foot video screen, where Braves players—in this case, pitcher Pedro Borbon—are interviewed live by fans in the plaza. Two camera crews (*previous page*) transmit the fans' questions to the players in the clubhouse, where another camera sends back their responses. Inside the stadium, video screens allow fans who've left their seats to keep up with the action or even to watch games being played in other cities. On the way back from the hotdog stand, fans can stop in Scout's Alley, a collection of touch-screen kiosks and computer games that test the user's knowledge of baseball techniques and history. But hungry fans who don't want to miss a single pitch never have to go to the hotdog stand in the first place: concessionaires roam the stands with hand-held computers, taking personalized food orders.

Turner Field represents a growing trend in sports and entertainment to transform fans from passive spectators to active participants. The stadium of the future will likely have terminals at each seat to access either the Internet or a ball-park-only intranet, so that fans can call up specific statistics at a moment's notice.

While the game unfolds, some of the stadium's most important players are at work underneath the stands and high up in a video control room. To minimize the possibility of rain delays, Turner Field boasts an automated turf drainage system that monitors ground moisture and will automatically begin draining the field when necessary.

In the Turner Field control room (*top, right*) technicians coordinate the text, audio and video to be transmitted to the giant screens overlooking the field as well

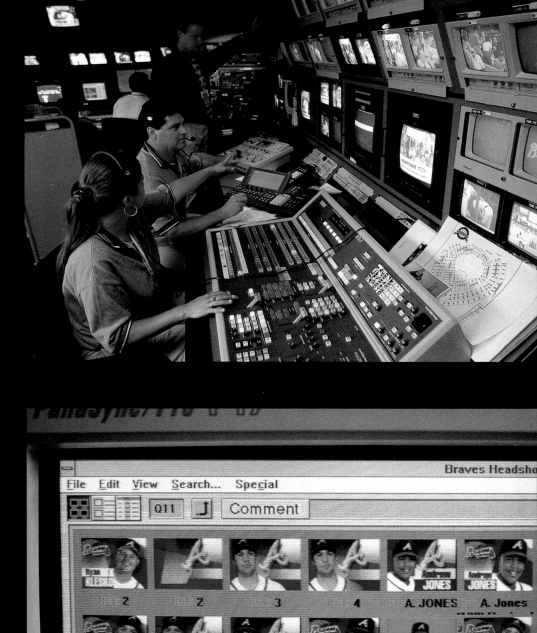

as to the screen at the entry plaza. When a player comes to bat, operators select a head shot (*above, right*) to accompany the statistics flashed on the scoreboard. A radar gun is used to calculate the ball's speed (*bottom, right*). Should he hit a home run, the touch of a button sets off an automated fireworks show that shoots out from above left field.

During the game in the Braves' dugout, manager Bobby Cox (*left*) studies computer printouts of the weaknesses and strengths of his players and those of the opposition. Every possible match-up is charted: the printout tells him, for example, how each of his batters has fared in the past against each of the opposition's pitchers. The printout also includes overall information about the opposing team, including how a certain player's tendencies may have changed in recent weeks. Managers may still make decisions based on gut instincts, but they now have access to myriad quantitative data against which to measure their hunches.
Photos by Larry C. Price

The Ultimate Time Machine

by Michael S. Malone

▶ WASHINGTON D.C.

It's 1:00 A.M. in the morning, your thesis is due at 9:00 A.M., and you suddenly realize you need to know the contents of Abraham Lincoln's pockets the night he was assassinated. The bookstores are closed, and the library down the street doesn't open until 10:00 A.M. The solution? You simply reach your hand through your computer and let your fingers walk you into the online collection of the Library of Congress. A moment later, much faster than if you were in the National Library itself, you are looking at a photograph of Lincoln's spectacles, his pocketknife, his linen handkerchief, a $5 Confederate note and the newspaper clippings that he carried in his leather wallet.

Although there's no substitute for actually visiting the stately reading room of the Library of Congress (*right*), the Library's World Wide Web site stays open 24 hours a day, allowing you to do research in your pajamas without ever standing in line. Hundreds of people around the world can consult the same document at the same time. Digitizing fragile historical records is also preserving them from wear and tear.
Photo by Dirck Halstead

The microprocessor is the ultimate time machine, enabling us to search the world for instant answers, to look back to the beginning of time and to cast forward into the future and its billions of possible scenarios.

But microprocessors do more than just traverse time; they preserve it as well. They enable us to study what was once too rare or too fragile for the eyes and hands of anyone but the powerful or the expert. In diagnostic tools they discover the agents of age and decay and offer the means to defeat them. In databases they preserve and archive images that would otherwise be as lost as the eras they represent. In analytical devices and design systems, they help us to preserve the works of God and humans, from Amazonian rain forests to Gaudí's cathedral, from cheetahs to a Cellini sculpture. In emergency rooms, they help to preserve young lives that might have become part of history far too soon.

The Argentine scholar Borges said that libraries are not only humankind's memory, but also its imagination. The history that is preserved and made infinitely present by the microprocessor is not just for display or nostalgia. It also exists to teach us the lessons of the past. To remind us of what we have forgotten. To place before us the great works of antiquity and to uplift us and show us the potential of humankind. To challenge us to use the tools of our time to find inspiring examples of humanity at its best. To fire our imaginations.

The whole universe, with all of its history, now lies before us. Microchips enable us to peer through telescopes to the distant reaches of the universe and to witness light that was present at the dawn of creation. What other past efforts, dead-ended by lack of technology, now only await the explorer ready to resurrect them? What discoveries, hidden by the

http://www.loc.gov

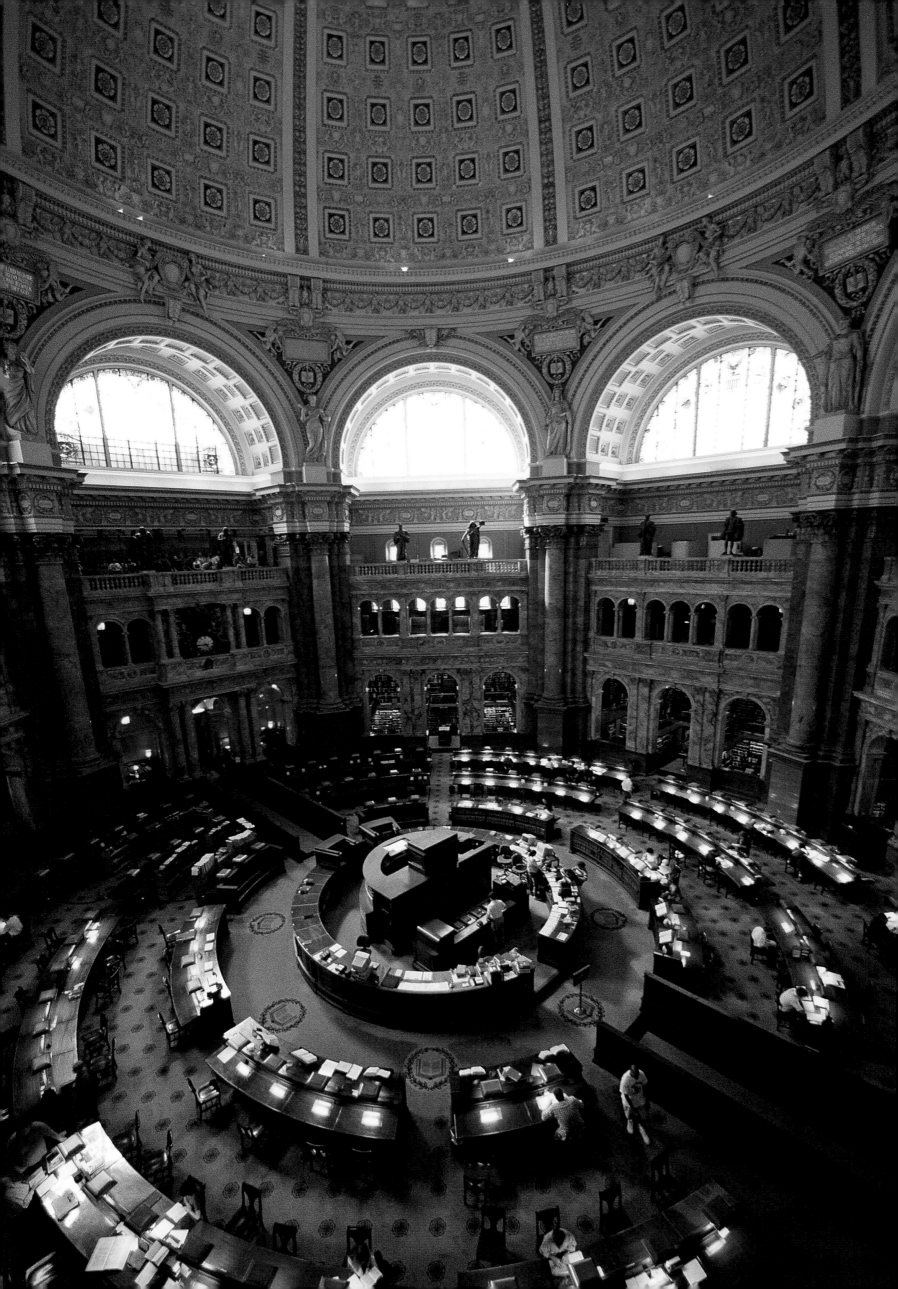

◀ ▼ NEW HAVEN, CONNECTICUT
Knowledge towers over visitors
to the Beinecke Rare Book and
Manuscript Library at Yale
University where, until recently,
scholars were only able to examine
the gems of the collection in closed
quarters and during limited hours.
Today some 15,000 photographs
and 1,200 pages of illuminated
historical manuscripts are available
in digital form, and the staff hopes
to digitize four times that amount
over the next 10 years. The Holy
Grail for book lovers at the Beinecke
remains a Gutenberg Bible (*below*).
Published in 1455, it was the first
book in Western civilization created
with movable metal type. The
Gutenberg printing press revolution-
ized Western culture by
facilitating a more affordable and
widespread distribution of informa-
tion. The Internet, though still
in its infancy, is already having an
equally profound effect on humanity's
ability to exchange ideas.
Photos by Bradley E. Clift

mountains of words that have long encased them, are waiting to
be unveiled? What powerful young minds, for generations
denied access to the instruments that would make their ideas
potent and real, will be freed to realize their fullest potential?

The microprocessor is as great a tool as any we've ever
known. How has it already changed us? And how will it change
us still? The answers are as diverse as the photographs in this
book. One thing is certain: we are already a changed people
for having known the microprocessor. Only 500 years ago,
humanity believed the horizon marked the edge of the universe.
Now we accept that our universe is boundless. We can think
in terms of billionths of seconds and in microns, and be
comfortable in a timeless world in which past, present and
future are here and now. But most of all, we are learning to
appreciate what it is like to reach out to any place on the globe,
any era of the past, any idea ever conceived, and hold it in the
palm of our hand.

NEW YORK, NEW YORK

Organizing the family snapshots is a big job, especially when the family is Time Inc. More than 22 million photos, many of them icons of the twentieth century, make up Time's historic archive. Until 1996, they consisted of slides, negatives and prints. They were kept in hundreds of file cabinets, with each image's physical location logged in a card catalogue. Today, a team of archivists are scanning and entering the images and text into a digital database that can be searched by numerous researchers simultaneously. Five million images are now in the system, and thousands are being added daily. Barcodes ease the tracking of the 30,000 photos sent out each year to fulfill reprint requests. By 1998, some of the archive will be available online for those wishing to take a trip through history.
Photo by Misha Erwitt

FLORENCE, ITALY

Art bursts out of museum walls in the wired age, accessible to anyone with a modem and a mouse. Web surfers around the world can point their browsers to watch in real time as Italian restorer Giovanni Morigi works on Benvenuto Cellini's Renaissance masterpiece. *Perseus with the Head of Medusa* was damaged by centuries of exposure to weather and pollution in Florence's outdoor Loggia dei Lanzi. At www.perseo.org, art lovers can also download video of earlier phases of the restoration and post questions for Morigi and his team of specialists.
Photo by Guglielmo de' Micheli

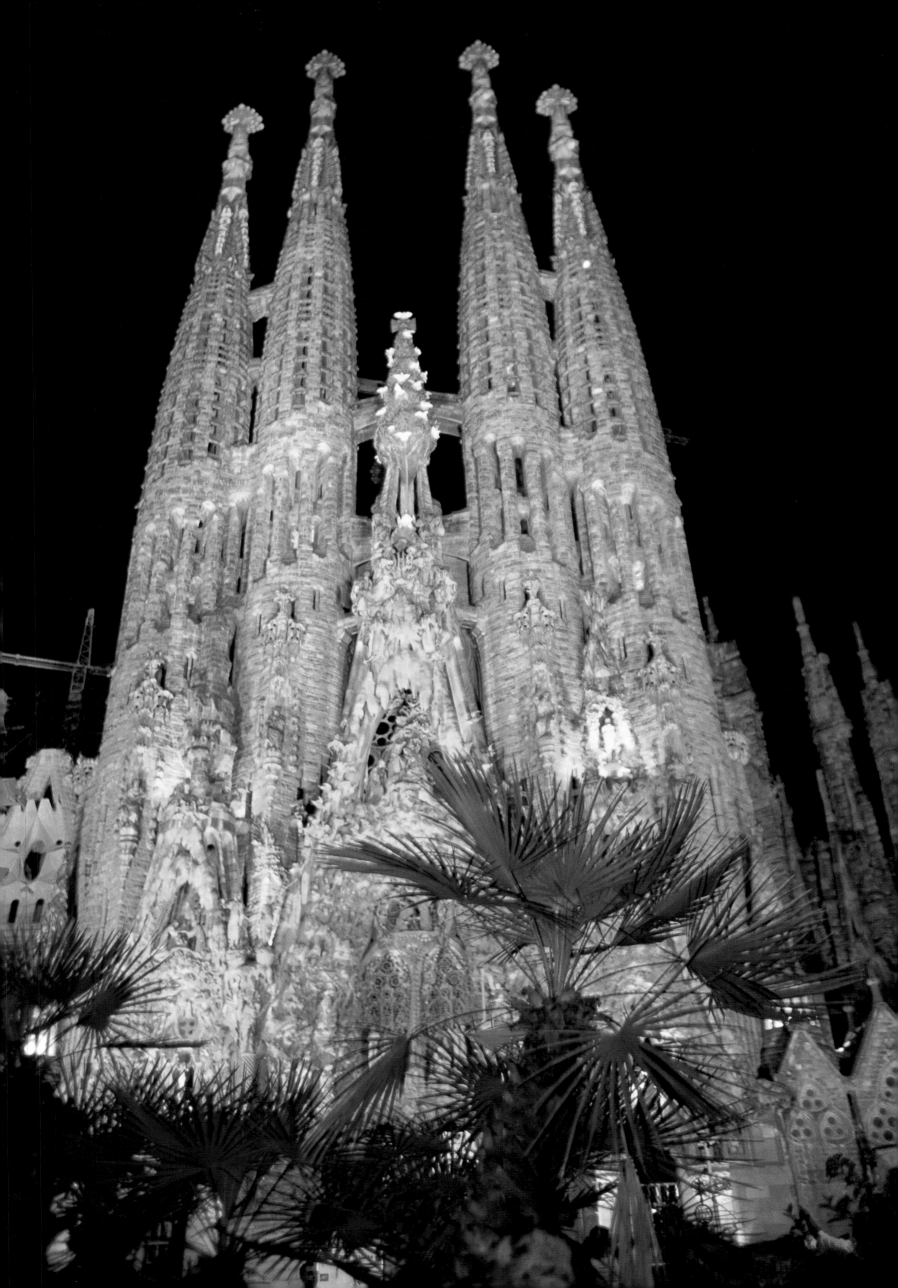

◄► BARCELONA, SPAIN

The signature landmark of a proud city, 114-year-old Sagrada Familia Cathedral rises unfinished over Barcelona (*left*). Work continues on the cathedral 70 years after the sudden death of the architect, Antonio Gaudí. Architectural director Jordi Bonet (*right*) leads a team (*below*) working from computer-generated plans created from a plaster model Gaudí left of the cathedral. Computers, a staple in the design of new buildings, are especially suited to reconstructing Gaudí's plans, says Bonet, since his work was based on precise geometric forms such as parabolas, hyperbolas and spirals. "The computer," says Bonet, "is indispensable in determining the precise coordinates of the intersections of the columns, arches and roofs, as well as their volume, weight and center of gravity." The computer-generated plans will also allow Bonet to pass on his work to another team of specialists—a practical necessity since, at the current rate of construction, the cathedral won't be finished for another 50 years. The time needed to complete the monument has never troubled the cathedral's developers. As Gaudí said more than 70 years ago: "My client is not in a hurry."
Photos by Ed Kashi

▶ **VERONA, ITALY**

Three eras and an aria: *Aida* is staged in an ancient Roman amphitheater. Audience members can buy tickets for the opera over the World Wide Web. Half the opera lovers who crowd into Verona's outdoor arena during the summer season come from abroad; with the multilingual Web, they can now choose their own seats and order tickets—in Italian, French, English or German—for spectacles like Giuseppe Verdi's *Aida*.
Photo by Roberto Koch

http://www.cosi.it/verona/

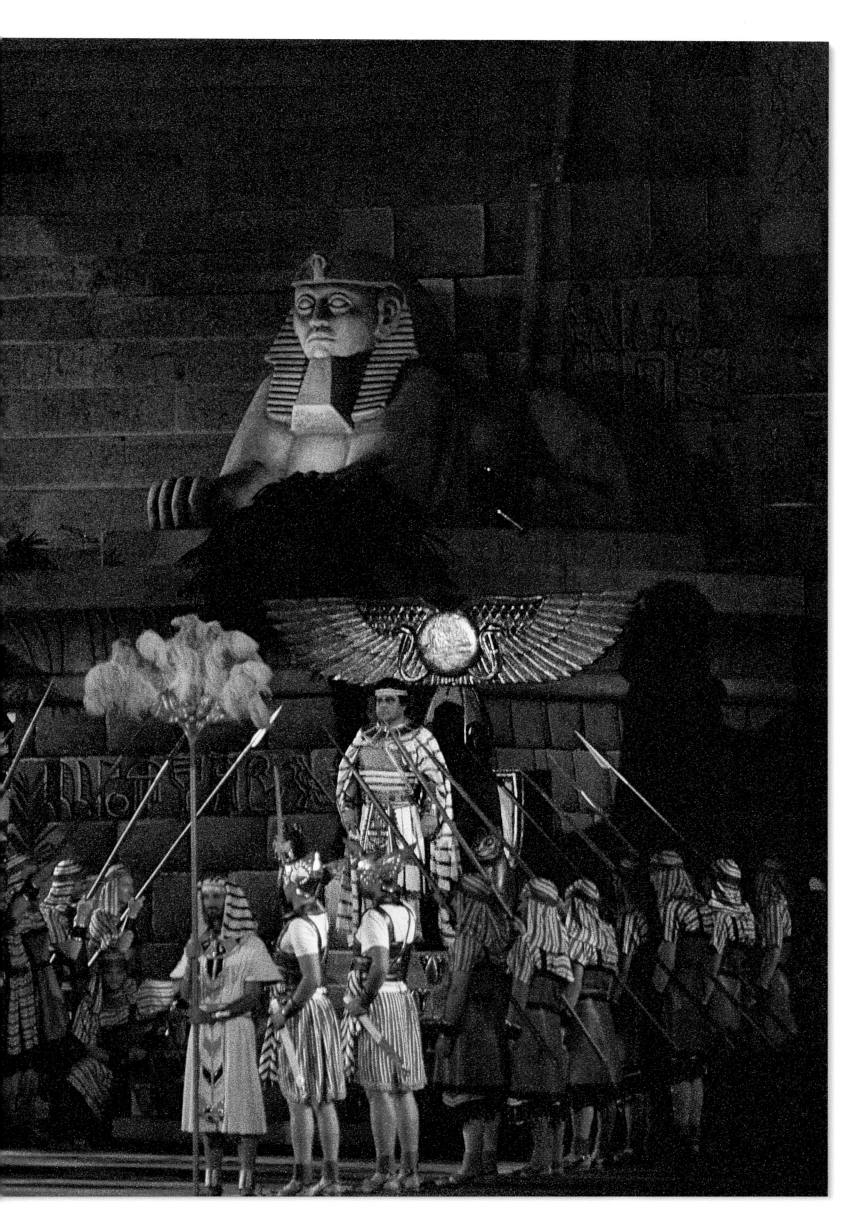

▲ ▶ LAS VEGAS, NEVADA

Want to run away and join the circus? If you've got experience with aerial bungee ballet, Japanese *Taiko* drumming or writing computer code, Montreal's world-renowned Cirque du Soleil could be the place for you. The troupe's performers are wowing audiences with their production, *Mystère,* at the Treasure Island Hotel. The cast and crew of *Mystère* perform in a state-of-the-art facility, using computer-driven special effects that contribute to the surreal world the artists bring to life each evening. Automated trampolines are programmed to launch performers into the air at exactly 45 degrees, hydraulic stage lifts carry artists and scenic elements on and off stage on cue and a 924-circuit lighting system is customized to follow its cues without a hitch while the nearly 40 technicians communicate via wireless headsets. Despite the extensive capabilities of the system, it plays second fiddle to the creative talents of the performers, explains technician Tod Toresdahl. "We never want to let the technological upstage the artistic. We work very hard to be as invisible as possible."
Photos by David Hiser

▲ ▶ HONG KONG, CHINA

There's a new cure for being homesick, and it's called IPIX. The illusion is that you control a camera on a peak overlooking, say, Hong Kong, from your desktop computer back in Chicago. By moving a cursor across the image, the viewer can spin in a full circle, zoom in, zoom out and view the scene from every imaginable angle. The technology may revolutionize the travel industry by not only allowing you to preview the sights before you arrive, but also to pan around the hotel room your travel agent has reserved for you to make sure it meets with your approval.

A preview of what IPIX technology, from Interactive Picture Corporation, has to offer was developed by marketing agency Poppe Tyson Interactive in conjunction with Intel Asia Pacific in Hong Kong. The site was created to document life on the streets of their famous city during the return of sovereignty from the

http://www.intel.com/hk1997

British to the Chinese. Images such as those taken with a special 8-m.m. panoramic lens of the Man Mo Temple by photographer Sue Royle (*right*) were brought together by a Web design team (*top*) into a seamless mosaic. Many of the thousands of visitors to the Web site described their visit as "the closest thing to returning home."
Photos by Jeffrey Aaronson

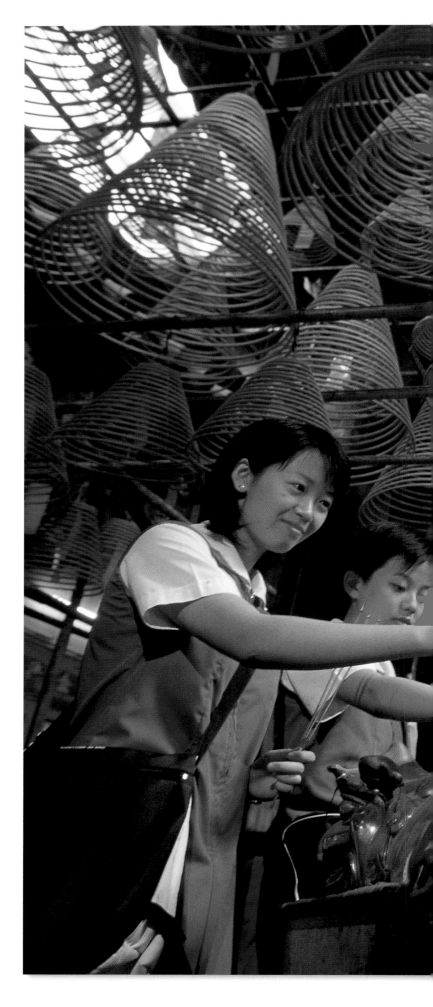

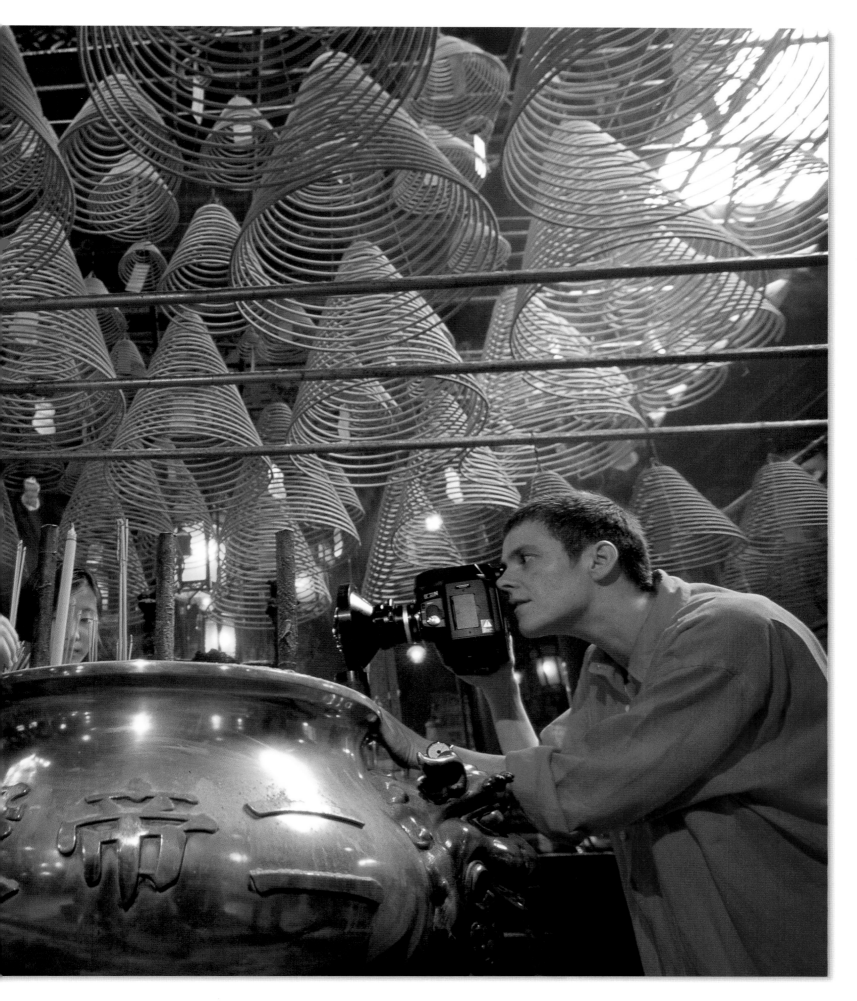

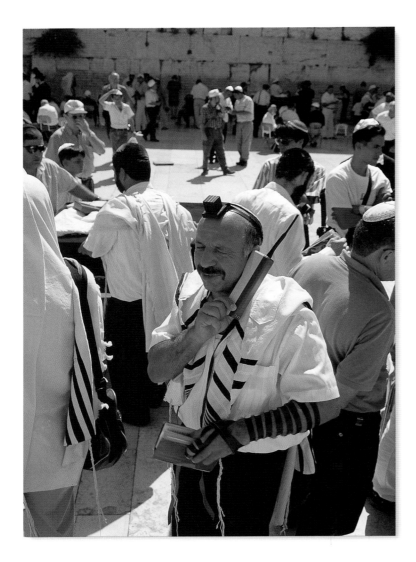

▲ JERUSALEM, ISRAEL

From his mouth to God's ear. Prayer shawl around his shoulders, *Tefillin* (prayer box) atop his head and cell phone at his ear, a visitor to the Wailing Wall, the site holiest to Jews, manages to balance his secular obligations with his spiritual life. In many countries, cell phones—once a status symbol for the wealthy—have become an indispensable and even inescapable aspect of modern life. Cellular phone use is so prevalent in Israel, where the phones now account for more than one-third of the country's telephones (giving Israel the world's highest per capita rate), that many restaurants have instituted "no cell phone" sections.
Photo by Ricki Rosen

http://www.virtual.co.il/

▼ **JERUSALEM, ISRAEL**

Stuffing an e-mailed prayer into the cracks of the Wailing Wall, a messenger from Virtual Jerusalem helps far-flung Jews talk to God. About 200 e-mailed prayers a day reach the Wall, sacred to Jews who believe that prayers delivered there reach God more quickly. The company's Web site (*bottom, left*) offers live video of the Wall, and chat rooms where company founder Avi Moskowitz says, "Jewish people around the world can gather as a community."

Companies like Virtual Jerusalem, many started by veterans of Israel's electronics-heavy military, fuel the economy. Only the United States boasts more tech start-ups per year.
Photo by Ricki Rosen

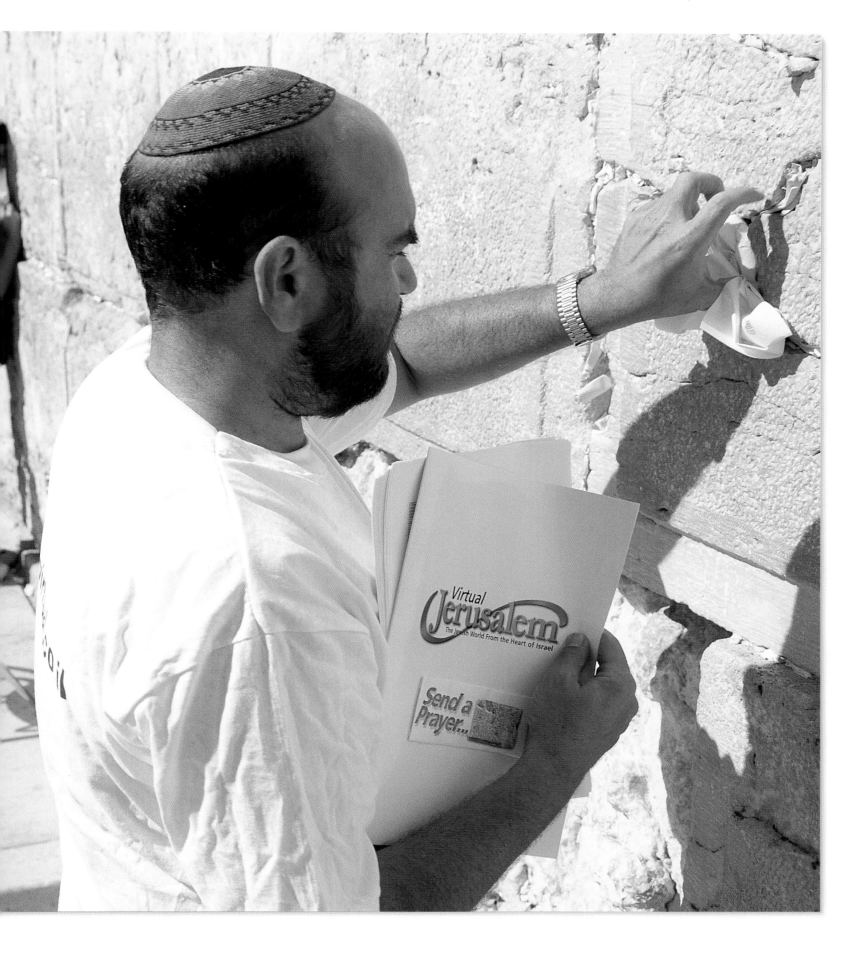

▼ ▶ PIEDMONT, WYOMING
Traveling through time, space and the World Wide Web, Japanese and American members of the Church of Jesus Christ of Latter-Day Saints journey via wagon train from Nebraska to Utah, re-enacting a trip taken by Mormons to escape religious persecution 150 years ago.

Using a solar-powered laptop, complete with wireless modem, Osamu Sekiguchi of Tokyo posted his impressions of the journey to a Japanese Web site. Margaret Clark (*right*), a nurse who walked all 1,000 miles (and who had never touched a computer prior to the trip) was the expedition's English-language webmaster.

The daily journals uploaded to the expedition's Web site received more than 500,000 hits during the 10-week trip.
Photos by Lori Adamski-Peek

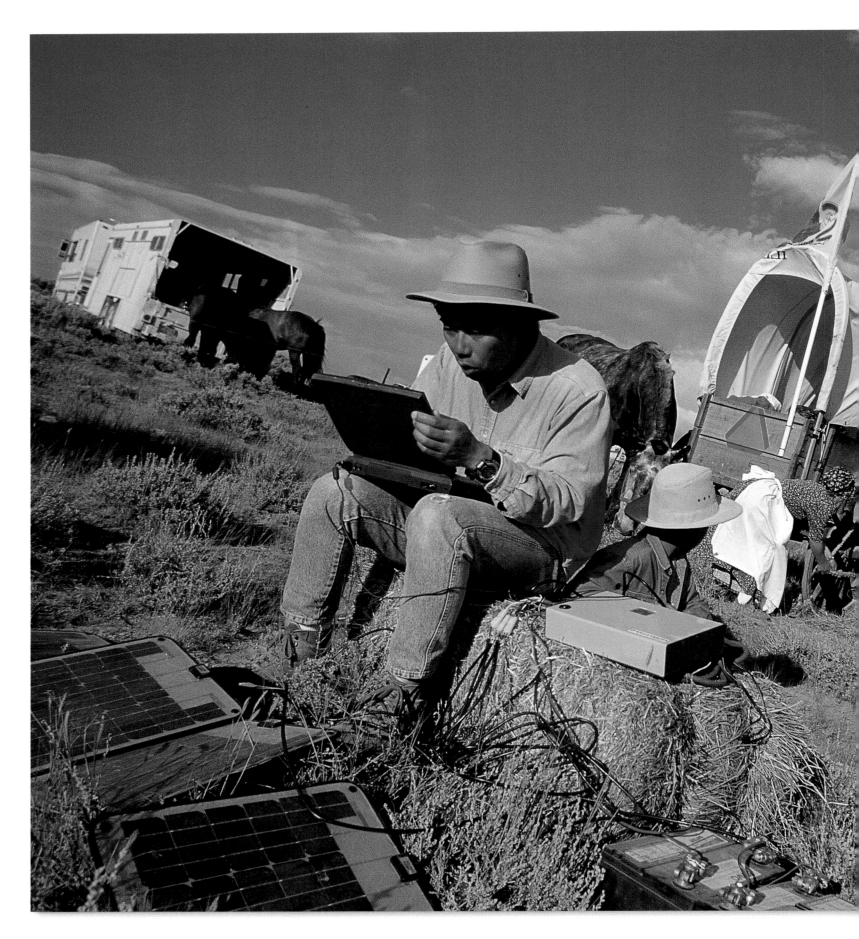

http://heritage.uen.org/cgi-bin/

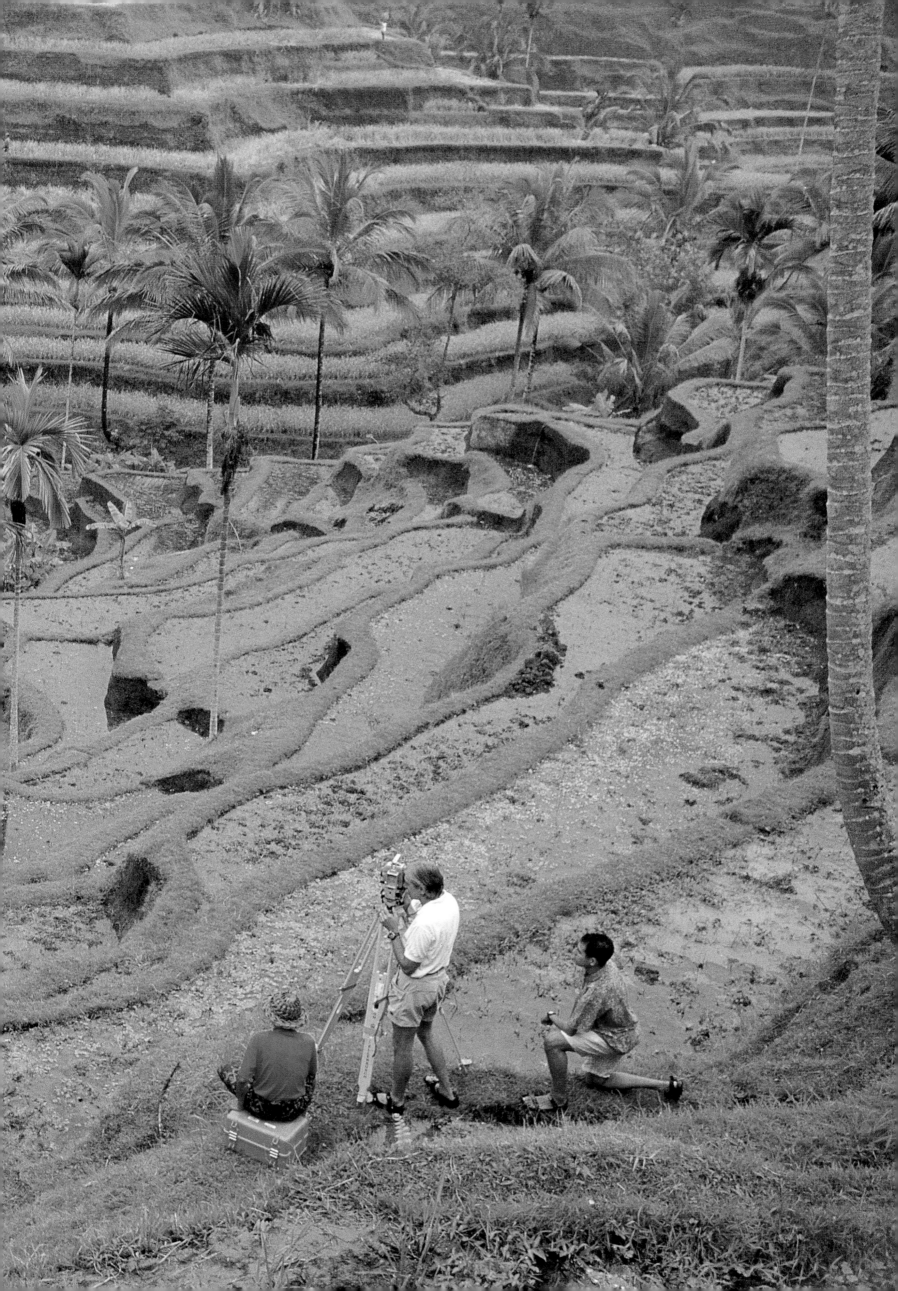

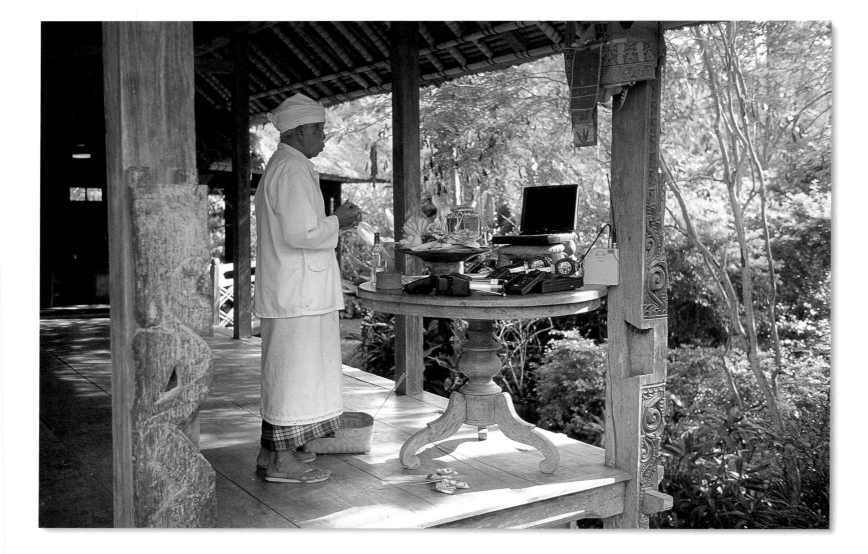

The "steps of God" are what the Balinese call their elaborate network of rice terraces. For centuries, the complex water systems that nourished this land were maintained by "water priests," who combined religious ritual with water management in a system that worked in harmony with the environment and encouraged cooperation among the rice farmers.

In the mid 1970s, development agencies stepped in and attempted to increase Bali's annual rice yield, and convinced farmers to adopt methods of modern agribusiness. Rather than working together, rotating fields and sharing resources with their neighbors, the farmers began to overuse fertilizers and pesticides and to use their fields continuously, without giving the land a chance to recuperate. Instead of improving on centuries of traditional methods, these modern systems caused numerous problems as rice crops started to fail, insects plagued the land and pesticide-tainted groundwater became undrinkable.

The solution to the problem came in an unexpected way. An American professor, who had worked with Balinese farmers in the past, heard their complaints and theorized that it was the water priests' ancient systems that had kept the delicate ecosystem of the rice terraces stable for centuries.

Professor Steve Lansing, an anthropologist from the University of Michigan, and his colleague, computer expert and ecologist James Kremer, decided to develop a computer model to help prove that the old methods were better for sustainable rice production. Their program simulated the water systems, including variables such as weather patterns, water levels, the presence of pests and even temple rituals. As a result, Lansing and Kremer were able to affirm that the traditional methods followed by the water priests had in fact produced better yields with less environmental damage than the more scientific methods advocated by the development agencies.

The application Lansing and Kremer developed has helped convert the skeptics and is now used to augment the old systems, which are again being used by the water priests. "They're teaching me," says Lansing, "as much as I teach them." In the village of Sebatu (*above*), a priest blesses Lansing's instruments before they are used to measure the terraces, track insect dispersal, record the water speed through the ancient canals and measure chemical levels in the water in order to monitor the ecosystem and keep the computer model up-to-date.

Lansing hopes to apply these computer models in other locations. "We're trying to understand how people succeed in areas where cooperation has worked for centuries." Meanwhile, Balinese rice farmers once again offer prayers at small shrines erected to Dewa Sri, the goddess of rice.

Photos by Leonard Lueras

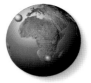

◄ JOHANNESBURG, SOUTH AFRICA

Fast felines under siege, cheetahs get a high-tech boost at the DeWildt Center, where Alan Strachan uses a portable scanner to identify a cheetah. The scanner reads a small chip, implanted just under the animal's skin. "Thanks to these chips we can instantly and accurately identify each cheetah," says the DeWildt Center's Ann Van Dyk. "I can tell you about any one of our cubs, and who the great-great-grandfather was all the way back to our first animals." The genetic information is crucial to the center's efforts to build up the world population, because inbreeding is a big threat to the genetic strength of the cats. "When we started breeding captive cheetahs 25 years ago," says Van Dyk, "they were on the verge of extinction in southern Africa. Now they're no longer considered endangered."

Photo by Mark Peters

▷ NOVATO, CALIFORNIA

Cat scan technology: Sue Smith of the Marin Humane Society scans a pet cat to identify its owner. Over the past nine years, the Marin Humane Society has implanted more than 15,000 pets with microchips (*below*) containing the owner's name, address and phone number— information that is then logged into a nationwide database of more than 250,000 animals. The electronic tag, which takes about a minute to implant, costs pet owners $5 for cats and $10 for dogs. The result? About a 400 percent increase in the rate of return of lost pets to owners. "When you find an animal that's been chipped and you can reunite it with its owners," says Smith, "that's the best thing in the world."

Photos by Charles O'Rear

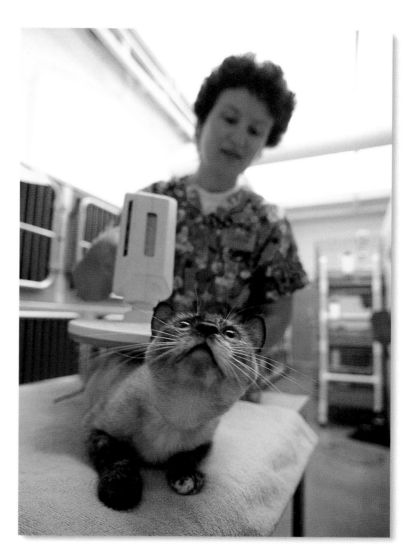

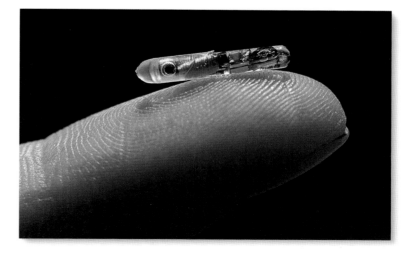

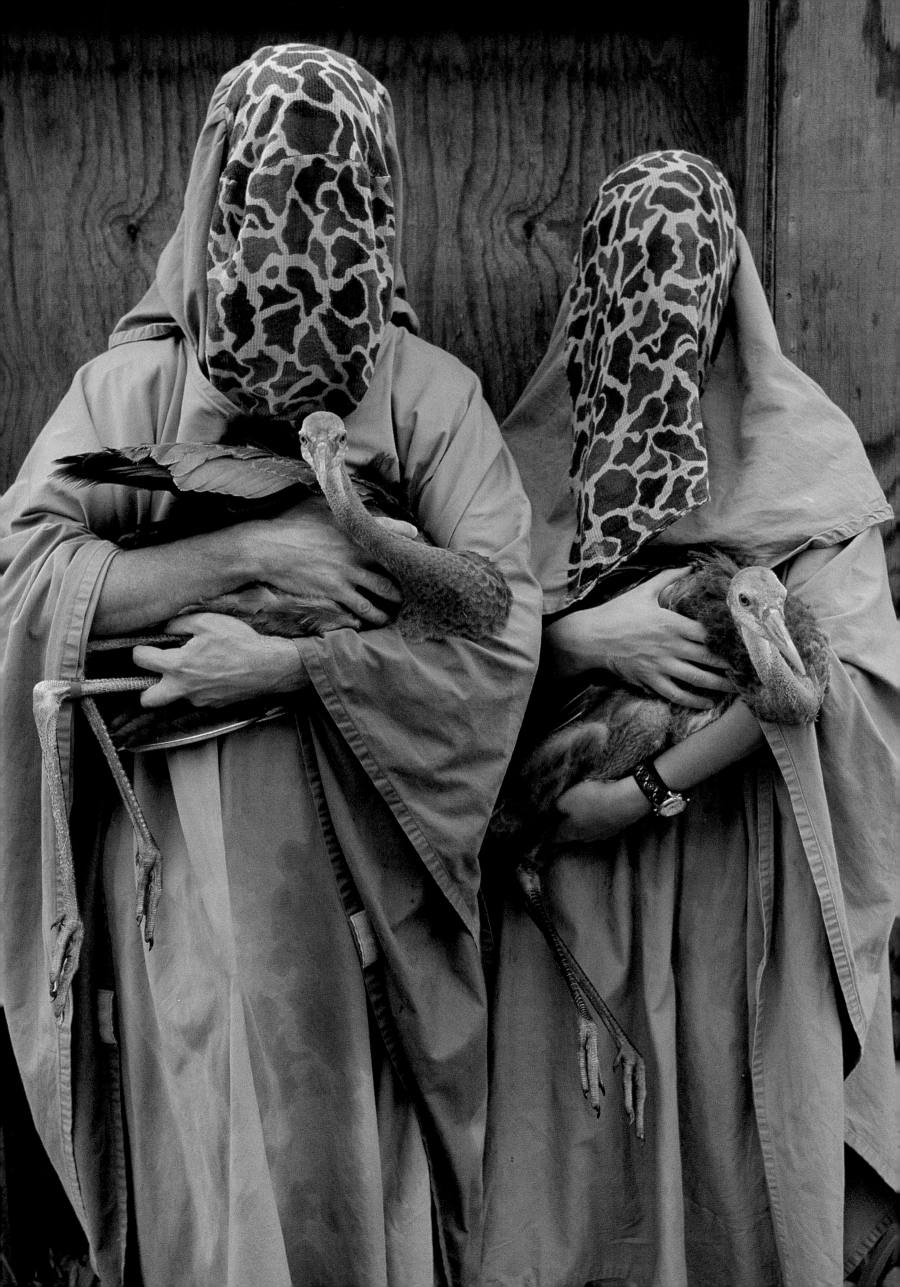

◀▶ NEW ORLEANS, LOUISIANA
Endangered species get a second
chance, thanks to the Audubon
Center for Research of Endangered
Species, where projects include
increasing the world's population
of Mississippi Sand Hill cranes.

Baby cranes conceived in test
tubes spend their first 30 days in an
incubator with a precise computer-
monitored thermostat. When the
crane chicks hatch, their eggshells
are numbered and catalogued for
future reference (*right*). As the baby
cranes grow, researchers hide their
faces to make sure the hatchlings
don't bond with humans (*left and
below, right*). To further ensure
their successful assimilation into
the wild, a hand-held replica of an
adult crane is used to feed the birds
(*below, right*). Prior to release, each
bird is fitted with a radio transmit-
ter that allows scientists to track its
whereabouts.

To circumvent the inbreeding
that weakens many endangered
species, scientists at the center
match sperm and egg donors for all
species born at the center, including
the Sand Hill cranes, on a database
that tracks the bloodlines of ani-
mals in captivity around the world.

The center also maintains a
"cryogenic zoo," a freezer of liquid
nitrogen with a computer-aided
cooling system containing the
genetic material of over 200 ani-
mals representing 20 different
species (*top, right*).
Photos by Annie Griffiths Belt

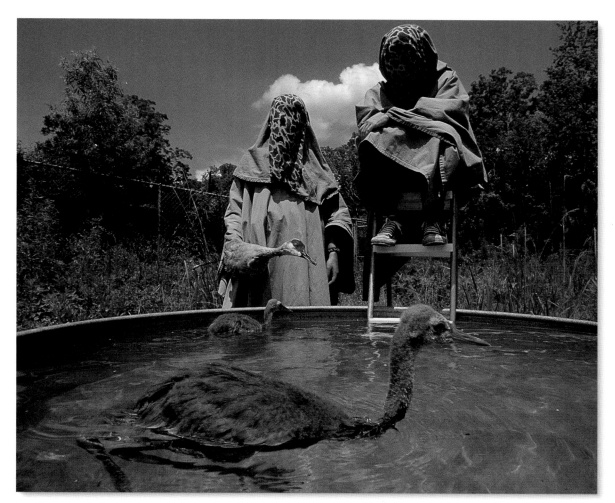

◄ NEWPORT, OREGON

When the plight of Keiko, the orca made famous for his role in *Free Willy*, was brought to public attention, it set off a series of events and controversies that still engage biologists in heated debate. Keiko was underweight and living in a cramped tank in a Mexico City amusement park until January 1996, when he was transported to a new state-of-the-art tank at the Oregon Coast Aquarium. Today, as his health improves, biologists are considering releasing him back into the wild. After his 18 years in captivity, though, Keiko may be too domesticated to thrive in the open sea—an issue which has sparked debate among animal rights activists, biologists and Keiko's caretakers.

Marine mammal specialists believe that each orca's extended family group, or pod, has its own distinct dialect of sounds, so that its members can readily identify one another. Biologists hope that if they find Keiko's original family pod, the members might accept him and help him adapt to living in the wild.

Until then, scientists are working with Keiko to learn more about orcas, popularly known as killer whales. They are studying his language with the help of underwater microphones, known as hydrophones, that record his sounds. Keiko's vocalizations are catalogued on a computer database to help researchers try to identify his family group, and to learn more about the complexities of cetacean language. In addition, the 24-hour video surveillance of Keiko is helping scientists learn more about orca behavior.

Keiko participates in a surveillance of his own as he peeks in on mammologist Cinthia Alia-Marion (*left*) as she records data on various marine mammals at the Oregon Coast Aquarium.
Photo by Gary Braasch

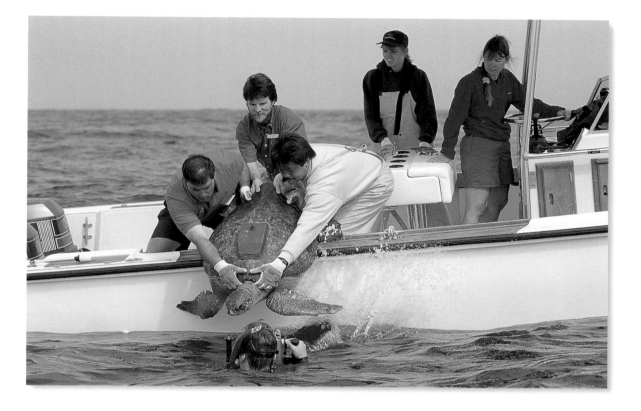

▲ SAN DIEGO, CALIFORNIA

A turtle goes home to the waters off the coast of San Diego almost a year after being found, inexplicably, in the frigid waters of Alaska's Prince William Sound. Glued to the back of this East Pacific Green Turtle, nicknamed Wrong-Way Corrigan by scientists at Hubbs-Sea World Research Institute, is a two-pound satellite transmitter that should provide information about this endangered species that has never before been available. Sensors in the transmitter gather data continuously, including his dive depth and the temperature of the water he inhabits. When Corrigan surfaces, this information and his location is relayed via satellite to researchers who hope to track his whereabouts for at least a year before the transmitter is shed. With the information, they plan to develop conservation strategies to save the species from extinction. Similar transmitters have been used to follow animals as large as blue whales, but this is the first time a male green sea turtle has been electronically tracked.
Photo by Bob Couey

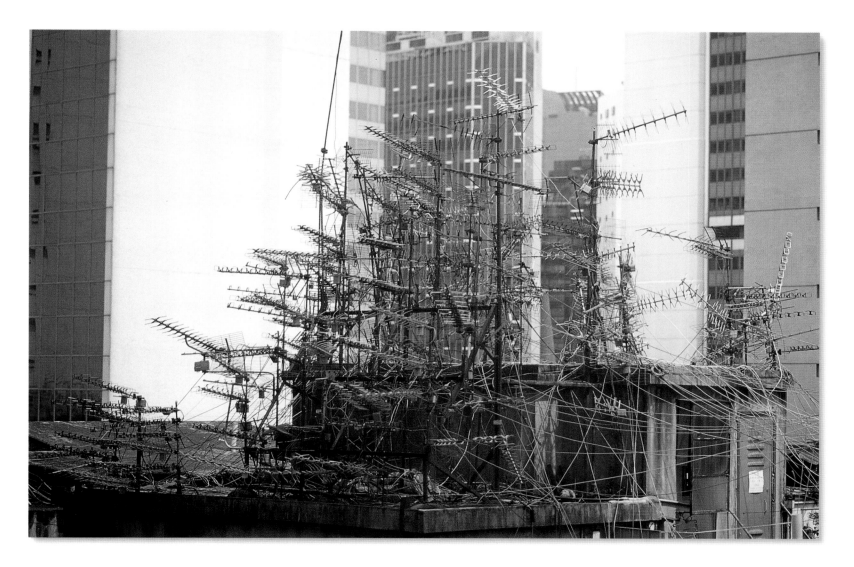

◀ MAYA BIOSPHERE RESERVE, GUATEMALA

A Global Positioning System (GPS) unit allows conservationists to leave "digital bread crumbs" in order to find their way back to the exact same locations in the expansive rain forest.

Using a digital receiver, conservationists gather information from four of the 24 GPS satellites circling the earth, each of which transmits a time and distance algorithm. These readings allow them to calculate their location to within 100 yards. Once the location is verified, the conservationists can return to the same site every six months to document changes since their last visit. Using a combination of aerial photography, satellite imagery and video, they track unauthorized logging and other illegal activities in an attempt to protect the rainforest.

These efforts are aided by equipment donated by Intel to the nonprofit group Conservation International, which manages similar projects throughout Latin America, Africa and Asia.
Photo by Dana Slaymaker

▲ HONG KONG, CHINA

A metallic forest that advancing technology will soon eliminate grows in a tangle on a rooftop. Already as quaint as dial telephones in some parts of the world, television antennas are rapidly being pushed aside by cable and digital wireless transmission of information. But cell phones need antennas too, leading some companies in the United States to camouflage the unsightly antennas within a building's architecture or inside a grove of trees.
Photo by Jeffrey Aaronson

While fascination with UFOs and the search for extraterrestrial life continue to capture the world's imagination, we still know practically nothing about the two-thirds of our planet's surface that is covered with water. Until 50 years ago the surface of the sea was an impenetrable curtain; what lay below was as distant and unknown as the other side of the moon. Jacques Cousteau's invention of the aqualung in 1943 opened up the first 300 feet of this unknown world. Military submarines, operating at depths of 1,000 feet, expanded our knowledge even more, but the average depth of the ocean is 13,000 feet, meaning that most of what is down there remains a mystery.

Inaccessible to humans, the deepest of the deep sea is best explored by microprocessor-controlled robots. These machines, known as remote operating vehicles, or ROVs, use digital cameras, each about the size of a cigar, to photograph at depths up to 7,000 feet.

These robots, which *National Geographic* inventor and contributing photographer Emory Kristof (*below*) controls from a boat on the surface, have brought back remarkable images of strange sea creatures that live in deep sea vents.
Photo by Wes Skiles

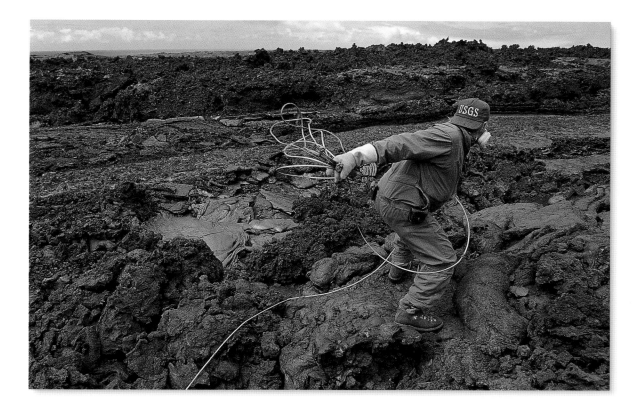

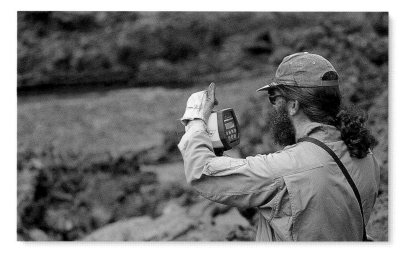

KILAUEA, HAWAII

While many people consider volcanoes to be tourist attractions, they are, in fact, quite deadly. Each year, about 1,000 people are killed worldwide by volcanic eruptions. By the year 2000, nearly 500 million people around the world will be living near potentially active volcanoes, creating a sense of urgency among scientists to better understand and predict the activity occurring beneath the earth's crust.

During his 20-year study of mighty Kilauea, Jim Kauahikaua (above) has seen some dramatic changes in the tools used to study this force of nature. Because of the astounding heat, any sophisticated measuring device like a thermometer would melt, so crude devices like the hammerhead being thrown into the lava by Carl Thornber of the U.S. Geological Survey (top), are used to collect a sample of the molten lava. When the lava cools, scientists are able to measure its liquid temperature. Such methods are now being complemented by radiometers that remotely sense temperature, laser range finders that measure the width of a lava channel and radar guns that calculate the lava's speed (following page). Researchers also use remote seismic sensors, digital cameras and GPS sensors to try to predict eruptions.

Photos by G. Brad Lewis

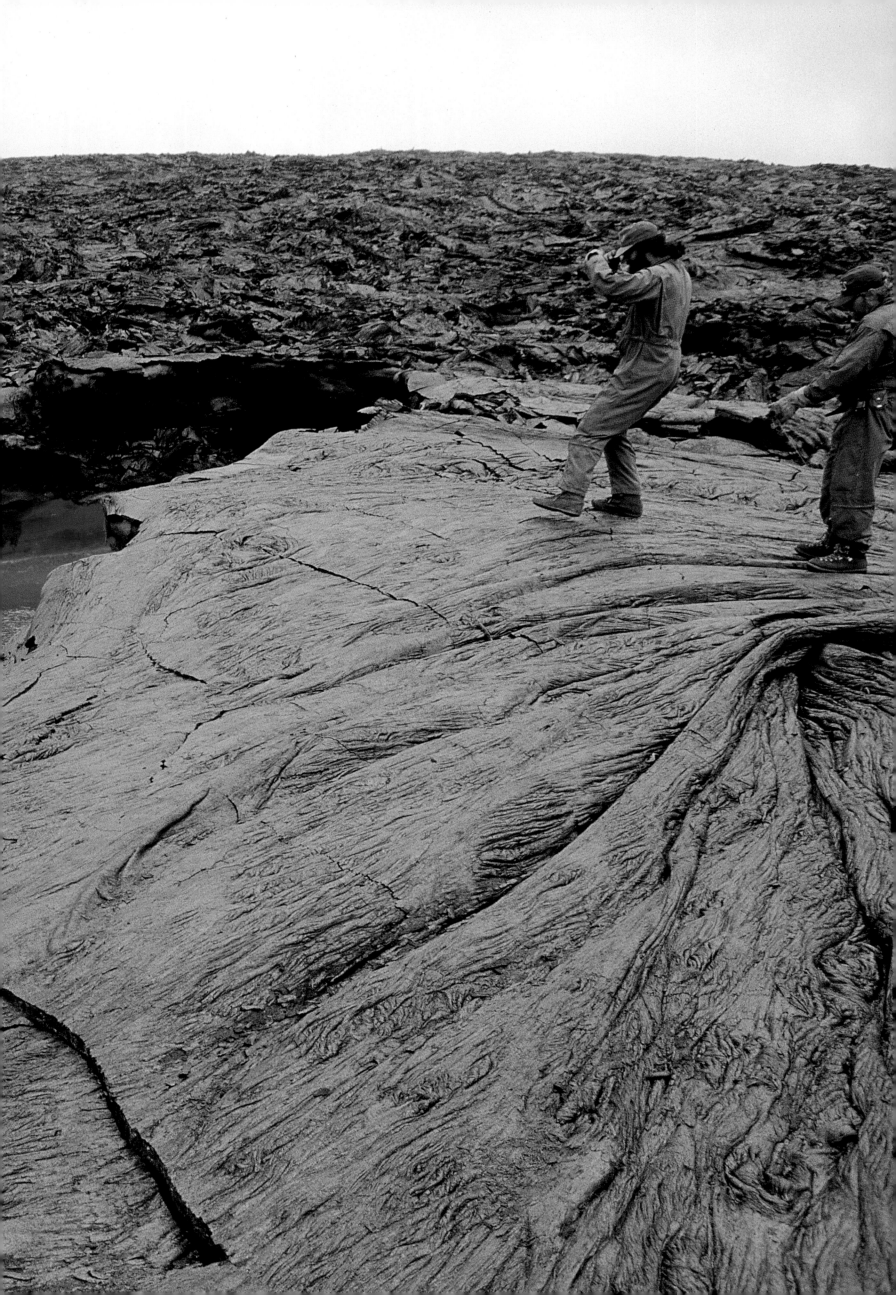

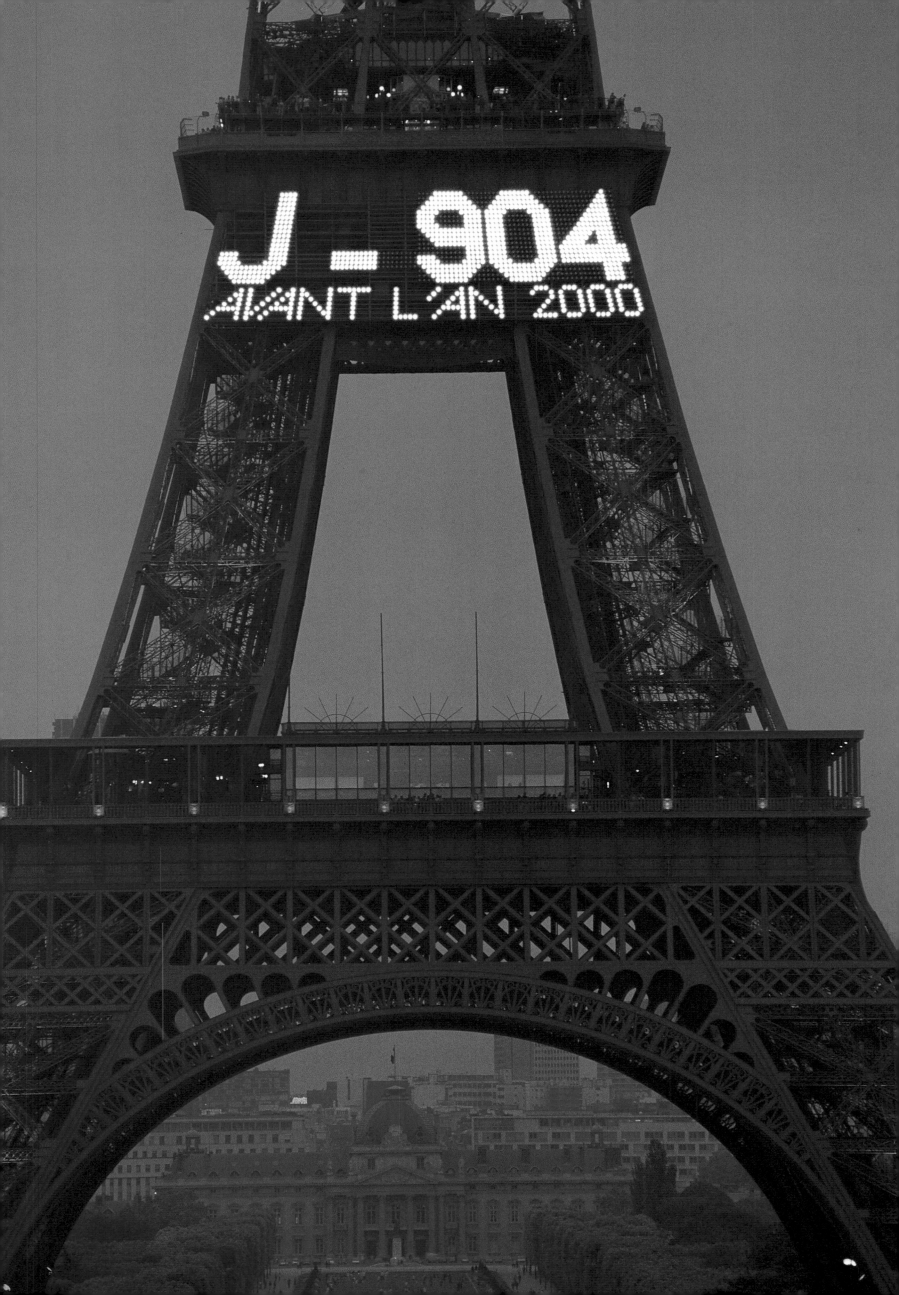

◀ PARIS, FRANCE

The Eiffel Tower's bright lights hang like the sword of Damocles over the modern world's head, counting down the days to the year 2000. While many millennium celebrations have been planned years in advance, there is one group of individuals who wish that a little more planning had taken place 30 years ago at the dawn of the computer age. Their worry? If millions of computer programs worldwide aren't rewritten by midnight on December 31, 1999, elevators will stop running, credit cards will be declared expired, ATMs will stop dispensing cash, Social Security payments will come to a halt, bank records will be erased, phone systems will be silenced and nuclear power plants won't be able to measure radiation levels.

The reason? It turns out that the software in most mainframe computers is programmed to read only the last two digits of a year, so that the year "2000" comes out as "1900." In other words, unless the problem is fixed, computers will register the first day of the year 2000 as January 1, 1900. (Thankfully, the problem doesn't affect personal or desktop computers.)

The dating disaster could cost as much as $600 billion to fix, which, according to *The New York Times*, might trigger a global recession in the process. Programmers are working feverishly to rewrite trillions of lines of computer code in the months remaining, but it's anyone's guess whether they'll succeed. The big winners are experts in Cobol, a now-obscure computer language popular in the 1960s and 1970s. Cobol programmers are being lured from retirement by consulting fees of $1,000 a day to rewrite the computer codes that make the modern world hum.

Newsweek aptly summed up this unusual race against time: "No amount of money or resources will postpone the year 2000. It will arrive on time, even if all too many computers fail to recognize its presence. Tick, tick, tick, tick, tick…"
Photo by Arnaud de Wildenberg

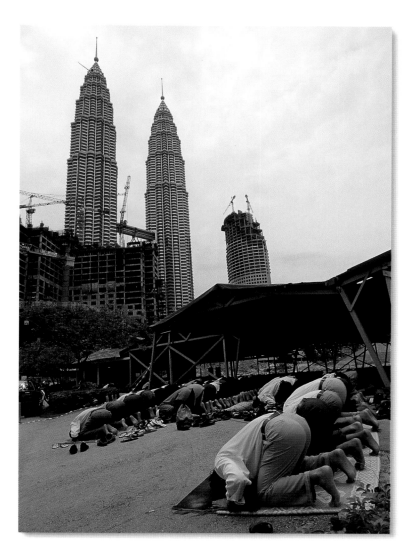

▲ ▶ KUALA LUMPUR, MALAYSIA

The Malaysian Government is spending billions of dollars—in a country where the per capita income is U.S. $4,200—to transform the tropical southeast Asian nation into a computing capital rivaling Silicon Valley.

Bowed in reverence toward Mecca, workers (*above*) pray near the Petronas Towers (*next page*), the world's tallest buildings. These twin spires form the northern border of the Multimedia Supercorridor (MSC), formerly a 30-mile swatch of oil palm plantations. The MSC will include Cyberjaya, or cybercity, and Putrajaya, a new national capital planned to be the world's first paperless bureaucracy.

Throughout the corridor, there are plans to install fiber-optic cables and software, so that schools can be wired for long-distance learning; hospitals can be connected by videophone to remote parts of the country; residents can carry smart cards embedded with money, medical records and security codes; and a multimedia university can be built to train the next generation of Malaysian engineers.
Photos by Tara Sosrowardoyo

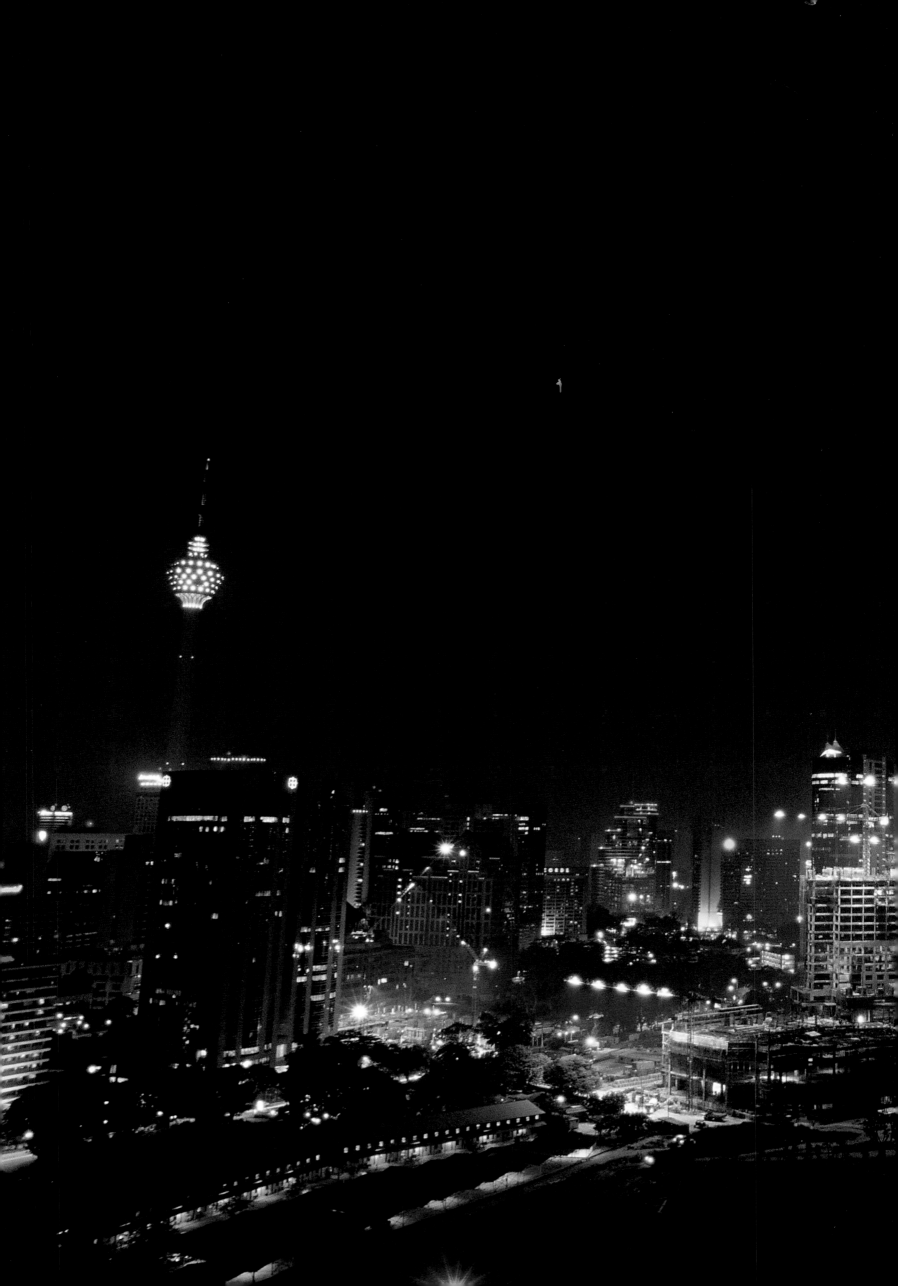

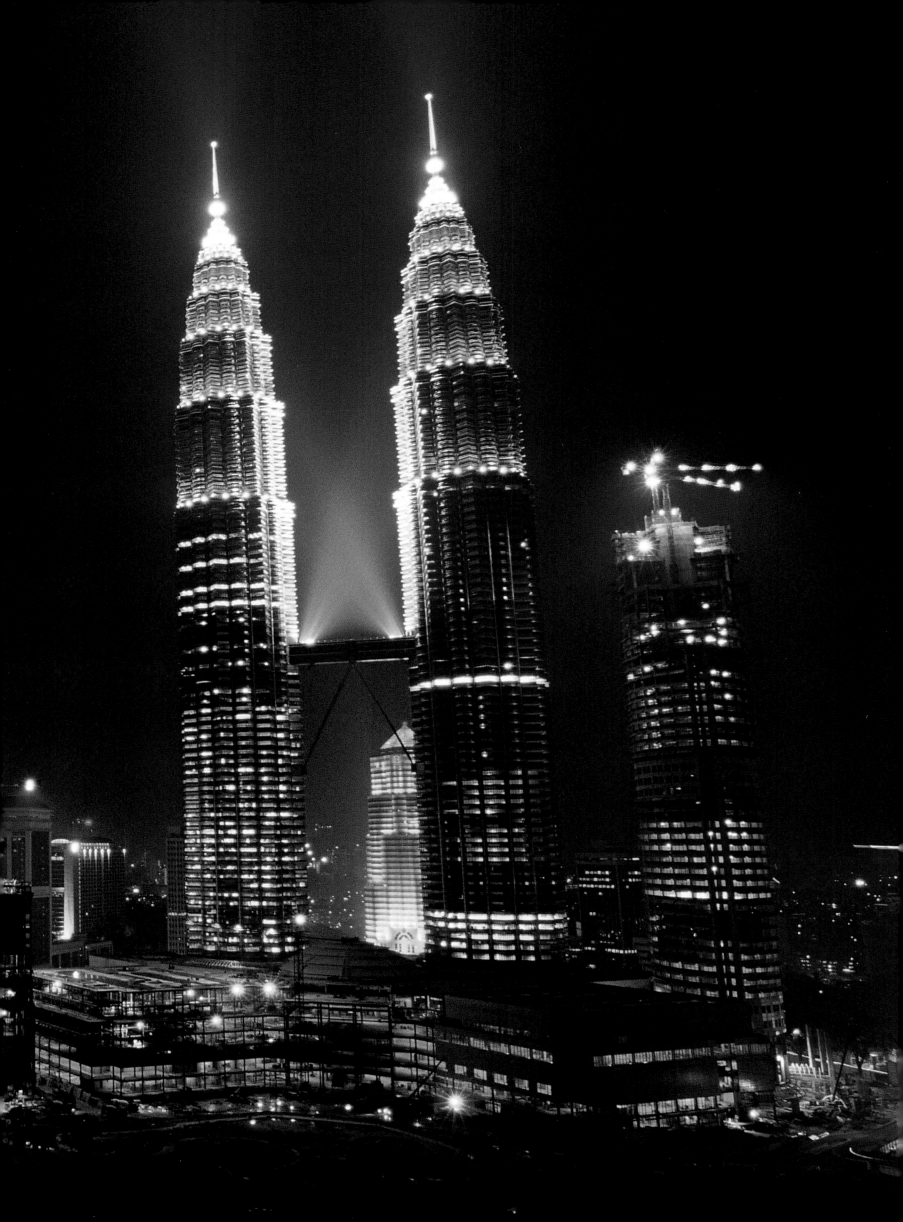

The rockets' red glare sparkles with a high-tech touch over Longwood Gardens in Pennsylvania. For seven decades, extravaganzas featuring fireworks synchronized with sound, lights and fountains have drawn thousands of spectators to Longwood each summer. But since 1984, the first year the shows were planned and orchestrated by computer, they have become much more intricate and complex. Designers Colvin Randall and Ken Clark can now set timing cues to intervals as precise as one-sixteenth of a second, coordinating the actions of the 1,982 charges, the 1,700 fountain jets and the 600 lights to the sounds of Wagner's *Ring Cycle* opera. *Photo by Michael Bryant*

Stars shimmer in the cloudless sky above Hawaii's Mauna Kea, home to the powerful Keck I and Keck II telescopes. Supercomputers analyzing images captured by the telescopes recently pinpointed the existence of a galaxy 13 billion light years from earth. That achievement may soon be eclipsed by NASA's current project, a $44 million effort to develop a virtual telescope that will create images by combining the data from telescopes worldwide. *Photo by G. Brad Lewis*

The Making of a Silicon Chip

It comes from one of the most common elements on earth: sand. Just as steel and coal powered our past, silicon made from sand has become the foundation of our future. After undergoing an extraordinary transformation, this simple element, mined from the earth, eventually becomes the silicon wafers from which microchips are built.

Beginning deep in the earth, quartz, which is believed to make up 28 percent of the earth's crust, is mined in quarries and then shipped to one of the few companies that specializes in processing this element into purified silicon. One of these companies is Wacker Siltronic in Germany, where electric arc furnaces transform the quartz to metallurgical-grade silicon. In a process designed to further weed out impurities, the silicon is converted to a liquid, distilled, and then redeposited in the form of semiconductor grade rods, which are, at that point, 99.999999 percent pure. These rods are then mechanically broken into chunks (*above*) and packed into quartz crucibles, where they are melted at 2,593 degrees Fahrenheit.

A monocrystal seed is introduced to the melted silicon, and as the seed rotates in the melted silicon, a crystal grows (*below*). After a few days, the monocrystal is slowly extracted, resulting in a 5-foot-long ingot of silicon which, depending on its diameter, is worth from $8,000 to $16,000 (*right*). These pure silicon ingots,

J. Kyle Keener

shipped to customers. Every week, Wacker Siltronic produces around 800 ingots, enough to create more than 500,000 wafers.

In Hillsboro, Oregon, chip architects are developing the latest circuit designs in a never-ending quest to fit more transistors on a chip, thus increasing performance. Intel's first microprocessor, shipped in 1971 for Japanese calculators, held 2,300 transistors; the 300-megahertz Pentium II processor cartridge, released in May 1997, contains over 20 million. To check the location of transistors on a multilayered microprocessor, Intel layout experts examine a diagram of a chip on a computer screen. A magnified diagram, or die plot (*above*), shows the complexity of these microcircuits.

The architect's completed designs are then transferred to a mainframe computer and processed through an electron beam that "writes" these designs into a metal film on a piece of quartz glass, to make a mask (*left*). The making of a chip is a combination of repeating steps consisting of the application of a thin film, followed by photolithography and then etching, in which the mask acts much like a negative. Of paramount

Paul Chesley

weighing up to 264 pounds each, are then sliced by diamond saws into wafers, which are washed, polished, cleaned and inspected both visually (*far left*) and mechanically. The wafers are then scanned with lasers to find surface defects and particles less than 1/300th the width of a human hair before being

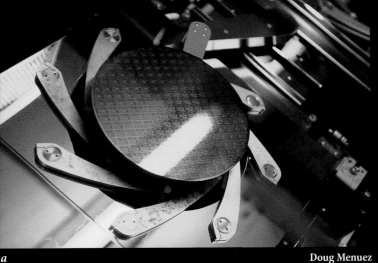

a Doug Menuez

b Doug Menuez

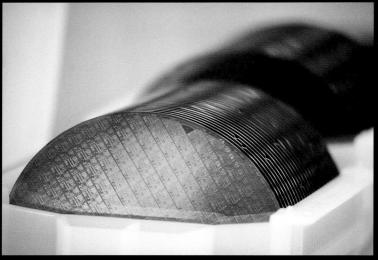

c Doug Menuez

d Doug Menuez

importance is the precise alignment of each mask: if one mask is out of alignment more than a fraction of a micron (one millionth of a meter), the entire wafer is useless.

When light is shone through the mask, circuitry designs are "printed" onto a wafer. Each newly designed chip requires approximately 20 masks that are

positioned as overlays at different points throughout the process—a journey that includes several hundred steps from wafer to finished chip. The primary steps include coating the wafer with an emulsion called "photoresist" under a special yellow light designed to avoid premature exposure (*a*); exposing the wafer to ultraviolet light through a mask to transfer the first layer of pattern onto the wafer; etching the pattern into the wafer and removing the photoresist so the next layer of circuitry can be applied; storing the wafers, before the next mask is applied, with alignment references notched on their edges (*b*); and loading the wafers, in lots of 25, into a "boat" for transport to an area where they'll be implanted with various elements to change each layer's particular electrical properties (*c*). An eight-inch wafer, seen here under inspection light (*d*), will host more than 200 Pentium II processor chips.

Each chip is tested throughout the entire process—both while part of a wafer and after separation. During a procedure known as "wafer sort," an electrical test is

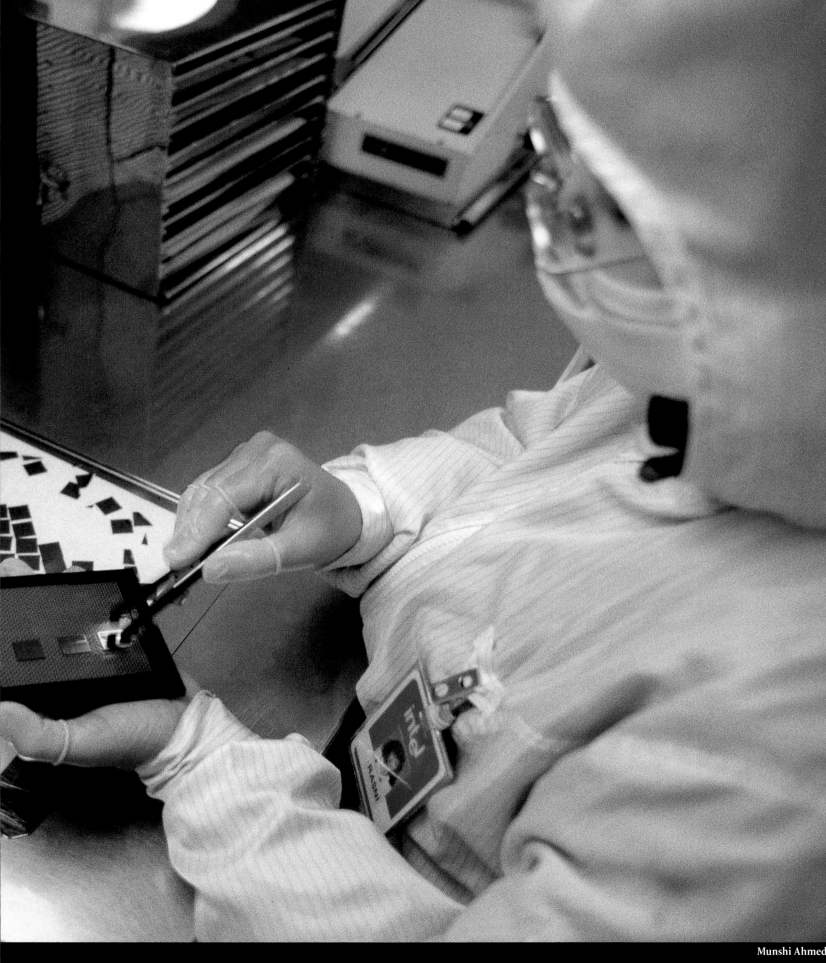

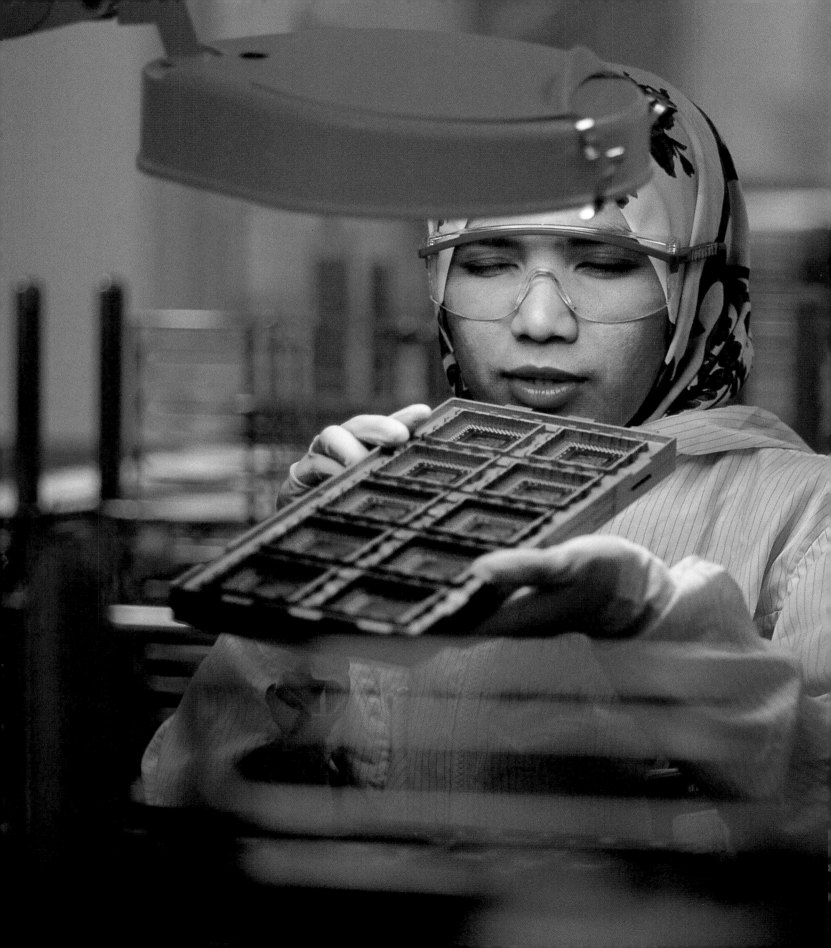

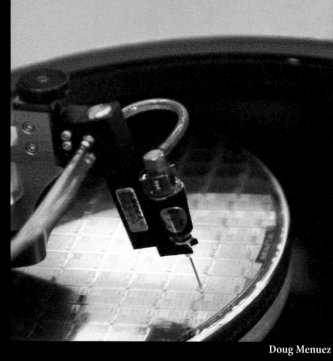

Doug Menuez

Munshi Ahmed

conducted to eliminate defective chips. Needle-like probes conduct over 10,000 checks per second on the wafer. A chip that fails a test for any reason in this automated process is marked with a dot of ink that indicates it will not be mounted in packaging (*above*).

When the chip-making process is complete, wafers are cut with a diamond saw in order to separate each individual chip, which at this point can be referred to as a "die." Once each die is separated (*previous page*), it is placed on a static-free plate to be transported to the next step—the "die attach"—where the chip is inserted into its "packaging." Chip packaging protects the die from environmental elements and provides the electrical connections needed for the die to communicate with the circuit board onto which it will later be mounted.

At an Intel plant in Penang, Malaysia (*left*), after a battery of sophisticated tests, a technician visually inspects a tray of finished processors before they are sent to a warehouse and used to fulfill customer orders.

The culture behind the scenes of chip fabrication is perhaps the most fascinating element of the process. The world's largest "fab," or chip fabrication factory, is in Rio Rancho, New Mexico, where production never stops, and the clean rooms alone cover the area of three football fields. An otherworldly atmosphere plays host to the technicians, who

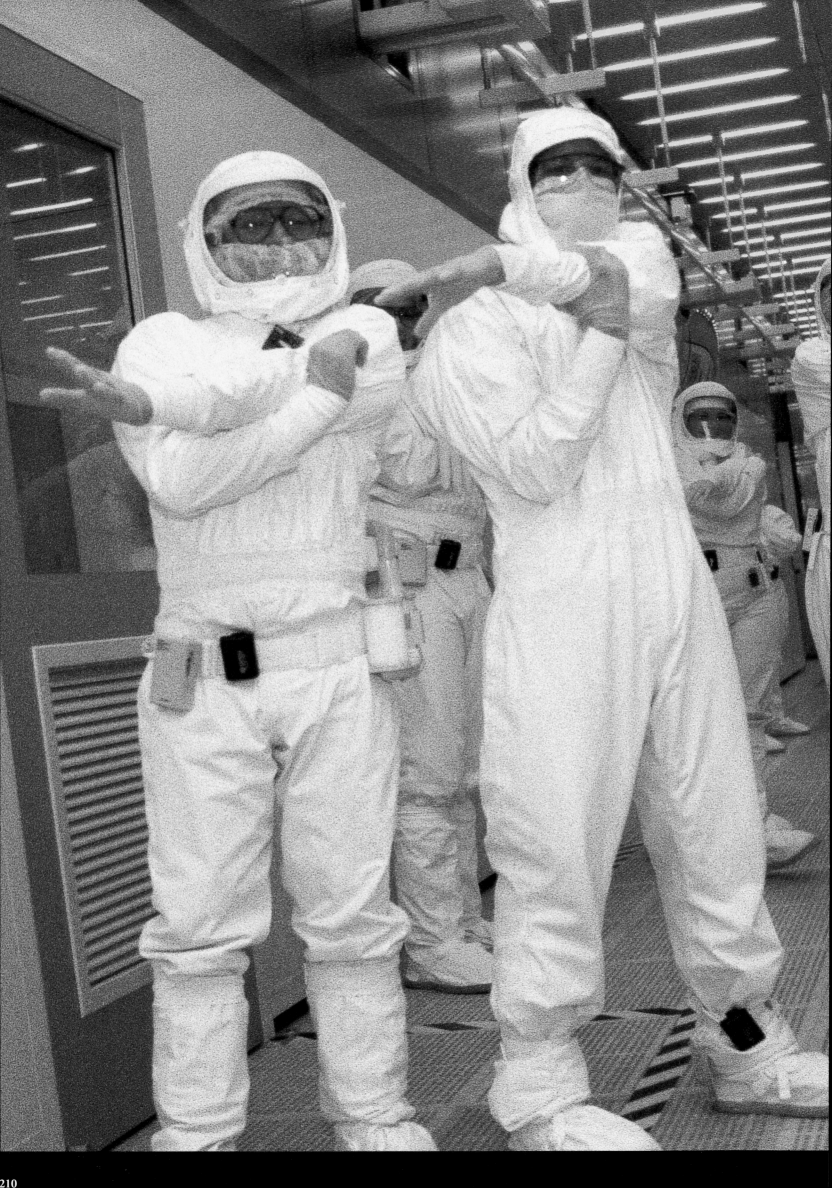

Doug Menuez

spend their 12-hour shifts encased in GORE-TEX® "bunny suits." Workers wear this required garb over their clothes to keep minute particles such as dead skin cells from contaminating the microscopic circuits.

To further minimize the presence of airborne particles, technicians wear helmets that pump their expelled breath through a special filter package (*above*). Powerful pumps in the ceiling also continually pour filtered air into the fab, replacing it eight times a minute.

Technicians take two stretch breaks before their day is done (*left*). These stretch sessions also become general meetings between shifts so that as one crew finishes up, it shares production updates with the new crew coming on.

With quality control done, the chips are ready for market. From wafer to chip to market, the process takes up to 45 days and is divided among Intel employees in over a dozen countries around the world—a global high-tech relay in which microchips, precious cargo of our age, are the baton.

Photos by Peter Ginter, J. Kyle Keener, Paul Chesley, Doug Menuez and Munshi Ahmed

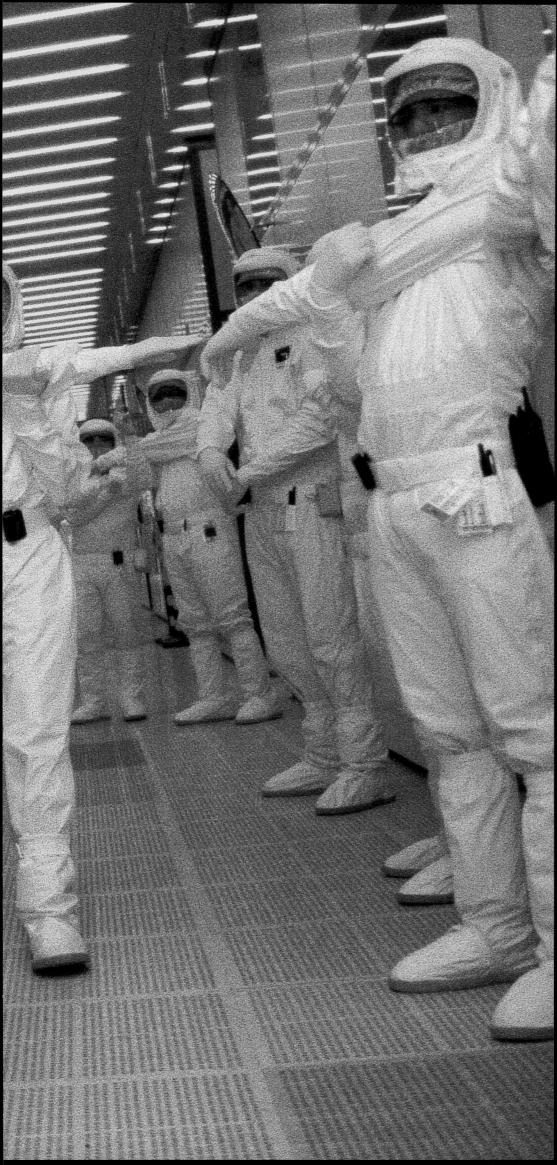

Doug Menuez

Photographers' Locations

The photographs in *One Digital Day* were all taken on the same day across the globe. The red dots on the map below represent the locations where the world's top photographers were dispatched to capture how microchips affect civilization on a typical day.

Jeffrey Aaronson, *Hong Kong, China*
Lori Adamski-Peek, *Salt Lake City, Utah*
Munshi Ahmed, *Penang, Malaysia*
Glenn Hernán Arcos Molina, *Atacama, Chile*
Eric Lars Bakke, *Denver, Colorado*
James Balog, *Denver, Colorado/ Chicago, Illinois*
Henry A. Barrios, *Bakersfield, California*
Pablo Bartholomew, *Bangalore, India*
Carol Bates, *Tashkent, Uzbekistan*
Nicole Bengiveno, *Poughkeepsie, New York*
Alan Berner, *Adelanto, California*
Ken Bohn, *San Diego, California*
Torin Boyd, *Tokyo, Japan*
Gary Braasch, *Newport, Oregon*
Sisse Brimberg, *Helsinki, Finland*
Michael Bryant, *Washington, D.C.*
Cindy Burnham, *Fort Bragg, North Carolina*
Paul Chesley, *Santa Clara, California*
Bradley E. Clift, *Bristol, Connecticut*
Bob Couey, *San Diego, California*
J. Scott Crist, *Sacramento, California*
Guglielmo de' Micheli, *Viareggio, Italy*
Michel Deschamps, *Bordeaux, France*
Arnaud de Wildenberg, *Paris, France*
Jay Dickman, *Colorado Springs, Colorado*
Brad Doherty, *Dallas, Texas*
David Doubilet, *Bimini Island, Bahamas*
Misha Erwitt, *Bronx, New York*
Melissa Farlow, *Louisville, Kentucky*
Dana Fineman-Appel, *Hollywood, California*
Natalie Fobes, *Seattle, Washington*
Frank Fournier, *Dakar, Senegal*
Bill Frakes, *Orlando, Florida*
Michael Freeman, *Manchester, England*
Raphaël Gaillarde, *Poitiers, France*
John Gaps III, *Des Moines, Iowa*

Peter Ginter, *Munich, Germany*
Diego Goldberg, *São Paolo, Brazil*
Annie Griffiths Belt, *New Orleans, Louisiana*
Lori Grinker, *Sarajevo, Bosnia*
Mehmet Gulbiz, *Istanbul, Turkey*
Dirck Halstead, *Fairfax, Virginia*
Keith Hamshere, *London, England*
Acey C. Harper, *Folsom, California*
Michael Hewitt, *Birmingham, England*
David Hiser, *Las Vegas, Nevada*
Fritz Hoffmann, *Shanghai, China*
Doug Hoke, *Oklahoma City, Oklahoma*
Nikolai Ignatiev, *Moscow, Russia*
Kenneth Jarecke, *Hamilton, Montana*
Ed Kashi, *Barcelona, Spain*
Karen Kasmauski, *Columbus, Georgia*
Shelly Katz, *Memphis, Tennessee*
J. Kyle Keener, *Hillsboro, Oregon*
Nick Kelsh, *Philadelphia, Pennsylvania*
David Hume Kennerly, *Portland, Oregon*
Roberto Koch, *Verona, Italy*
Kim Komenich, *Redwood City, California*
Emory Kristof, *Arlington, Virginia*
Steve Krongard, *Pasadena, California*
Kaku Kurita, *Tokyo, Japan*
Lois Lammerhuber, *Linz, Austria*
Michael Lange, *Stavanger, Norway*
Sarah Leen, *Long Beach, California*
Andy Levin, *San Francisco, California*
Alan Lewis, *Belfast, Northern Ireland*
Barry Lewis, *Leixlip, Ireland*
G. Brad Lewis, *Mauna Kea, Hawaii*
Steve Liss, *San Jose, California*
R. Ian Lloyd, *Singapore*
Jon Love, *Sydney, Australia*
Gerd Ludwig, *Rostov, Russia*
Leonard Lueras, *Denpasar, Bali*
Stephanie Maze, *Upper Saddle River, New Jersey*
Dilip Mehta, *Bangkok, Thailand*

Rudi Meisel, *Amsterdam, Netherlands*
Héctor Méndez-Caratini, *Mayaguez, Puerto Rico*
Doug Menuez, *Rio Rancho, New Mexico*
Peter J. Menzel, *San Anselmo, California*
Dod Miller, *Swindon, England*
David Modell, *Cambridge, England*
Jeffrey Morgan, *Newcastle, Wales*
Robin Moyer, *Manila, Philippines*
Richard Nugent, *Paducah, Kentucky*
Tony O'Brien, *Albuquerque, New Mexico*
Sam Ogden, *Cambridge, Massachusetts*
Randy Olson, *Pittsburgh, Pennsylvania*
Charles O'Rear, *Novato, California*
Ki Ho Park, *Taipei, Taiwan*
Mark Peters, *Johannesburg, South Africa*
Luis Fernando Pino, *Palmira, Colombia*
Larry C. Price, *Atlanta, Georgia*
Ollivier Pringalle, *Dubai, United Arab Emirates*
Philip Quirk, *Yuendumu, Australia*
Seth Resnick, *Lexington, Massachusetts*
Rick Rickman, *San Diego, California*
Steve Ringman, *DuPont, Washington*
Denise Rocco, *San Francisco, California*
Ricki Rosen, *Jerusalem, Israel*
Olivier Roux, *Geremie, Haiti*
Joel Sartore, *Urbana, Illinois*
Wes Skiles, *Arlington, Virginia*
Dana Slaymaker, *Maya Biosphere Reserve, Guatemala*
Rick Smolan, *Sun Valley, Idaho*
Tara Sosrowardoyo, *Kuala Lumpur, Malaysia*
Scott Thode, *New York, New York*
Joe Traver, *Rochester, New York*
Neal Ulevich, *Houston, Texas*
Mark R. van Manen, *Vancouver, Canada*
Stephen Wallace, *Mindoro Island, Philippines*
Theo Westenberger, *New York, New York*
Mark S. Wexler, *Chandler, Arizona*

Photographers' Biographies

Photographers

Jeffrey Aaronson, USA
Trained as a biochemist, Colorado-based Aaronson has produced award-winning photography for a host of major magazines, including *Time, Life, Newsweek, U.S. News & World Report, Fortune, Business Week, Condé Nast Traveler, Parade, Rolling Stone* and *Vanity Fair*.

Jeffrey Aaronson

Lori Adamski-Peek, USA
Adamski-Peek has covered seven Olympics from her base in Park City, Utah, and was the U.S. ski team photographer from 1983 to 1989. Her work has appeared in *Newsweek, Time, Sports Illustrated, Outdoor Photographer, Ski, Women's Sport and Fitness* and other magazines.

Munshi Ahmed, Singapore
For the past 21 years, Ahmed has covered Singapore and surrounding countries for various magazines, including *Fortune, Business Week* and *Asiaweek*. His images have also been featured in a number of books, including *Singapore: Island, City, State; Brunei: Abode of Peace; Singapore Celebrates*; and *The Lion and the Eagle: History of the Singapore Island Country Club*.

Glenn Hernán Arcos Molina, Chile
A graphic designer as well as a photographer, Arcos Molina is a correspondent for the Santiago-based daily *El Mercurio*.

Eric Lars Bakke, USA
A veteran of several *Day in the Life* book projects, Bakke is a contributing photographer for ESPN, the National Football League and Major League Baseball, and a contract photographer with Black Star. His work appears regularly in magazines such as *Time, Fortune* and *Sports Illustrated*.

James Balog, USA
Balog, an expert mountaineer and skier, has worked in the Canadian Arctic, the Himalayas and Easter Island on assignment for magazines including *National Geographic, Time, Life, Outside* and *Geo*. His books include *Wildlife Requiem*, a 1984 photographic examination of big-game hunting.

James Balog

Henry A. Barrios, USA
Barrios has been an award-winning newspaper photographer in California for 18 years.

Pablo Bartholomew, India
Affiliated with Gamma-Liaison, Bartholomew has twice won World Press awards. His photographs have appeared in publications worldwide, including *National Geographic, The New York Times, Paris Match* and *Geo*.

Carol Bates, USA
Trained as a sculptor and ceramicist as well as a photographer, Bates specializes in architectural photography and shooting for nonprofit organizations.

Nicole Bengiveno, USA
Based in New York, award-winning freelance photographer Bengiveno has photographed Central Asia and Albania for *National Geographic* and has participated in the *Day in the Life* book series since 1980. Her work appears regularly in *U.S. News & World Report*.

Alan Berner, USA
Berner, a staff photographer at the *Seattle Times*, holds college degrees in both philosophy and photojournalism. He has been named Regional Press Photographer of the Year three times. His work includes numerous projects of social concern, including Washington state's American Indian tribes, Seattle's homeless population, pollution and growth in the Northwest.

Ken Bohn, USA
San Diego-based Bohn is a staff photographer for Sea World of California. His work has been published in several major American newspapers, including *USA Today,* the *Chicago Sun-Times* and the New York *Daily News*.

Torin Boyd, Japan
Boyd began his career photographing for surfing magazines. Now a contract photographer in Tokyo for *U.S. News & World Report*, he has participated in seven *Day in the Life* projects.

Gary Braasch, USA
Braasch, specializing in nature and environmental photography, is a regular assignment photographer for *Life, Audubon, Natural History* and *The New York Times*. His images have also been published in more than 100 magazines worldwide, including *National Geographic, Discover, Time, BBC Wildlife, Geo* and *Scientific American*.

Sisse Brimberg, Denmark
Before moving to the United States in the mid-1970s, Brimberg established and managed her own photography studio in Copenhagen. She later joined the staff of *National Geographic*, where assignments took her around the world. She is now a freelancer.

Michael Bryant, USA
A winner of several regional Photographer of the Year awards, Bryant has participated in four *Day in the Life* projects. One of Bryant's images graces the cover of *A Day in the Life of Ireland*.

Michael Bryant

Cindy Burnham, USA
The assignment editor and senior photographer at the *Fayetteville Observer Times* in North Carolina, Burnham is the co-founder of Nautilus Productions, a freelance photography/video company. Her images have appeared on the covers and pages of *Newsweek, The New York Times, Army Times, USA Today,* the *Philadelphia Inquirer* and numerous other periodicals.

Paul Chesley, USA
Chesley, a freelancer based in Aspen, Colorado, has completed dozens of assignments for *National Geographic, Life, Geo* and other leading publications. Chesley has worked on 13 *Day in the Life* books as well as on *24 Hours in Cyberspace*, and his solo exhibitions have appeared in museums worldwide.

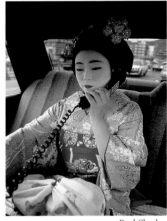

Paul Chesley

Bradley E. Clift, USA
Clift is a photographer for *The Hartford Courant*, and a participant in several *Day in the Life* projects. *A Day in the Life of California* featured one his images on the cover.

Bob Couey, USA
Couey, the photo services manager at Sea World of California, has published images in the *Los Angeles Times, The New York Times, People*, and *A Day in the Life of California*, among other publications.

J. Scott Crist, USA
Before joining Intel, where he first envisioned *One Digital Day*, Crist was an award-winning photojournalist who covered the Vietnam War, the famine in Africa and other major international stories. He has also worked as a film writer, producer and a new media project manager. Crist currently manages several internal communications programs at Intel.

Guglielmo de' Micheli, Italy
De' Micheli is a freelance photo-journalist whose work regularly appears in major American and European publications. A contributor to many *Day in the Life* books and *24 Hours in Cyberspace*, his work in *A Day in the Life of Ireland* earned him a prestigious Award of Excellence from *Communication Arts*.

Michel Deschamps, France
Deschamps is one of France's best-known sports photographers.

Arnaud de Wildenberg, France
A lawyer as well as a photographer, two-time World Press prizewinner de Wildenberg has covered international news stories for *Time, Stern, Paris Match* and other leading magazines. He is affiliated with the Gamma and Sygma photo agencies.

Jay Dickman, USA
Dickman, a Pulitzer Prize winner, is a contributor to *National Geographic, Time, Life, Fortune, Forbes* and other publications.

Brad Doherty, USA
Doherty worked as a staff photographer for the *Daily Texan* at the University of Texas, Austin, and was a photography intern for the *Quincy Patriot-Ledger* and the *Colorado Springs Sun*.

David Doubilet, USA
The world's premier underwater photographer, Doubilet has contributed to nearly 50 articles in *National Geographic*. His books include *Light in the Sea; Pacific: An Undersea Journey; Pearls*; and *Under the Sea from A–Z*, a children's book which he produced in collaboration with his wife, Annie.

Misha Erwitt, USA
New York native Erwitt began taking pictures at age 11. His work has been published in major U.S. magazines, and he has participated in eight *Day in the Life* books. He is now on the staff of the New York *Daily News*.

Misha Erwitt

Melissa Farlow, USA
Farlow, an award-winning photographer and teacher, has participated in several *Day in the Life* books as well as in *24 Hours in Cyberspace*. She is a regular contributor to *National Geographic*, and she recently documented several African families for *Women in the Material World*, a book examining the lives of women in various cultures around the world.

Melissa Farlow

Dana Fineman-Appel, USA
A contributing photographer at *Life* magazine, Fineman-Appel has participated in several *Day in the Life* books.

Natalie Fobes, USA
Fobes, who is based in Seattle, is a recipient of the prestigious Alicia Patterson Foundation grant. Her book, *Reaching Home: Pacific Salmon, Pacific People*, won numerous awards and spawned several other book and CD-ROM projects.

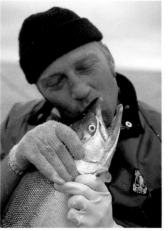
Natalie Fobes

Frank Fournier, France
Fournier trained as a doctor before becoming a photojournalist. He has covered the Rwandan massacres, the war in Bosnia, the Los Angeles Olympics and rescue efforts in the aftermath of the eruption of Colombia's Nevado del Ruiz volcano. His work has won several World Press Photo Foundation awards and has appeared in *National Geographic, Time, Newsweek, Stern* and *Life*.

Bill Frakes, USA
A contract photographer for *Sports Illustrated*, Frakes has participated in several *Day in the Life* books. He was on the *Miami Herald* photographic staff when it won a Pulitzer Prize in 1992.

Michael Freeman, UK
Freeman, holder of a Masters Degree in Geography from Brassenose College, Oxford University, has been widely published in magazines such as *Smithsonian, Life, International Wildlife, Stern, Paris Match, GQ, National Geographic, Omni, Geo* and *Condé Nast Traveler*.

Raphaël Gaillarde, France
A leading photographer with Gamma-Liaison, Gaillarde has published his photographs in *Paris Match, Geo*, and other major magazines in Europe. Among his several World Press awards is the prestigious Oskar Barnack prize.

John Gaps III, USA
Gaps has worked for the Associated Press for the past 10 years, doing general assignment and combat photography.

Peter Ginter, Germany
Ginter's awards include the 1992 Gold Award from the World Press Photo Foundation.

Diego Goldberg, Argentina
Director of photography at *Clarin*, the Buenos Aires newspaper that is the world's largest circulation Spanish-language daily, Goldberg is among the jurors for the Eugene Smith and World Press Photo Awards.

Annie Griffiths Belt, USA
Griffiths Belt, born and raised in Minneapolis, is a regular contributor to *National Geographic*. Her award-winning photography has also appeared in *Life, Geo, Fortune, Stern* and many other publications. Her book credits include *A Day in the Life of Ireland, Baseball in America, The Power to Heal, Women in the Material World, A Day in the Life of Hollywood*, and *A Day in the Life of Italy*.

Lori Grinker, USA
Grinker's work has taken her to the Middle East, Southeast Asia, Eastern Europe, the former Soviet Union and Africa. Her work has been exhibited in museums and galleries in Paris, Arles,

Amsterdam, Jerusalem, Miami, Chicago, Santa Fe and New York. Photos from her book, *The Invisible Thread: A Portrait of Jewish American Women*, are part of the permanent collections of the Israeli Museum in Jerusalem, the Jewish Museum in Amsterdam and the Jewish Museum of New York City.

Mehmet Gulbiz, Turkey
Gulbiz shoots regularly for *Der Spiegel*, and is associated with SIPA Press of Paris and the Focus Agency of Hamburg.

Dirck Halstead, USA
Time magazine's senior White House photographer, Halstead began his career covering the Guatemalan revolution of 1954. Since then, he has traveled worldwide on assignment for UPI and *Time*.

Keith Hamshere, UK
Hamshere is a unit photographer whose film work includes more than two dozen major motion pictures since 1985, including *Immortal Beloved, Patriot Games, Hamlet, Great Balls of Fire* and *The Last Emperor*.

Acey C. Harper, USA
Part of the original staff of *USA Today*, California-based Harper has traveled worldwide for magazines such as *People, National Geographic* and *Time*. He has won numerous awards for photography and photo editing and has contributed to several book projects.

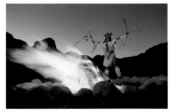
Acey Harper

Michael Hewitt, UK
Hewitt, who specializes in sports photography, burst onto the world scene at the 1992 Olympics in Barcelona. Since then he has found a niche covering motor sports, particularly Formula 1 racing and ocean yacht racing. He is affiliated with the Allsport agency.

David Hiser, USA
An award-winning outdoor-oriented editorial photographer and photo educator, Hiser has produced work for *National Geographic, Audubon* and *Life*.

Fritz Hoffmann, USA
Hoffmann, a former staff photographer for *The Knoxville News-Sentinel*, joined Network Photographers in 1996. The London-based picture agency covers assignments for major world news, business and feature publications as well as for corporate and advertising clients.

Doug Hoke, USA
In addition to working at *The Daily Oklahoman* as a staff photographer for 20 years, Hoke has worked for *Sports Illustrated, Fortune, Business Week, Sport, Entrepreneur, People* and Disney Adventures.

Nikolai Ignatiev, Russia
Moscow-born Ignatiev took up photography after serving two years in the Soviet Army as a military interpreter in Afghanistan. His first published picture appeared in *Newsweek* in 1984. Now a professional photographer based in Great Britain, he returns regularly to Russia on assignments.

Kenneth Jarecke, USA
Jarecke began his career in 1982 as a freelancer for the Associated Press while still a student and football player at the University of Nebraska. A former *Time* photographer, he is now at *Newsweek*, and has covered turmoil in Haiti, Northern Ireland and the Persian Gulf. The award-winning Jarecke has also produced cover stories for *Life, Sports Illustrated, Fortune, The New York Times Magazine* and other publications.

Ed Kashi, USA
Since 1991, Kashi has worked almost exclusively for *National Geographic*, specializing in Middle East issues. His cover story on the Kurds for *National Geographic* inspired his book, *When the Borders Bleed.*

Ed Kashi

Karen Kasmauski, USA
Kasmauski, born in Japan, has traveled worldwide as a regular photographer for *National Geographic*. Her April 1995 story

on Ho Chi Minh City appeared on the cover. Her work has also appeared in *The Power to Heal* and several other book projects.

Karen Kasmauski

Shelly Katz, USA
Katz has covered every major U.S. presidential campaign since 1959, as well as wars, riots, earthquakes and turmoil in the Middle East. He has been a contract photographer for *Time* and has participated in several *Day in the Life* projects.

J. Kyle Keener, USA
A four-time winner of the regional Photographer of the Year award, Keener has traveled extensively and has covered the AIDS crisis in Uganda, Nelson Mandela's release from prison in South Africa and ethnic violence in Rwanda. He is a staff photographer for the *Detroit Free Press.*

Nick Kelsh, USA
Kelsh has been the recipient of numerous photographic awards for his work, which has appeared in *Newsweek, Life, National Geographic, Geo* and other major magazines. In 1996, he collaborated with Pulitzer prize-winning author Anna Quindlen to create the book *Naked Babies,* now in its fifth printing.

David Hume Kennerly, USA
A former personal photographer for President Gerald Ford, Kennerly won a Pulitzer Prize in 1972 for his coverage of the Vietnam War. His storied career has included stints at *Time, Newsweek, Life* and UPI and has taken him on assignment to more than 125 countries. He is a contributing correspondent for ABC's *Good Morning America Sunday,* and has produced Emmy Award–winning feature films for television. He has also been a photographer on five *Day in the Life* book projects, as well as on *Passage to Vietnam.*

Roberto Koch, Italy
Koch, who holds a Ph.D. in electronics, has exhibited his photos internationally and been published widely in the world press. *Istanti di Russia,* a collection of his best work in Russia, won the Kodak prize for photography in 1988.

Kim Komenich, USA
San Francisco Examiner staff photographer Komenich received the 1987 Pulitzer Prize for his coverage of the Filipino revolution. His work has appeared in *Life, Newsweek, Time* and other magazines, and he has taught advanced documentary photography for a decade.

Emory Kristof, USA
A staff photographer at *National Geographic* for 30 years until his retirement in 1994, Kristof is a pioneer in high-tech deep-water photography.

Steve Krongard, USA
Award-winning photographer Krongard lives in an 18th-century farmhouse outside of New York City. He shoots in his SoHo studio, as well as around the world, for a variety of corporate clients in the airline, technology, banking and other industries.

Kaku Kurita, Japan
Kurita, one of Japan's most successful international photojournalists, began his career at the Tokyo Olympics in 1964. He has been affiliated with Gamma-Liaison in Tokyo for 22 years.

Lois Lammerhuber, Austria
Self-taught as a photographer, Lammerhuber is a regular contributor to *Geo.*

Michael Lange, Germany
Lange's work has appeared in many European and American magazines, including *Stern, Geo, Fortune* and *Discover.*

Sarah Leen, USA
Leen's work appears regularly in *National Geographic*, and she has participated in six *Day in the Life* books. She has been an instructor at the Missouri Photo Workshop and the Maine Photographic Workshop.

Andy Levin, USA
Levin, a contributing photographer at *Life* who has participated in 10 *Day in the Life* projects, has won awards from the Art Directors Club and the National Press Photographers Association.

Alan Lewis, UK
The founder of Belfast's Photo Press Agency, Lewis has twice been named Northern Ireland's press photographer of the year. Winner of numerous other awards, he was also a contributor to *A Day in the Life of Ireland.*

Barry Lewis, UK
A former school teacher, Lewis won the World Press Photo's Oskar Barnack Award in 1991. Lewis has worked on many books and magazines, including the *London Sunday Times Magazine, Life, Geo, Fortune* and *Newsweek.*

G. Brad Lewis, USA
Lewis lives in Hawaii on the flank of Kilauea, the most active volcano on earth. Internationally recognized as a leading volcano photographer, he has published images in numerous publications including *National Geographic, Time, Life, Newsweek, Outside, Summit, Omni, Outdoor Photographer, Geo* and *Stern.* His work is also used in advertising, books, and calendars. His nature images were exhibited at the United Nations Earth Summit in Rio de Janeiro.

Steve Liss, USA
Liss, an award-winning photographer, has had more than two dozen pictures grace the cover of *Time,* for which he has covered presidential campaigns for several decades.

Steve Liss

R. Ian Lloyd, Singapore
Lloyd's work has appeared in 30 books on Asia and on the covers

of *Newsweek, National Geographic, Traveler* and *Business Week*. His photograph was chosen for the cover of *24 Hours in Cyberspace*.

Jon Love, Australia
Love apprenticed with Gregory Heisler and several other New York-based photographers in the mid-1980s before beginning his own career as a shooter for *New York Magazine, Parade, Forbes, Newsweek* and *Business Week*. He now works with a wide range of corporate and advertising clients in Australia and other countries.

Gerd Ludwig, Germany
The co-founder of Visum, Germany's first photographer-owned photo agency, Ludwig has worked in more than 70 countries. His most recent assignments have focused on changes in Russia and Eastern Europe since the collapse of the Soviet Union and the fall of the Berlin Wall. His work has appeared in *National Geographic, Stern, Spiegel, Time, Life, Newsweek, Fortune, Geo* and other magazines.

Leonard Lueras, USA
For the past 12 years, Lueras has been based on the Indonesian island of Bali. A writer, designer and publisher as well as photographer, he has produced scores of books during the more than three decades he has lived in the Asia-Pacific region.

Stephanie Maze, USA
An award-winning photographer formerly on the staff of the *San Francisco Chronicle*, Maze has been published in *National Geographic, Geo, Newsweek, Time, People, The New York Times Magazine* and other publications. She has covered three Olympic Games and participated in 10 *Day in the Life* projects; other book credits include *The Power to Heal, Passage to Vietnam* and *Women in the Material World*. Her latest project is a series of children's books about various adult occupations, entitled "I Want to Be...."

Dilip Mehta, Canada
Acclaimed worldwide for his coverage of the Bhopal disaster and for his documentation of the Gandhi family's political careers, Mehta now spends about half his time on assignment outside of India. When in the country, he covers the modernization of India as seen in the growth of high-tech industry and the explosion of a middle-class economy. His work has appeared in *Time, Newsweek, Life, The New York Times Magazine, National Geographic, Fortune, Stern, Geo* and other magazines.

Rudi Meisel, Germany
Meisel's work has appeared in *Stern, Spiegel, Geo, Art* and *The Economist*. He has also taken part in several *Day in the Life* projects.

Héctor Méndez-Caratini, Puerto Rico
Méndez-Caratini, whose award-winning work has documented the evolving cultural heritage of Caribbean nations, has photographs in the permanent collections of The Metropolitan Museum of Art, The Center for Creative Photography, The Fine Arts Museum in Venezuela and the Institute of Puerto Rican Culture.

Doug Menuez, USA
Menuez's work has appeared in six *Day in the Life* books, as well as in *The Power to Heal, Circle of Life, 24 Hours in Cyberspace* and *The African Americans*. He is the founder of Reportage, an agency specializing in black-and-white photojournalism for corporations, and was the co-producer of *15 Seconds: The Great California Earthquake of 1989*, a book that raised more than a half-million dollars for earthquake victims.

Peter J. Menzel, USA
Menzel is best known for his two most recent books, *Material World: A Global Family Portrait*, and *Women in the Material World*. The California-based photographer's work has appeared in many national and international publications including *National Geographic, Life, Forbes, U.S. News*

Peter Menzel

& World Report, Smithsonian, The New York Times Magazine, Geo, Stern, Paris Match and *Le Figaro*.

Dod Miller, UK
Miller grew up in the former Soviet Union, the United States, and South Africa, and began his photography career as a freelancer for the *London Times* in the mid-1980s.

David Modell, UK
Winner of multiple awards, Modell works on assignment for virtually every major European magazine.

Jeffrey Morgan, UK
An engineer who also works as a freelance photographer and lecturer, Morgan is an award-winning regular contributor to the *Guardian*.

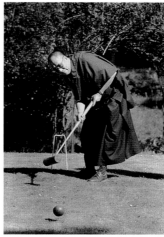
Jeffrey Morgan

Robin Moyer, USA
A longtime resident of Asia, Manila-based Moyer has been photographing for *Time* since 1979. In 1983 he won numerous awards for his work in Lebanon, including the World Press Picture of the Year.

Richard Nugent, USA
Nugent was a co-recipient of the Pulitzer Prize in 1976 while working as a staff photographer for the *Louisville Courier-Journal Sunday Magazine*. Ten years later he teamed with another Pulitzer Prize winner, author John Ed Pearce, on a two-year book project to document the Ohio River.

Tony O'Brien, USA
For *Life* magazine, O'Brien has covered the wars in Afghanistan and the Persian Gulf, a Mount Everest expedition and daily life in a monastery.

Sam Ogden, USA
Photographs by Ogden, a native Bostonian who specializes in science and high-tech, have been published in most major science magazines. A regular contributor to *Scientific American* and *Science*, he recently completed a book with renowned pediatrician T. Berry Brazelton.

Randy Olson, USA
Olson has shot several assignments for *National Geographic*. A former staff photographer at the *Pittsburgh Press*, his awards include Newspaper Photographer of the Year, an Alicia Patterson Fellowship and the Robert F. Kennedy Award.

Charles O'Rear, USA
A winemaker in California's Napa Valley, O'Rear is a former staff photographer for the *Los Angeles Times* who has shot two dozen stories for *National Geographic*. Co-founder of stock agency Westlight, he has also published books on Silicon Valley and the Napa Valley.

Charles O'Rear

Ki Ho Park, Korea
A graduate of the Rhode Island School of Design, Park currently operates Kistone Photography. His work has appeared in *Forbes, Fortune, Business Week* and many other magazines.

Mark Peters, Zimbabwe
Born in Zimbabwe, Peters began his career as a news photographer for his native country's *Bulawayo Chronicle*. Since becoming a South Africa-based contract photographer in 1984, he has covered major news stories such as the Persian Gulf War and conflicts in Afghanistan, Israel, China, Rwanda and Somalia. His February 1990 *Newsweek* cover photograph was the first image of Nelson Mandela as a free man to be transmitted around the world.

Luis Fernando Pino, Colombia
Pino is an award-winning photographer who has exhibited his work throughout Latin America.

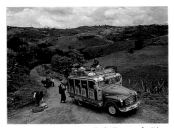
Luis Fernando Pino

Larry C. Price, USA
Price has won two Pulitzer Prizes—one in 1981 for his coverage of the coup in Liberia, the other in 1985 for his photographs of Angola and El Salvador. He is currently on staff at the *Fort Worth Star-Telegram*.

Ollivier Pringalle, France
Pringalle specializes in fashion and advertising photography.

Philip Quirk, Australia
Quirk, a member of the Wildlight Photo Agency, is represented in the collection of the National Gallery of Australia. His recent books include *Wildlight: Images of Australia* and *Farm: Life on the Land*.

Seth Resnick, USA
Resnick's work has been published in *Business Week, Forbes, National Geographic, Newsweek, The New York Times, Time* and *Travel and Leisure*, among other publications. He maintains a Web site designed to market both assignment and stock photography and to deliver images digitally to clients around the world.

Rick Rickman, USA
A Pulitzer Prize winner, Rickman has traveled around the world on assignment for *National Geographic* and other publications.

Steve Ringman, USA
Ringman, a staff photograher at the *Seattle Times*, has twice been named Photographer of the Year by the National Press Photographers Association.

Denise Rocco, USA
Rocco coordinated book and CD-ROM development for two major Against All Odds projects—*From Alice to Ocean* and *Passage to Vietnam*. A specialist in digital photography, she shot Microsoft's *Mungo Park* adventure travel magazine in Mali, Cambodia and the Fiji Islands. She also participated in the *24 Hours in Cyberspace* project.

Denise Rocco

Ricki Rosen, Israel
Rosen is currently working on two books: one on Jerusalem, and the other on the immigration to Israel of a half-million refugees from Ethiopia and the former Soviet Union.

Olivier Roux, France
Based in Luxembourg, Roux works for the international relief agency Médicins Sans Frontières.

Joel Sartore, USA
Sartore, a regular contributor to *National Geographic*, has lived in Nebraska nearly all his life. His latest book is *The Company We Keep: America's Endangered Species*.

Wes Skiles, USA
A television and documentary filmmaker as well as a still photographer, Skiles is best known for his work in the adventure realm. He has more than 100 shows to his credit as a producer, director and cameraman.

Dana Slaymaker, USA
After two decades of experience as a professional photographer, Slaymaker returned to graduate school to become a remote sensing specialist. His work has been exhibited at the Phoenix Museum of Art, the Tucson Museum of Art and the New Mexico Museum of Fine Art, among other venues.

Dana Slaymaker

Rick Smolan, USA
A former *Time, Life,* and *National Geographic* photographer, Smolan has spent a decade finding ways to place himself and his projects directly in the path of the converging worlds of photography, design and publishing technology. In 1981 he created the *Day in the Life* book series—including *A Day in the Life of America*, the best-selling photographic title in American history. Four of the books have been featured on the covers of *Time* and *Newsweek*.

Tara Sosrowardoyo, Indonesia
Sosrowardoyo's work has appeared in *Time, The New York Times, Newsweek, Vogue, Geo, Marie Claire, Islands, Asiaweek, Asia Magazine* and *Discovery*. His book credits include *Passage to Vietnam* and *24 Hours in Cyberspace*. He is a co-founder of Indo-Pix, a stock agency that specializes in images of Indonesia.

Scott Thode, USA
Thode's work has been exhibited at the Visa Pour L'Image photo festival in Perpignan, France; the Electric Blanket AIDS Project; the Colonnade Gallery in Washington, D.C.; and the P.S. 122 Gallery in New York City.

Joe Traver, USA
Traver was the first freelance photographer to be elected president of the National Press Photographers Association. He was the 1990 National Football League Photographer of the Year.

Joe Traver

Neal Ulevich, USA
Ulevich won a Pulitzer Prize in 1977 while a news photographer for the Associated Press. He now works for the Communications Department of AP, where he assists in implenting new digital imaging, wireless communications and advanced archiving techniques.

Mark R. van Manen, Canada
Vancouver Sun staff photographer van Manen began working in newspapers while still a teenager and first started shooting freelance assignments for the *Sun* while working in the paper's photo lab. His assignments have since taken him around the world.

Stephen Wallace, USA
Wallace, a graduate of Georgetown University's school of foreign service, is a self-taught photographer based in Southeast Asia. He is represented by the Black Star Agency.

Theo Westenberger, USA
Westenberger has photographed for *Life, Newsweek, Smithsonian, Sports Illustrated, Condé Nast Traveler, Time, Money, Fortune, Entertainment Weekly* and *People*. The U.S. Postal Service honored her by using two of her photographs of American Indian dancers on 32-cent stamps.

Mark S. Wexler, USA
Wexler has covered such diverse topics as the American South for *National Geographic* and Japanese youth for *Smithsonian*. He won three World Press awards for his work on *A Day in the Life of Japan*.

Writers

Michael S. Malone, USA
Malone is the author of *The Microprocessor: A Biography* (Telos/Springer-Verlag), *The Big Score, Going Public* and co-author of *The Virtual Corporation*. He was one of the nation's first technology business reporters at the *San Jose Mercury-News*, and he has written for other newspapers and magazines throughout the world, including a column for *The New York Times*.

Bernard Ohanian, USA
Ohanian is the editorial director of international editions for *National Geographic*. He has held senior positions on the staffs of several other magazines, including *MacWEEK, Mother Jones, Publish* and the *Berkeley Monthly*, and has written and/or edited the text for numerous books of photojournalism, including *Baseball in America, A Day in the Life of Italy, The Face of Mercy, A Day in the Life of Ireland, The Power to Heal* and *In Pursuit of Ideas*.

Contributors, Advisors and Friends

Contributors

717 Trading Company
A & I Color
ABC World News Tonight
Accel Partners
Adobe Systems, Inc.
AG World Transport
Amazon.Com
Art Center College of
 Design
Atlanta Braves
Audobon Center for
 Research on
 Endangered Species
Avenue Grill
Barangay Bangkal
 Volunteer Fire Brigade
Baylor University Medical
 Hospital
Big Foot
Bloemenveiling Aalsmeer
Boston Computer
 Museum
Boston Edison Co.
Caterpillar, Inc.
Colorbar
Computer Chronicles
Cunningham
 Communications
Dallas Semi-Conductor
Defcon Conference
DiamondSoft
Digital Wisdom, Inc.
Dinan Engineering
Dowling & Dennis
Drive Savers
E•motion Studios
Eastman Kodak Company
Eber Electronics
EDventure Holdings
El Periódico
Evans & Sutherland
 Computer Corporation
Ex Machina
Extensis
Faulkner Color Lab
Federal Express
FemRx
Flathead Indian
 Reservation
Fleishman Hillard
 Hickson Singapore
Fortune Magazine
Fotoservizi per la Stampa
Frantoio Restaurant
Ft. Benning, Georgia
Ft. Bragg, North Carolina
General Atomics
 Aeronautical Systems,
 Inc.
Greenpeace Australia
Hi Fi
IBM Almaden
 Research Lab
Inside Edition

Institute For The Future
INTERACTIVE8
International Center for
 Tropical Agriculture
Intuit
Jhane Barnes, Inc.
Johnson Space Center
Karco Engineering
Keck Observatory
Kennywood Amusement
 Park
Kessler Institute
Koonce Financial Services
Lake Compounce
 Amusement Park
Levi Strauss & Co.
LSU Center for Advanced
 Microdevices
Lucasfilm, Ltd.
LXN Corp.
Macy's
Manitoba University
Marin Convention and
 Visitors Bureau
Maritiem Museum Prins
 Hendrik
Maroevich, O'Shea &
 Coghlan
Marshall Space Flight
 Center
Martin & Harris
 Appliances
Médecins Sans Frontières
Melcher Media
MetaCreations
Metagraphics
MIT Media Lab
Mixman Technologies
Mullen & Deadder
 Consulting
NASA Jet Propulsion
 Laboratory
NASA Johnson Space
 Center
National Center for
 Supercomputing
 Applications
University of Illinois at
 Urbana-Champaign
National Hydrologic
 Warning Council
NetNoir
Netscape
 Communications
New York City Public
 School for the Deaf
New York Stock Exchange
Newcastle Emlyn Satellite
 Centre
Newer Technology
Nocturne Productions
Nokia Communications
Odwalla
Orbis International
Oy Netsurfer Ltd.
Perini Navi

Philippine Domestic
 Terminal Management
Piazza D'Angelo
 Ristorante
Poppe Tyson Interactive
Port of Singapore
 Authority
Presse Sport
Priority EMS
Protozoa
Public Art for Public
 Schools
New York Division of
 School Facilities
Pupils of Ysgol Ddwylan
Pure Food Fish Market
Quark, Inc.
Redwood City Police
 Department
Ripley International
Roswell Bookbinding
Royal Netherlands
 Embassy
Sandia National
 Laboratories
Schenkein-Sherman
Shandwick Public
 Relations Hong Kong
Sharkpod
Sheil Land Associates
Sheila Donnelly &
 Associates
Singapore Discovery
 Centre
Sony Corporation of
 America
St. Jude's Children's
 Hospital
Stanford Alumni
 Association
StatOil
TED Conferences, Inc.
Telesensory, Inc.
Temple Expiatori de la
 Sagrada Família
The Agency
The Alexander Group
The Beckwith Group
The Microprocessor
 Report
The Mid-Atlantic Stone
 Center
The National Geographic
 Society
The Promotions Co.
The Smithsonian
 Institution, National
 Museum of American
 History
The Sony IMAX Theatre
The Xeroderma
 Pigmentosum Society,
 Inc.
Tiburon Lodge
Time Inc. Picture
 Collection

Tokyo Hilton
 International
Toto USA
United Airlines
United Artists Starport
United States Army &
 Navy
Universal Studios
University of Rochester
UPS
U.S. Olympic Training
 Center
U.S. Peace Corps Senegal
U.S. Robotics/Megahertz
U.S.G.S. Hawaii Volcano
 Observatory
Virtual Jerusalem
Wacker Siltronic
Wildfire Communications
World Economic Forum

Advisors and Friends

Alexandra Able
James Able
Zachary Able
Bill Abrams
Ames Adamson
Dan Adler
Noorilah Ahmad
Tan Wea Aik
Rhoda & Ira Albom
Dianne Alexander
Jerry Alexander
Jodie Allen
Paul Allen
David Allison
Monica Almeida
Stewart Alsop
John Altberg
Sol Amon
Great Ancheta
Craig Anderson
David Anderson
Jane Anderson
Leslie Anderson
Lisa Rene Anderson
Marc Andreessen
John F. Andrews, M.S.
Amit Anter-Kertes
Kasin Aramsereevong
Beau Arcenaux
Mahrokh Arefi
Mark Armstrong
David Arnold
Samir Arora
Lance Arsenault
Karen Arthur
Steve Ashby
Nathalie Atherall
Bill Atkinson
Fred Aurelio
Annette Ayala
Puan Azizah
Louis Baca
Mike Backes

Quentin Bacon
Tim Bajarin
John Baker
Vijayasundram
 Balasundram
Anat Balint
Lea Balint
M. Bara
Tonik Barber
Theresa Barbour
John Perry Barlow
Rick Barnes
Andrew & Lissa Barnum
Ed & Rena Barnum
Lori Barra
Mark Barrett
Robin Ruse-Rinehart
 Barris
Meggo Barthlow
Jim Bartlett
Randy Battat
Mary K. Bauman
Jane Bay
Carla Bayha
Emilie R. Baylon
David Beckwith
Martin Bell
Keith Bellows
Mortem Bendiksen
Jim Bennett
Tom Bentkowski
Randi Benton
Arthur Bentula
Maura Bergen
Gussie Bergerman
Peter Bergman
Dave Berhman
Bill Berkman
Ashley Berkowitz
Andy Berlin
Judy Bermas
Richard Bernstein
Patrick Berry
Paul Berry
Tom Bettag
Gaia Bianchi di Lavagna
Carole Bidnick
Fred Bishop
Michael Bland
Barbara Blum
Michael Boatright
Ralph Bond
Jordi Bonet
Amy Bonetti
Ivar Bore
Diane Boumans
Ken Boumans
Pierce & Donna Bounds
Kelly Bowen
Declin Boyle
Jessica Brackman
Keith Bradley
Steve Bradt
Holly Brady
Paul Brainerd
Joe Brancatelli

Cabell Brand
Stewart Brand
Christy & Mark Brasseaux
Michael Braun
Sylvie Braun
Brigid Breen
Dick Brescani
Francois Bressy
Christiane Breustedt
Dave Briggeman
John Brisch
Sue Brisk
Sgt. Don Brister
David Broad
Dan Brockbank
Brian Brooks
Garth Brooks
Roberta Brosnaham
Daniel Brown
David Brown
John Seely Brown
Margot Brown
Michael Brown
Scott Brownstein
Matt Bruno
Ed Bruso
Al & Dawn Bunetta
Dr. John Burd
Kate Burleigh
Joan Burler
Sarah Burnette
Diane Burns
Dean Burrell
Robert Burrows
Robert Olin Butler
George Butters
Bill Cahan
Liam Cahill
Bill Calder
Katie Calhoun
Mild Calingo
Sean Callahan
Reid & Cathy Callanan
Nicholas & Yukine
 Callaway
Elsa Cameron
Claire Campana
Bill Campbell
Ed Campion
Jim Cannavino
Maggie Cannon
Marc Canter
Ron Cao
Steve Capps
Ken & Janet Carbone
Dave Cardinal
Bart Carlson
Helen Carrigan
Oscar Carrion
Tim Carroll
Todd Carter
Denise Caruso
John Caruthers
Joan Casadevall
Frank Casanova
Dan Case

Dr. Frank Catchpool	John Cranfill	Raya Dueñas	Kathleen Fritz	Zane Healy	George Jardine
Robert Cavallo	Liz Bond Crews	Dave Duggal	Dov Frohman	Duvall Hecht	Ned Jaroudi
Jim Cavuto	Deborah Crist	Agathe Dumond	Greg Frux	Kate Heery	Mac Jeffrey
Vergel Cenido	Kim Criswell	Hal Duncan	Brenda Fuller	Skip & Kathleen Heinecke	Gail Jeness
Alvin Cha	Chris Crompton	Tara Dunion	Dale Fuller	Ginny Heinlein	Natalie Jenkins
Ellen Chaffee	Heidi Cuttler	John & Eileen Dunn	Josh Gabriel	Greg & Pru Heisler	Peter Jennings
Cathy Chakmakian	Marie D'Amico	Eric Dura	John Gage	Ray Heizer	Bill Jesse
John Chambers	Junaidah Dahlan	John Durniak	Federica Gaida	Abbe Heller	DeShawn Johnson
Bob Chandler	Yogan Dalal	Billy & Betty Durrett	Dave Galat	Muriel Hermanns	Judith & Richard
Jan Chang	Brendan Daley	Oscar Dystel	Orange Galindo	Greg Hermsmeyer	Johnson-Marsano
Dave Chapman	Sky Dalton	Mary Dawn Earley	Pat Gallup	Jenny Hernandez	Scott Johnston
Petcharaporn	Kay Dangaard	Fred Ebrahimi	Sandra Gan	Rosa Herrington	Brennon Jones
Charoennibhonvanich	Linda Daniel	Steve Edelman	Marvin & Leslie Gans	Carolyn Herter	David Jones
Dicky Cheah	Bahman Dara	Major Michael Edrington	Ginger Gary	James Higa	James Jones
Cory Check	Todd Darling	Tonia Edwards	Jean Louis Gassée	John Hill	Randy Jones
Stella Chen	Rebecca Darwin	Dan Eilers	Jamey Gay	Mike Hill	Reese Jones
Joycelyne Cheung	Charles Darwin	Sandra Eisert	Jennifer Genco	Paul Hilts	Sue Jones
Harriett Choice	Sally Davenport	Dr. Kathy El-Messidi	J.D. Geneser	Noël Hirst	Susan Jones
Edwin Chow	Duncan Davidson	Roland & Laura Elgey	Elyse Genuth	Kaisa Hirvensalo	Hye Jin Joo
Laurence Chu	Robyn Davidson	Terry & Lana Elliott	Stefanos Georgantis	Thomas Hoehn	Hal Josephson
Katy & Rick Chudacoff	Jan Davis	Phillip Elmer-Dewitt	Fred Geyer	Sam Hoffman	Cecil Juanarena
Dr. Chu Yuk Chun	Kevin Davis	Rohn & Jeri Engh	Tom & Peg Gildersleeve	Peter Hogg	Chattie Juinio
Harry Chung	Richard Davis	Michela English	Scott Giordano	Nigel & Erin Holmes	Judith Justin
Allan G. Chute	Susan Davis	Mark Epley	Mr. Giurakozics	Peter Holt	Wallop Kaetkrai
James Cimino	Ysgol Y. Ddwylan	Ron Erickson	Bob Godlewski	Mike Homer	John Kao
Vincent Cimino	Jennifer De Vries	Amy Erwitt	Aaron Goldberg	Kim Honda	Kim Kapin
RoseAnn Cimino-Schott	Peter Dean	David & Sheri Erwitt	Marimuthu Gopal	Giok Hong	David Kaplan
Jess & Rhoda Claman	Kay Deasy	Ellen Erwitt	Mike Gordon	Nancy Hooff	Susan Kare
Tim Clancy	Dr. Daniel Debouck	Elliott Erwitt	Shikhar Gosh	Lynnette Hoogerhyde	Bruce Katz
Catherine Clark	Cliff Deeds	Erik & C.J. Erwitt	Tony Graham	Lee Soo Hooi	Dr. Jim Kauahikaua
Donna Clark	Glen DeFevere	Sasha Erwitt	Gregg Graisson	Will Hopkins	Guy & Beth Kawasaki
Andree Clift	Yurbano DelValle	Greg Eschner	Robin Granites	Naoto Hosaka	Father Alfred Keane
Margaret Clift	Ray & Barbara DeMoulin	Steve Eskinazi	Michael Grassick	Dana Houghton	Christopher Keefe
Craig Cline	Steve Denning	Steve Ettlinger	Brian & GiGi Grazer	Ingrid Houtkooper	Jeff Keener
Carol Co	Gail Dent	John Evans	Gary Greenfield	Ron Howard	Tom Kehler
Peter Cochran	Ralph Derrickson	Gary Fackler	Jeff Greenwald	Anita Howe-Waxman	Hanneke Kempen
David Cockerham	Dennis Derryberry	Mr. Fadli	Steve Gregory	Nan Howkins	Jenny Kendall
Debbie Cohen	Joseph Deutsch	Dr. Gary Fanton	Stan Grossfeld	Karina Howley	Tom Kendall
Robert Cohn	Weng Devaras	Jason Farrow	Nick Grouf	Jeff Howson	Chiam Boon Keng
David & Maggie Cole	David & Ann Devoss	Greg Faulkner	Bob Grove	John Huey	Anne Marie Kennan
Jeanne Cole	David Dilts	Mike Federle	Linda Grunberg	Dr. Michael Huff	Tom Kennedy
Randy Cole	Steve Dinan	Henry Feinberg	Joseph Guevara	Darnee Hughes	Sam Kennel
Gerri Coleman	Kathi Doak	Harlan Felt	Delia Guillermo	Barrie Hulce	Khoo Heng Keow
Wayne Collier	Judith H. Dobrzynski	Lori Fena	Hakan Guney	Karen Hwang	John Kernan
Budd Colligan	Mary Jane Dodge	Fany Feng	Catherine Guo	Patricia Hyde	Marie Kerr
Jimmy Colton	Walter Dods	Bran Ferren	Carl Gustin	Lindsey & Paul Iacovino	Sat Tara Khalsa
Becky, Cali, Christy &	John Doerr	Vholet Ferrer	Brad Hajim	Robin Insley	Tay Lay Kheng
Rickie Comeaux	Margit Dokter	Dr. Joseph Feste	Ed & Barbara Hajim	Christopher Ireland	Vinod Khosla
Coco Conn	Michael Dolbec	Keith Figlioli	G.B. Hajim	Chuck & Carol Isaacs	Mike Kier
Robert Conway	Captain Hank Dolbury	Jim & Ann Firestone	Lynne Hale	Cely Isabedra	Peggy Kilburn
Kathy Cook	Thomas Dolby	Bill Fishburn	Gail Hall	Laurie Isenberg	Jan Kingaard
Rob & Mary Anne Cook	Cora Domingo	Dave Fisher	Victoria Hamilton	Milton Isidro	Doug & Francoise
Scott Cook	Claire Donahue	George & Ann Fisher	Kendall Hansen	Vern & Pigeon Iuppa	Kirkland
Guy Cooper	Nick Donatiello	Victor Fisher	Mark Hardenfeldt	Mark Ivey	Robert Kirschenbaum
Syd Coppersmith	Brendon Donnelly	Mike Flynn	Pam Harrington	Pico Iyer	Dr. Steven Kirshblum
John Corcoran	Sheila Donnelly	Kevin Fong	Jay Harris	Naomi Izakura	Max Kirshnit
Jack & Helen Corn	Michael Donovan	Sofie Formica	Nick & Jane Harris	Charlie Jackson	Michael & Veronica
Danny Coronado	Bob Dougan	Paul Foster	Jon Hart	Jeffrey D. Jacobs	Kleeman
Sheila Costello	Liz Dowling	Bob Foth	Paul Hartley	Rita D. Jacobs	Harlan & Sandy Kleiman
Cotton Coulson	Richard Draper	Dave Fowler	Pieter Hartsook	Tom Jacobs	Joyce Klein
Agathe Coville	Arnold Drapkin	Nathan Fox	Barbara Haven	Kia Jam	Tim Kness
Laura Cox	Dr. Betsy Dresser	Lisa Francia	Rod Havriluck	Catriona Jameison	Alex Knight
Patrick Coyne	Gene & Gayle Driskell	Kirk Frederick	Stephen Hawking	Renee James	Kent Kobersteen
Don Crabb	Hugh Dubberly	Rolf Fricke	Jamie Hawn	Amy Janello	Diana Koh
Rick Cramer	Donna Dubkinsky	Jane Friedman	Steve Hayden	Melanie Janin	Jim Kohlenberger
Christin Crampton-Day	Dan Dubno	David Friend	Ward Hayter	Glen Janssens	Ayk Kokcü

Eng Chiaw Koon
Mikel Smith Koon
Les Koonce
Effie Kousoulas
Karen Kozak
Judith Krantz
Tony Krantz
Dannny Kraus
Kai Kraus
Jeff Kriendler
Ken Kruger
Meir Kryger
John & Vicki Kryzanowski
Hal Kurkowski
Kenneth P. Kuzmitski
Maxim Kuznetzov
Mark Kvamme
Noreen Kwan
Kip Kyler
Eliane & J. P. Laffont
Stephanie Laffont
Andrea Laine
Claude Lallart
Dr. Ralph Lamson
Sonia Land
Bill Lane
Judy Lang
Jaron Lanier
Adrienne Lansbergen
Steve Lansing
Chine Lanzmann
Tom LaPuzza
Ken Lassiter
Gilles Lassus
Jen Latham
Annie Lau
Maria Lau
Winnie Lau
Ronald Laub
Gary Lauder
Mr. Law
Barbara Lawrence
Sharon Le Gall
Carolee L. Lee
Dinah Lee
Patricia E. Lee
Priscilla Lee
Dan Leemann
Alan Lefkof
Lana Leiding
Joe & Marny Leis
Goh Kwee Leng
Ted Leonsis
Rick LePage
Brian Letts
Hugh Levin
Martin Levin
Bob Levine
Steve Levy
Dan'l & Susan Lewin
Andrew Lewis
David Lewis
Peter N. Lewis
Mimi Li
David Liddle
Anne Lim

Carmee Lim
John Lim
Stephanie Lim
Sondhi Limthongkul
Cici Lin
Celia Lines
Nurse Soo Lynette Ling
Amy Liu
George Liu
Jennifer Liu
John Loengard
Don Logan
Larry Logan
Karen Lomas
James & Mary Looram
Mark Looram
Patrick, Odile, Charlotte &
 Tadhg Looram
Sean Looram
Richard LoPinto
Gilman Louie
Piers Lowson
Edouard-Arthur Loye
Terry Lund
Paul Lundahl
David Lyman
Dana Lyon
Tereza Machado
Laurie Macklin
Lt. Chris Madden
Nancy Madlin
Larry Magid
Michael & Michelle
 Magnus
Katie, Caren &
 Dan Mahar
Paul Mahon
Mark Maimone
Tony & Judy Maine
Yvette Maldonado
Diedre Malone
Tim Malone
Alfred Mandel
Michael Manganiello
Tom Mangelsen
Al Manzello
Thom Marchionna
Gerald Margolis
Mary Ellen Mark
John Markoff
Art Marks
Bryan Marks
Harry Marks
Leslie Markus
Kevin Markwell
Dr. Frederique Marodon
Van Maroevich
Anna Marshall
Jessy Marshall
Kevin Marshall
Nick Marshall
Sue Masey
Lt. Megan Mason
Camille Massey
Davis Masten
Lucienne & Richard

Matthews
Jennifer Matthey
David Matthieson
Wendy J. Mattson
C. J. Maupin
Margaret Maupin
Mike May
Mike & Martha Mazzaschi
Paul McAfee
Georgia McCabe
John McChesney
Mike McConnell
Joe McDonnell
Mark McDougal
Mary McEvoy
Lou McFaddin
Alan McGowan
Ewan McGregor
Shawn McKee
Ron McManmon
Jack McWilliams
Azman Md Zin
Gene Meieran
Kevin Meisel
Charles Melcher
Jim & April Melcher
Tom & Sharon Melcher
Brita Meng
Dave, Rita, Molly, Dustin
 & Alissa Mennenga
Cheri Merrihew
Joyce Meskis
Judy Messeda
Bill Messing
Jane Metcalfe
Robert & Robyn Metcalfe
Theo Meyer
Hassan Miah
Jerry Michalski
Sharon Middendorf
Avram Miller
Dick Miller
Maddy Miller
Michael Miller
Rand Miller
Robyn Miller
Susan Miller
Dr. Richard Milsten
Valerie Minard
Dino Mincuzzi
Halsey Minor
Sidney Mitchell
Ciana Moira
Clement Mok
Tony Molinaro
Randy Montoya
Kathleen Moody
Robin Moody
Michael Moon
Paula Moore
Kathleen Moran
Mike Moreland
Marney Morris
Neill Morris
Ann Moscicki
Avi Moskowitz

Mary, Frank & Quinn
 Moslander
Jeff Moss
Joseph Mouzon
Debbie Muchow
Frances Mullan
Lisa Mullinax
Chuck Mulloy
Christopher Munday
Chandra Muniandy
Dennis & Zora Muren
Leila Murphy
Mary Beth Murrill
Nathan Myhrvold
Hank Nagashima
Dave Nagel
Michael Naimark
Hiroshi Nakamura
Victor Nakamura
Sergei Naoumov
Veronica Napoles
Graham Nash
Ron Nash
Hilary Nation
Cynthia Nead, C.C.T.A.
Eric Nee
David Beffa Negrini
Nicholas Negroponte
Duane Nelson
Grazia Neri
Michele Neri
Sophia Neu-schulz
Gillian Newson
Kevin Ng
Kim Nguyen
J. Terry Nickell
Carl Nicoll
Wayne Niskala
Susannah Patton, Chris &
 Sam Noble
Egdardo Nogales
Tom Noonan
Wan Zailena Noordin
Chase Norlin
Giorgio Notari
Chuck & Shirley Novak
Geordie Nugent
Martin O'Brien
Sara O'Brien
Matt Ocko
Hisako Ohta
David Okita
Karen Olcott
Kelly Oliver
Arthur Ollman
Ross Olney
Brendan Onyejikwe
Leen Oosterveen
Sonny Ordona
Dr. Dean Ornish
Alan Orso
Will Osborne, III
Gene Ostroff
John Owen
Emily A. Padilla
Captain Edward Page

Richard L. Page M.D.
Rusty Pallas
Mike Pandell
Rick Pappas
Andy Park
Brian Park
Cora Pascual
Pierre Pasteris
Somporn Patamanukroch
Kevin Patsel
Stephen Patten
Vince Patterson
Steve Patzer
Daniel Paul
Annamari Paussoi
Bo Peabody
Dr. David Pearce
Norman Pearl
Hilary Peck
Paolo Pedrinazzi
Pat Pekari
Ray Pellecchia
Jake Pena
Andy Perala
John Peralta
Matthew Lee Perkins
Tony Perkins
Gabe Perle
Liz Perle McKenna
Linda Lamb & Rich Peters
Tom Peters
Brent Peterson
Peter Petre
Elaine Petrochelli
Paolo Petrone
Sandy Petrykowski
Ghery Pettit
Phallop Phaiarry
Patricia Phelan
Vicki Pierce
John & Janet Pierson
Dana Plautz
Catherine Pledge
Robert Pledge
Ronald Pledge
Chris Poleway
Len Polisar
J. R. Poulsen
Dr. Joe Prendergast
Kristina Price
Robert Price
Robert Pritikin
Ralph Privitere
Thomas M. Privitere
Thomas V. Privitere
Natasha & Jeff Pruss
Nancy Querubin
Armando Quintero
Daniel Rabieh
Chari Rabinowtiz
Mitch Radcliff
Phra Rajapanyasuthee
William Ramwell
Dan Rascon
Doug Rasor
Nora Rawlinson

William Rawn
Bill Ray
Allen Razdow
Franck Rebourseau
Pamela Reed
Jacob Reid
Scott Reid
Kristin Reimer
Steve Rein
Tiffany Renfro
Roger Ressmeyer
Amir Reubin
Michael Reynolds
Tim Rhea
Doug Rice
Patti Richards
Frank Richardson
Amy Richter
Thomas P. Rielly
Susan Riker
Michael W. Ritchey
Barbara Roberts
Jeffrey Roberts
Ray Roberts
Debbie Donnelly & Justin
 Robinson
Beverly Robinson-Allison
Mick Robson
Sally Robson
Ervin Rodriguez
Michael Rogers
Peter Romanoff
Mary Rommelfanger
David S. Rose
Marylou Rosemeyer
Mike Rosenfelt
Steve Ross
Louis Rossetto
Mike Roswell
Pirjo Rotkonen
Galen & Barbara Rowell
Steve Roy
Melanie Rudnick
Mary Rummelfinger
Joe Runde
Isabel & Mike Rupert
John Russell
Dr. Nathan Russell
Stephen Ryall
Liam Ryan
Mark Rykoff
Marcel Saba
Bill Sabo
Glenn Sadullo
Jennifer Saffo
Nola Safro
Barbara Sailor
Michele Sain
Tony Salamanca
Lelia & Sebastião Salgado
Marianne Samenko
Kirsten Samuel
Curt Sanburn
Will & Marta Sanburn
Jared Sandberg
Joaquim Sans

Tom Santos
Jason Sarret
Laura Satchwill
Amy Satran
Selina Saw
Murray & Jenny Sayle
Mark Schlichting
Eric Schmidt
Jennifer Schmidt
Ida Schofield
Jeff Schon
Duane Schulz
Bob Schureman
Terry Schussler
Julie Schwerin
Pat & Karen Scott
David Sculley
John Sculley
Ryan Sears
Scott Sedlik
John Seely Brown
Nikki Seligman
Charlene Sellers
Richard Sergay
Vani Seshadri
Fabrizio Sgariglia
Ken Shapero
Jack Sharma
Yuri Shatalin
Denise Shephard
Kathe Sherman
Ron Sherman
Stephanie Sherman
Donna Shirley
Timothy P. Shriver
Dave Siegel
Madhulika Sikkam
Jerry Sim
Greg Simon
Andrew Singer
Bob Siroka
SueAnn Sisto, Ph.D., P.T.
Vanessa Skelton
Lisa & Bob Skinner
Tom Skinner
Mike Slade
Michael Slater
Diana Smedley
Martin Cruz Smith
Megan Smith
Rick Smith
Rodney Smith
Savannah Smith
Sherilyn Smith
Leslie Smolan
Marvin & Gloria Smolan
Reed & Lily Smolan
Sandy Smolan
Marie Snidow
Pat Sobranis
Peter Soh
Adam Sohn
Joy & Marty Solomon
Nancy Soto
Joe & Maura Sparks
Lisa Spivey

Alan Spoon
Barbara Spoonamore
Tom Springett
Mark Stahlman
Carol Stakenas
Lovisa Stannow
Ken & Marisa Starr
Mari T. Steed
Suzanne Stefanac
Mitch Stein
Greg Steltenpohl
Dr. Julian Stevens
Todd Stevens
Stewart Family
Laura Stewart
Ron Stewart
Mandy Stier
Lisa Stimmel
Court Stockton
Jim Stockton
Bill Stone
Linda Stone
Brian Storm
Janet Storms
Christine Strand
Jan Stranski
Steve Stücky
Jennifer Su
Joy Tan Su-Mien
E. Sukumar
Tony Sun
Peter Sutch
Dick & Germaine Swanson
Greg Swayne
Grainne Sweetman
Jack Sydow
Jolene Sykes
Steve Symonds
Reggie Taar
Dean Takahasi
Noriko Takikawa
Nan Talese
Aroon Tan
Magdalene Tan
Mark Tan
Osbert Tan
Phyllis Tan
Sheila Tang
Jay Tannenbaum
Permsak Tansthitaya
Bill Taylor
Michael Tchao
Sepaktakraw
 TeamMohd Mazli
Annette Temple
Joyce Tenneson
Mat Teofisto
T. H. Teoh
Michael Tette
Paul Theroux
Frank Thomas
Craig Thompson
Dr. Carl Thornber
Saadia Tiare
Laurel Todd
Leonie Toland

Sunday Tollefson
Josh Touber
Tyler Townsend
Paul Toya
Eisake Toyokura
Keith Truelove
Karen Tucker
Joe Tulchin
Frank Turpin
Robert Tygar
Ken Tyler
Kanpriom Ungpakorn
Eric & Nina Utne
Louise Valesquez
Denny Vallianos
Doug Van Beek
Mike Van Der Kieft
Jurrie Van derWoude
Ann Van Dyk
Della Van Heyst
Mariska van Yzerloo
Dana Vandecoevering
Ignacio & Barbara Vasallo
Chit Ventura
Bernard Vignes
Raphael Villa San Juan
Grace Villarin
Paulo Viola
Sriram Viswanathan
Alberto Vitali
Pierre-François Voirin
Stuart Volkow
Jim Voorhies
Midori Wada
Tom Wages
Cardon Walker
Scott Walker
Chip Walters
Steve Wamboldt
Debbie Wang
Wisanu Wangwisut
Bill & Alyssa Warner
Chris Warner
John & Marva Warnock
Stan Waterman
Chadia Webb
Nick Weigel
Marvin Weinberger
Mark Weiser
Maura Duncan Welch
Kevin Weldon
Albert Wen
Russ Werner
Eve West
Tom Westenberg
Megan Wheeler
Jane White
Ree Whitford
Kevin Whitmore
Marissa Whitmore
Red Whittaker
Karen Wickre
James Wiebe
Sherri Wigger
John Wilczak
Dave Wilhoit

Mary Wilkerson
Sue Wilkinson
Dave Willard
Jason Willett
Preston Williams
Robin & Marsha Williams
Kevin Wills
Dean Wilson
Eric Wilson
Ann Winblad
Tad Wineman
Dave Winer
Matt & Julie Winokur
Don Winslow
Charlie Winton
Stephan Wittkaemper
David Witzke
Curtis Wong
Dawn Wong
Lois A. Wong
Penelope Wong
Dussanee Wongratanachot
Lola Wood
Jerry Woodall
Serena Woodall
Susan Woodall
Jim Woods
Sam & Max Worrin
Simon Worrin
Chuck Wright
Eric Wyka
Qing Xi
David Yakir
Jerry Yang
Mr. Yap
Ron Yara
Ng Kin Yee
Tom Yellin
Joyce Yeltin
Cheryl Yen
Deborah Yen
Shirley Yeung
To Lien Yin
Rosalind Wong Yoke
Dendy Young
Jim Young
Candy Yu
Kate Yuschenkoff
Yvone Yvone
Eric Zakoske
Eric Zarakov
Beth Zarcone
Thomas Zaso
Brian Zhou
Michael Zilber
Tom Zimmerman
Ingrid Ziskind
Moses Znaimer
Don Zochert
Nina Zolt

Staff

Project Directors
Rick Smolan
Jennifer Erwitt

Editorial Director
Mike Cerre
Globe TV

Managing Editor
Andrew R. Lax

Art Director
Thomas K. Walker
GRAF/x

Director of Photography
Karen Mullarkey

Sponsorship Director
Gina Privitere

General Manager
Katya Able

Production Director
Corey Hajim

Assignment Editors
Mary Jane Call
Stephanie Cheifet
Paul Dion
Dorthe Doerholt
Breda Fahey-Thomas
Corey Hajim
Eileen Hansen
Sumiko Kurita
Peter Lengsfelder
Meaghan Looram
Greg Milano
Patrick Moyroud
Nicole Policicchio
Gina Privitere
Jennifer Winston

Essay Writer
Michael S. Malone

Caption Writer
Bernard Ohanian
National Geographic

Photo Researchers
Breda Fahey-Thomas
Meaghan Looram
Greg Milano
Gina Privitere

Picture Editors
Mike Davis
Detroit Free Press
Bill Douthitt
National Geographic
Diego Goldberg
Diario Clarin
Colin Jacobson
Michele McNally
Fortune Magazine
Karen Mullarkey
Larry Nighswander
*The School of Visual
Communication,
Ohio University*
Michele Stephenson
Time

Production Assistant
Brynn Breuner

Copy Editors/Proofreaders
Eileen Hansen
Mimi Kusch
Grace Loh
Joan Rosenberg

Controller
Rita Dulebohn

Legal Counsel
Barry Reder
*Coblentz, Cahen, McCabe &
Breyer*

Accounting
Bob Powers
Calegari & Morris, Accountants
Eugene Blumberg

Administrative Assistant
Sunny Leigh Woodall

Culinary Consultants
Joe & Marny Leis
Avenue Grill
Paolo Pedrinazzi
Frantoio
Paolo Petrone
D'Angelo

Systems Administration
David Latham
Jim Witous
Michael Gordon
Dave De Graff

Interns
Josh Haner
Kate Reder
Daniel Shain

Travel Consultants
Adrienne Humphrey
Kathy Baker
Small World Travel

Literary Agent
Bill Gladstone
Waterside Productions

Special Advisors
Pam Alexander
Alexander Communications
Ken Auletta
The New Yorker
Andy Cunningham
Cunningham Communications
Daniel Brown
Metagraphics
Russell Brown
Adobe Systems
Albert Chu
AT&T Labs
Esther Dyson
Release 1.0
Danny Hillis
Larry Keeley
The Doblin Group
Scott Kurnit
The Mining Company
Jonathan D. Lazarus
Microsoft Corporation
Patrick McGovern
IDG
Regis McKenna
Roger McNamee
Integral Capital Partners
Phillip Moffitt
Steve Perlman
WebTV
Paul Saffo
Institute for the Future
Jonathan Seybold
Joe Schoendorf
Accel Partners
Richard Saul Wurman
TED Conferences

Intel Corporation
Keith Chapple
John Crawford
J. Scott Crist
Sandra Duncan
Kim Fujikawa
Charlotte Gibberman
Jim Jacobson
Jim Jarrett
Bob Jecmen
Ted Jenkins
Tracy Koon
Gwyn Kramer
Sharon Le Gall
Susan Rockrise
Chris Scharein
Teri Silva
Joanne Simkins
Kevin Teixeira
Rick Willson
Kathie Wood
David Yaniec
Albert Yu

Dai Nippon Printing Co., Ltd.
Junichi Iwama
Masanobu Kamigaki
Yuichi Mio
Shuichi Seino

Shipping Consultant
Greg McLaughlin
A G World Transport

The stories continue online; see additional images,
video and audio interviews with the photographers
and subjects, and much more. Please come to
the One Digital Day *Web site to learn more about*
the people and places featured in this book:

www.intel.com/OneDigitalDay